EXPRESSIVE FIGURE DRAWING

NEW MATERIALS, CONCEPTS, AND TECHNIQUES

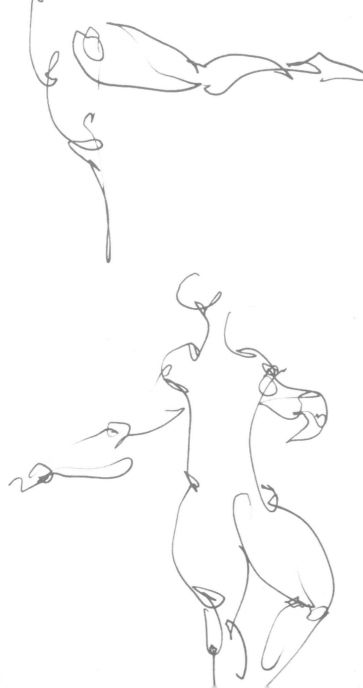

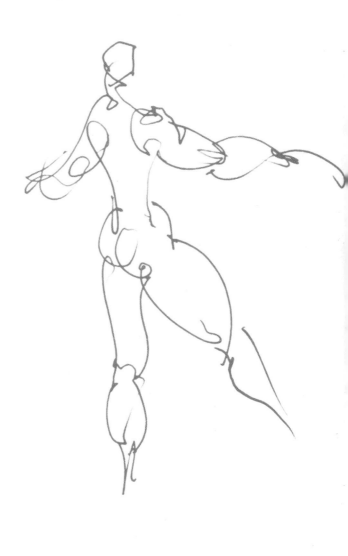

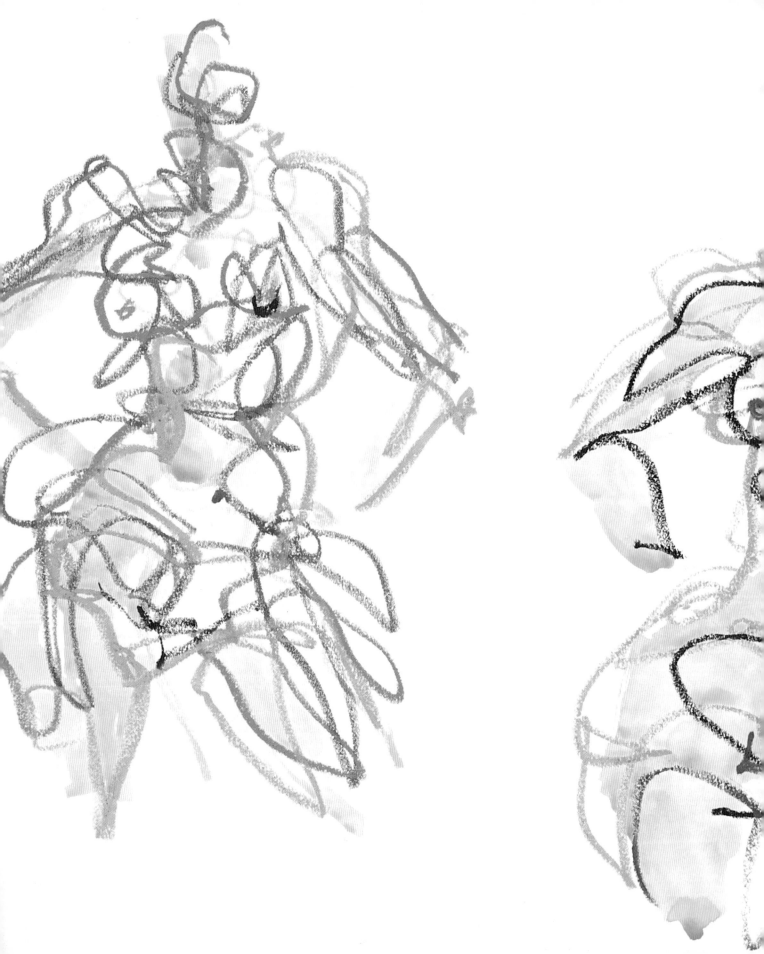

EXPRESSIVE
FIGURE DRAWING

NEW MATERIALS, CONCEPTS, AND TECHNIQUES

Bill Buchman

Watson-Guptill Publications / New York

Published in the United States by Watson-Guptill
Publications, an imprint of the Crown Publishing
Group, a division of Random House, Inc., New York.

www.crownpublishing.com
www.watsonguptill.com

WATSON-GUPTILL is a registered trademark and
the WG and Horse designs are trademarks of
Random House, Inc.

Library of Congress Cataloging-in-Publication Data

Buchman, Bill.
 Expressive figure drawing : new materials, con-
cepts, and techniques / by Bill Buchman. — 1st ed.
 p. cm.
 Includes index.
 ISBN 978-0-8230-3314-0
 1. Figure drawing—Technique. I. Title.
 NC765.B83 2010
 743.4—dc22
 2010003421

Printed in China

Designed by veést design

10 9 8 7 6 5 4 3 2 1

First Edition

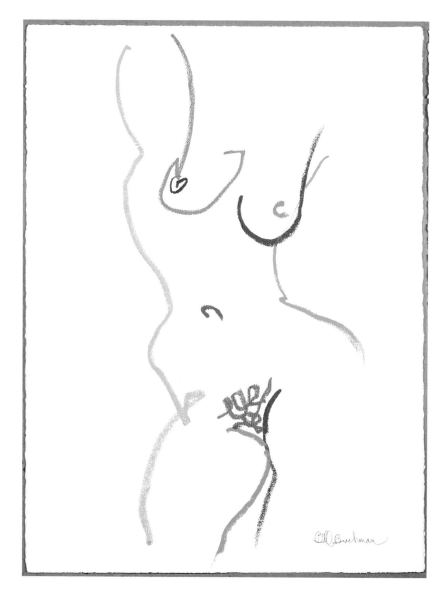

(p. 1) *Ballet Moves,* 1993, ink on paper, 12 x 9 inches (30.5 x 23 cm), collection of the artist

(p. 2–3) *Nude Figures 37,* 2008, oil pastel and watercolor on watercolor paper, 18 x 24 inches (45.7 x 61 cm), collection of the artist

▲ *Eve,* 2008, oil pastel on watercolor paper, 30 x 22 inches (76.2 x 55.9 cm), collection of the artist

▶ *In the Moment,* 2010, Sumi ink on paper, 24 x 11.3 inches (61 x 28.7 cm), collection of the artist

(p. 7) *Ballet Leaps,* 2008, acrylic ink and water-soluble crayon on paper, 12 x 9 inches (30.5 x 23 cm), collection of the artist

To the memory of my parents, Natalie and Louis

I wish to thank my wife, Mette, and my son, Noah, for their patience, understanding, and support during the gestation and birth of this book; Candace Raney, executive editor at Watson-Guptill for seeing and believing in the possibilities of this project and enabling it to come to fruition; my editor, Alison Hagge, for her organizational expertise and cheerful clarity throughout the editing process; designer, Vera Fong (veést design), for creating the beautiful layout; the models who have posed for me, especially Claudia Schwartz and Zoe Zimmerman; and all others, past and present, who have encouraged and nourished my artistic vision.

It is a humbling experience to tread in a field where there are so many giant footprints. I am completely indebted to all the dedicated artists, teachers, and writers who have created, kept, and expanded the traditions and methods of figure drawing and from whom I have learned so much. I have drawn heavily in my development and teaching from my teachers Fletcher Martin and Victor D'Amico and a wonderful California illustrator named David Pacheco (not the Disney artist/animator). In addition, I wish to acknowledge certain writers on the subject of figure drawing whose books in particular have informed my own thinking, development, and teaching methods. These include Arthur Zaidenberg, Kimon Nicolaides, Robert Kaupelis, Nathan Goldstein, and Harold Speed. These innovative teachers and thinkers have produced a body of thoughts, concepts, methods, and terminologies that clarify and codify the ideas and methods of figure drawing in ways that nurture individual freedom of expression. I also wish to acknowledge my students, who, by allowing me the privilege of following and guiding them in their engagement with this challenging subject, have enriched my understanding, confirmed many beliefs, forced me to modify others, and generally showed me the great value of this particular human endeavor. They have shown me that learning how to draw confidently generates satisfaction and joy as well as enhances life. The results I have witnessed in classes with students of all ages and skill levels have given me confidence that the principles and methods herein are sound and yield very rapid progress when diligently applied. In this last phrase lies the most important key of them all: In art we learn by doing.

CONTENTS

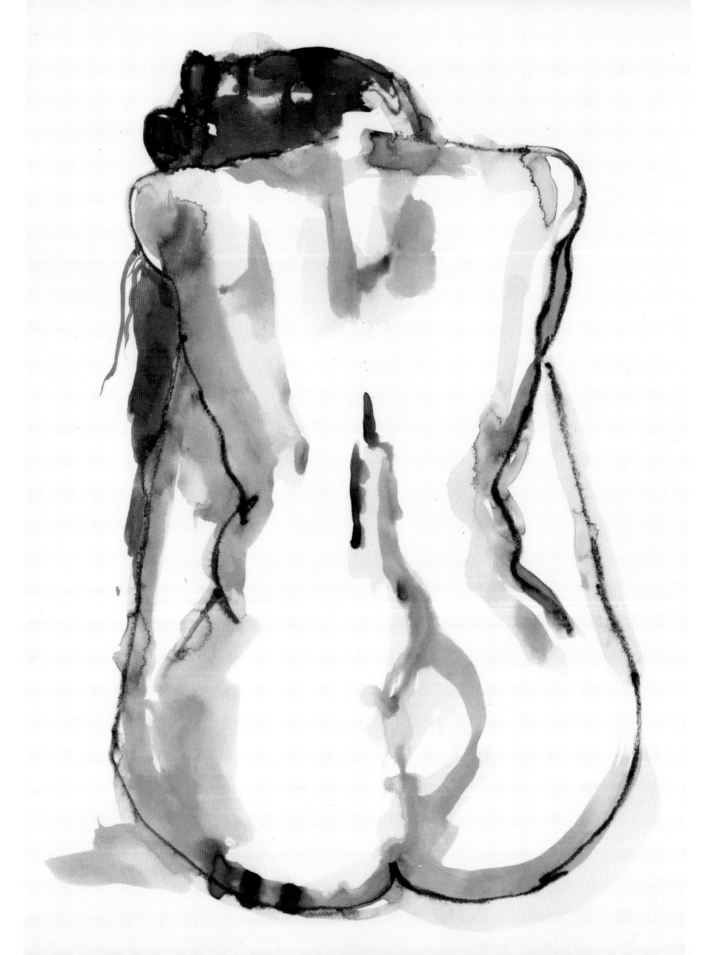

PREFACE

There are those for whom art is primarily theoretical and conceptual. For others art is concrete and about verisimilitude—what we can see and reproduce of the visible world as it is. Some find transcendence in the everyday appearance of things. And still others see the visible world as just the starting point for creating art that expresses a meaning beyond what is visible.

This last group places the goal of self-expression paramount in their works. A vision of or a yearning for an idea or an ideal drives these artists. They tease, trick, tickle, and torture their themes and motifs to bring out the maximum meaning. These are the artists in the expressive tradition. They have used the form and attitudes of that most expressive thing, the human body, to convey attitudes of mind. With the human form as a source book, they have imaged forth visions and archetypes that express, in myriad ways, the essence of man's spirit. It is in the hopes of encouraging the continuation and furthering of this tradition of the figure that I have made this book.

Learning to draw is about learning how to see, understand, and imagine. When faithfully explored, the techniques of expressive drawing can enable artists of every persuasion to explore and deepen their art. Anyone just starting out, or at any stage thereafter, will find that they will be able to advance on a firm footing and find their way by using these approaches. In whatever category you find yourself, you will find keys here to unlock your creativity and build skills that you can apply to your chosen approach. It is for you, who will use these keys and enjoy the artistic expansion they give, that this book is written.

This book is about learning the foundational techniques, observational principles, and conceptual and attitudinal skills that will give you a thorough basis for being able to draw the human figure (and anything else you wish to draw) expressively and with confidence. It is also about how to synchronize your use of the exciting tools and materials of art with these techniques, principles, and skills. And finally, it is about learning how to make artistic decisions that will elevate your drawings from renderings to personally felt journeys based on a direct, deeply felt, and thoughtful confrontation with your actual visual experience.

◄ *Attitude 95,* 1994, acrylic ink and
water-soluble crayon on watercolor paper,
23 ½ x 16 ½ inches (59.7 x 41.9 cm),
private collection

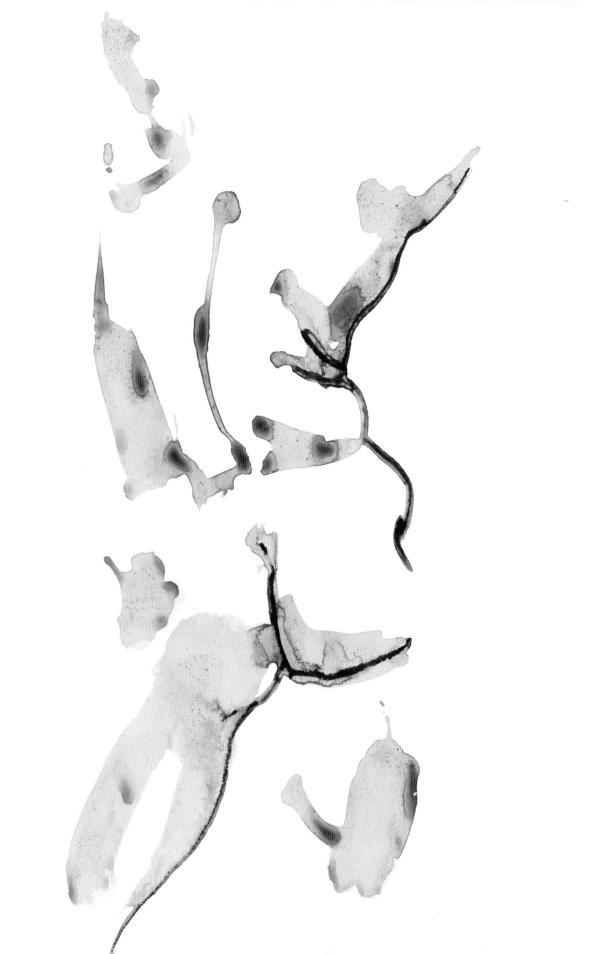

INTRODUCTION

The deep urge to express the beauty and mystery of the human form has been at the center of the art-making process throughout history. Among many other intrinsic motives, this is due, no doubt, to the fact that representing the figure is one of the most fascinating and pleasurable forms of making art there is. The oldest known examples of figurative art are voluptuously carved figurines from around 35,000 years ago in what is now Europe. In the many centuries that have followed, innumerable different stylistic languages, techniques, and media for representing the figure have evolved in virtually all cultures. Today we enjoy a vast trove of knowledge and techniques on this endless subject and are inspired by a seemingly unlimited flood of new materials, processes, and images. At the same time we have a daunting abundance of diverging theories, systems, and methods. The possible ways to explore this most enjoyable pursuit seem virtually infinite.

This healthy diversity contributes to a wonderfully wide world of possibilities and results. However, the student looking for direction can easily become confused and even discouraged by the maze of information that he encounters through classes, books, and fellow artists. It seems that one artist uses a rule with great success, yet another artist ignores or breaks the same rule with equal success. This is the setting in which each aspiring artist must find his way.

Both the teaching and learning of art-making processes present many unique challenges. The student must find the system that works best for her and learn how to expand upon it to make her work her own. The teacher must find what will best help his students to find their way. I have tried to provide a way that is concrete but not written in stone—a way that is designed to keep the student opening new doors and discovering new ideas and possibilities while absorbing established knowledge and traditions.

This book will introduce you to new ways of thinking about and working with the figure. At the same time, it presents streamlined versions of the traditional concepts and practices. I wish to take you on a journey to understand the body differently—to see it with new eyes, to understand the body as an artistic and poetic subject rather than a mere biological form.

Everyone has an artist within. Learning to draw the figure and explore the endless possibilities of this splendid subject is one of the greatest ways of getting in touch with your inner artist. It is one of the traditional ways of building a foundation for doing all kinds of art. Herein is a map for your journey through this wilderness with methods that, while they provide a certain amount of order, will still encourage and enable you to explore the unlimited expressive possibilities inherent in the art of figure drawing.

◀ *Male Nude 1,* 1998, acrylic ink and water-soluble crayon on watercolor paper, 23½ x 16½ inches (59.7 x 41.9 cm), collection of the artist

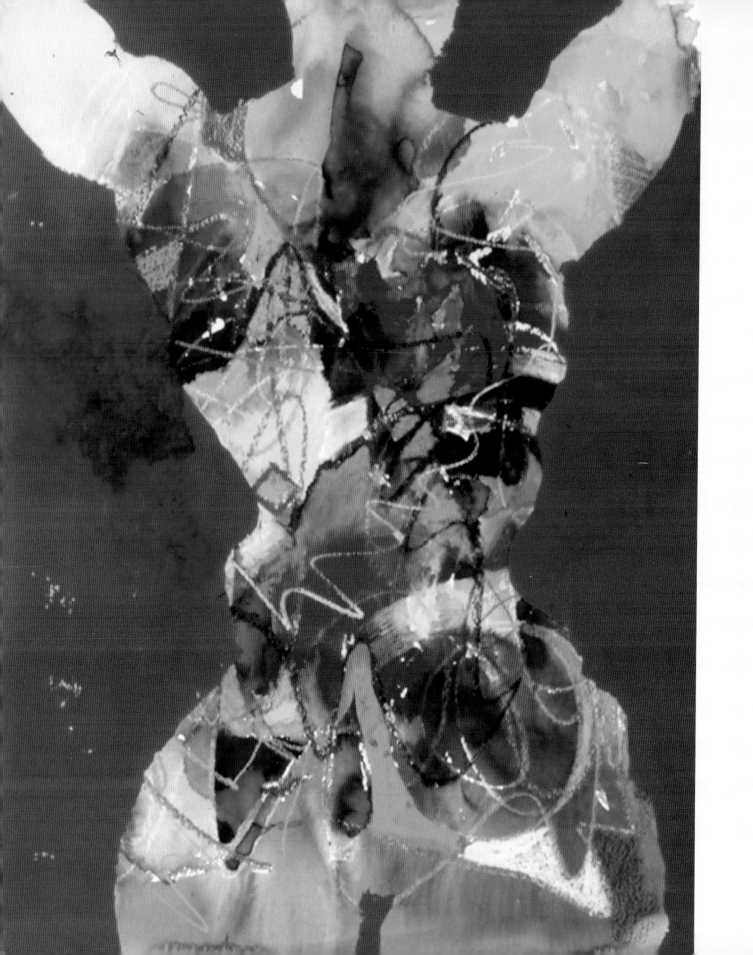

PART I: Expressive Figure Drawing Essentials

The methods in this book can be summarized by four simple words: *Art is an attitude.* Your attitude—what you know, what you feel, how you think, and how you approach your art—is going to determine your results. Developing as an artist is a matter of finding and cultivating the attitude that will get you where you wish to go.

The art-is-an-attitude method is in essence very simple:

- You are making poetry.
- The marks you make express your ideas.
- Focus on the process.
- Be confident. Don't fuss.

Whether you lean toward a realistic or an interpretive approach, the fundamental concepts covered here will be of value to you. My wish is that you will find ideas and tools here that you can use to bring your drawings alive—and that you will enjoy the process. Your ability to improve your drawing skills and confidence are limited only by how faithfully you apply these concepts.

It takes guts to put the techniques and approaches presented in a book into action, but when you do the benefits will be quickly apparent. My experience as a musician has taught me the value of a training program as a basis for the creative act. This book is a training program. Incorporate these ideas into your drawing practice, and no matter what your level, you will improve.

◀ *New Nude VI,* 2008, watercolor, acrylic, and oil pastel on watercolor paper, 24 x 18 inches (61 x 45.7 cm), private collection

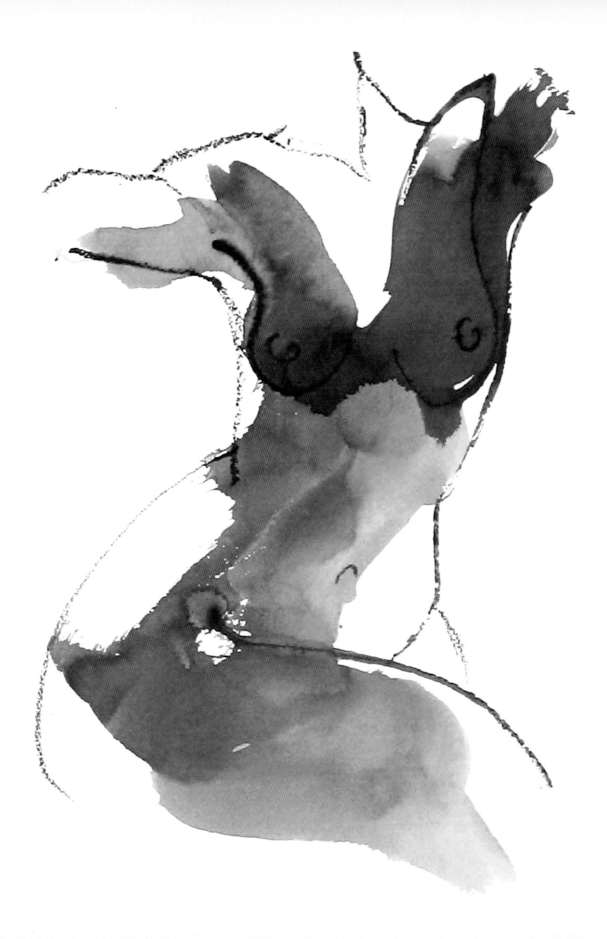

THE DRAWING PROCESS

Process can be defined as a natural and gradual progression toward a definable result. This applies to how you approach each drawing as well as to the entire learning-to-draw project. The important thing is to take the time to develop the process that works for you.

Too often, drawing students set out to make drawings and become discouraged when things don't go as expected. They get down on themselves, criticize every mark as they make it, and end up being frustrated at every turn. At this point things start to go downhill. They forget what their goal is and they give up, or, if their desire is strong, they decide to plod on without really making much progress. There is a better way.

The most fundamental concept to grasp may be stated thusly: *Think process, not product.* You need a good process to get good results. What is this process? It is a mind-sharpening process—a progressive program of drawing that develops your skills and awareness. It can't be said often enough that, in so many respects, your success depends upon being able to forget about finished results when you draw.

Here is a description of a good process:

- Lower your expectations and raise your spirits.
- Make mistakes, but make good mistakes.
- Don't fiddle—and don't erase.
- Be patient. Be true to what you see.

Instead of trying to make a "good" drawing, have a good experience.

When you draw, you are learning constantly. In reality, how you approach the drawing process is a big determining factor in your progress. A good drawing is the byproduct of a good learning process. When you work, think of *drawing,* not of *making a drawing.*

Learning to improve your figure-drawing skills requires patience, and the learning process needs to be enjoyable. Don't pressure yourself. Get rid of those enormous expectations. Get rid of that destructive urge to be too self-critical. These are real barriers to progress. When you draw, look for what you have done well, and learn from that. It is very important to give yourself mental and emotional breathing room as you make progress. After all, we learn one step at a time.

◀ *Attitude 110,* 2005, acrylic wash and water-soluble crayon on paper, 24 x 18 inches (61 x 46 cm), private collection

FOUNDATIONAL CONCEPTS

There is an old blues song called "You've Got to Know How." Learning anything is always a matter of knowing how to go about it. This is certainly true of drawing the figure. There is a grand logic to how the parts of the body fit together. Likewise, there is a grand logic to how the different parts of the drawing process fit together.

Learning how to draw is very much dependent upon understanding precisely what it is you are trying to accomplish and then going about it in the right way. You are building a skill set. Some of those skills are tangible while others are quite intangible and subtle. You need to find out what works—which techniques and approaches can help you to get there and which attitudes work well and which do not. Then, of course, you must implement the things that do work best for you.

The figure-drawing learning process is multifaceted. Like the human figure itself, you have to walk around it and study it and work on it from many angles. It is a continual process of sharpening your mind, your knowledge, and your skills. This is what is so exciting about it. It involves special ways of thinking. It particularly calls for building up the attitudes of confidence, courage, and even fearlessness.

Although it is necessary to present the fundamentals and concepts of the drawing process individually, there are no hard-and-fast lines separating them—and they frequently overlap. While the different approaches may sometimes appear to contradict or oppose one another, they are actually all aspects of one process. In Part III of this book, I have organized the foundational concepts around seven central elements:

- Gesture
- Mass
- Line
- Structure
- Shape
- Volume
- Color

An understanding of how to use these elements—accompanied by solid strategies for observation and an awareness of how to use speed, tempo, and rhythm (which I discuss at length in chapters 2 and 11, respectively)—will provide you with a solid foundation for drawing anything you wish.

You build up your awareness of these elements and the principles they involve by working on the relevant drawing skills one at a time. At a certain point, it naturally becomes easier to bring several fundamentals into play at the same time in a single drawing. In this way, you expand the range of your skills. This is the essential learning method, and it is very effective.

[SEEKING INSPIRATION]

We all have the potential to make inspired art. In fact, being inspired is one of the fundamentals of the drawing process. Learning to make creative, expressive, and inspired drawings and learning the fundamentals of figure drawing are both part of one pleasurable process. This is the bedrock of the expressive learning approach.

But, you may wonder, *how can inspiration be taught or learned?* In this way: You can create a pathway that encourages inspiration. You can create the conditions that allow inspiration to happen.

We all have an inner artist that has something to tell us if we allow it to come to the surface. Take the time and do the exercises offered throughout the book. They will help you to go to that place where inspiration takes place naturally and, at times, even effortlessly.

▼ *Four Views, Four Readings,* 1994, pen, ink, and acrylic wash on paper, 16½ x 23 inches (41.9 x 58.4 cm), collection of the artist

These four quick studies from different angles around the room were done at the beginning of a single-pose drawing session. The angle on the second one struck me as the most expressive, so I followed up with more in-depth life drawings, which can be found on pages 20, 21, and 123.

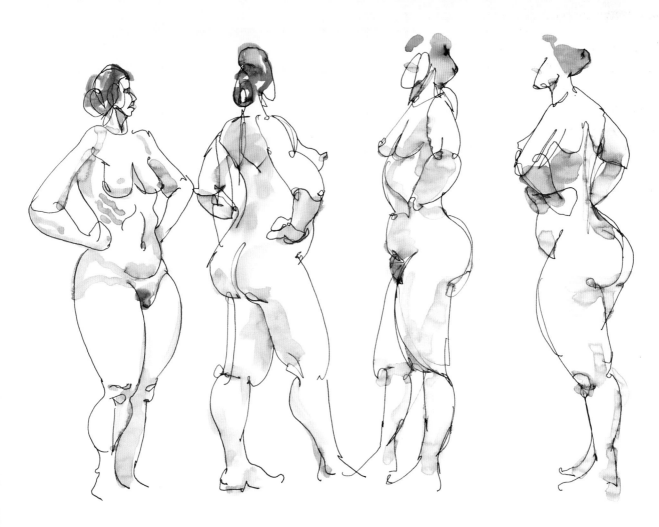

MULTIPLE-LEVELS EXERCISES

It is helpful to learn how to see and draw the figure on separate levels or aspects and to be able to shift from one to another. This exercise—which involves a series of two-minute drawings based on a semireclining pose—develops flexibility of perception and execution.

Recommended Materials
• Conté crayon 2B
• Canson Biggie Sketch pad

Geometric Shapes
Holding the crayon on its side and drawing with the long edge, focus on capturing the simple, large geometric shapes. Carve out the figure in quick, firm strokes.

Shapes as Mass
Now, using the flat side of a broken Conté crayon, record each of the same large shapes as a mass. Add some simplified contours using the point of the crayon.

Shadows and Highlights
Record the darks and lights of the figure, with a series of rapid stippled marks. Repeat marks on top of and next to each other to build up darker areas. This technique takes a little longer than the other three.

Contour Lines
Using contour lines alone, make a general record of the main shapes. These shapes should be easier to identify after having done the first three studies.

▼ Doing a series of different techniques of the same pose in rapid succession is a great way to tune up your seeing and drawing skills. From top left, these sketches concentrate respectively on geometric shapes; shapes as mass; shadows and highlights; and simplified contour lines.

SELECTIVE SEEING EXERCISE

Becoming a good observer is mainly about learning what to look for and what to ignore. This is called selective seeing. You can train yourself to see one aspect of the figure at a time. This exercise gets you to concentrate first on the negative space and then on the overlapping contours that you observe on one side of the figure. These overlapping contours can communicate the figure's structure without literal proportions. Allow yourself three to four minutes to render each figure/contour.

Recommended Materials
• Conté crayon 2B
• Canson Biggie Sketch pad

Overlapping Contours
Begin on the left third of the page. With the flat side of a broken piece of Conté crayon, draw the negative space visible along the right side of the figure, creating a continuous fluid stroke. Be sure to look at the space along the edge, not the mass, as you draw. Nevertheless, this process will describe the outline of the mass of the figure.

Then look at the distinct masses of the figure—such as head, neck, shoulders—and record, with the crayon point, how their edges overlap each other along that outline. Follow some of the overlapping contours well inside the figure to define the forms further. Repeat this exercise two more times, filling out the page.

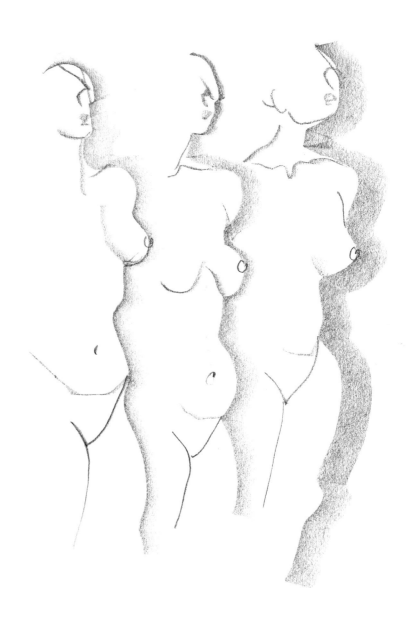

▲ These drawings record the negative space and the overlapping contours. This is one example of selective observation in practice.

A GUIDING PRINCIPLE

There is a unifying rule of action—a master key—that will enable you to integrate all of the fundamental concepts into your drawings one at a time: Always draw with a guiding principle. This magical key is based on the idea of making an advance decision regarding your way of seeing selectively or a way of using your materials or—most frequently (as in the exercise on the previous page)—both. It is both a way of seeing and a way of drawing.

You choose, before you even touch the paper, the one fundamental quality that you are going to concentrate on and then you choose a drawing implement, medium, and method that will help you to capture and emphasize this quality. In so doing, your way of seeing and your way of drawing dovetail into a single principle or concept that guides your drawing process. Sometimes the emphasis is more on the manner of seeing, and other times it is more about the manner of manipulating your materials. When you adhere to and are guided by your chosen process, something wonderful happens. The *process* makes the drawing. This is the gateway to interesting, exciting, and focused drawings.

So how do you choose this strategy, this guiding principle? It can be any simple idea, subject, skill, technique, procedure, plan, feeling, or limit. You can concentrate on one of the elements of drawing, such as line, mass, negative space, light and shadow, or structure. Alternatively, moods, thoughts, experiences, or emotions can provide the basis for your approach. The thirty-minute drawings on this spread were created during an evening drawing session with one long pose. (A fourth and final drawing can be found on page 123.) This allowed me to focus on a number of drawing strategies in one session.

To come up with a guiding principle, ask yourself things such as, "What am I trying to accomplish? What do I wish to say? How much time do I have? What would I like to work on and improve today? Am I going to capture the flow of the lines or analyze the structure? What

is a reachable goal?" Your answers will determine your choice of methods, size, placement, materials, mental approach, tempo, and so forth. Think about these things before you start to draw and be determined to make methodical progress in this way.

The pose or the body type of your model often will suggest what materials to use as well as the guiding

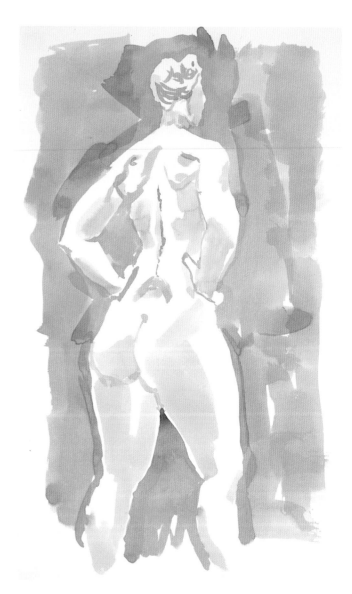

▲ Done with a Sumi brush and thin washes of acrylic ink, this study required great care. The negative space was captured first, then the body shadows were added. There was no preliminary sketch. This is a great way to develop brush control.

thought for your drawing. For example, a model with an angular body and pose may inspire jagged movements, whereas a fluid pose may suggest flowing lines. The fluid pose or body may cause you to choose a fast-flowing pen or, perhaps, brush and ink. Your own body movements should mimic the rhythm of your subject. If your subject is graceful, move gracefully; if you have a model with a powerful body, move in a way that conveys strength. These are just examples. The possibilities are limitless. The poetry of drawing the figure is about being sensitive to the moment. Let the circumstances—the particular qualities of the model, the pose, the lighting, and so forth—influence your drawing strategy. Remember, in the expressive approach, *how* you draw is as or sometimes even more important than *what* you draw.

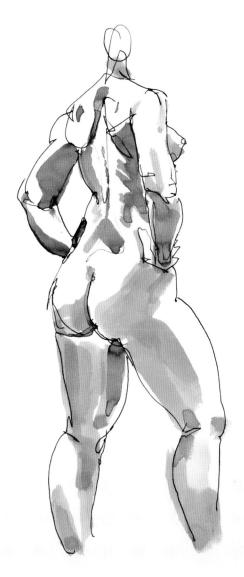

▲ This line drawing was quickly and freely drawn with a medium-nib fountain pen. Shadows were then laid in with a Sumi brush with a 1-inch head and acrylic ink. The previous drawing made doing these careful shadows seem easy.

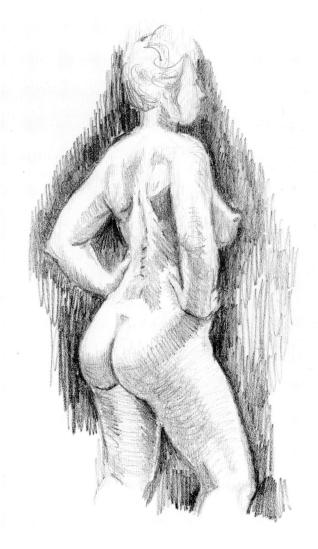

▲ This study, done with a 6B woodless pencil, embraced several goals: to capture the internal structural angles, to study the darks and lights and the negative space relationships to create contrast and volume, and to explore a sense of direction in the shadows along the shifting planes of the surface. At different points in the drawing process, each of these was the guiding principle.

GUIDING PRINCIPLE EXERCISE

For this exercise, the guiding principle is a simple "how." In practical terms, this means your hand must follow what your eye sees in a rhythmic and fluid manner. Give yourself two minutes to "carve" the big shapes of each figure into the page.

Recommended Materials
• Conté crayon 2B
• Canson Biggie Sketch pad

Thick and Thin Strokes
Use a broken half stick of Conté crayon on its flat side. Twist and turn the crayon to get thicker and thinner swaths of tone as you follow the most basic contours of the figure. The swaths give a sense of roundness to the image, creating both line and shadow at the same time. As your hand follows your eye and moves in a rhythmic manner, the technique creates the drawing, turning crayon marks on the page into muscles.

▼ To capture the feeling of muscularity of your model, make sure to exaggerate the bulk of the forms slightly.

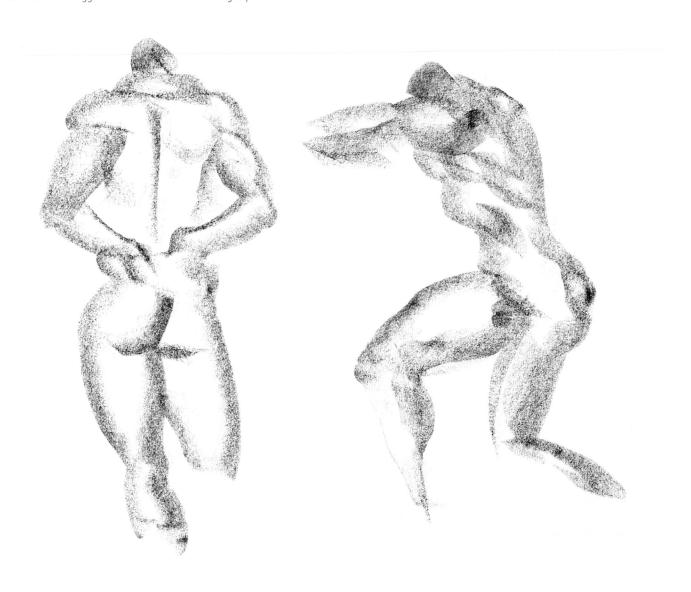

TRUST THE PROCESS

Once you have chosen your guiding principle, it is crucial that you remain committed to it all the way through the completion of the drawing. This requires trusting the process. If you do, you will have an amazing experience. The process will make the drawing. You will become the faithful medium through which the drawing comes into being. This is how you create the conditions for inspiration to happen. This is how to get in the zone, where you get yourself out of the way and let your inner artist shine through. I have seen it happen many times in the classroom. This approach works.

You may wonder why it works. It is simply because the guiding principle technique forces you to make decisions, and the drawing process is all about making decisions. The guiding principle determines which *kind* of decisions you will be making. It helps you decide, quite simply, what to include and what to leave out.

It keeps the whole process focused. By limiting the focus of what you are going to look for and how you are going to record it, you automatically give your drawing process power, meaning, direction, consistency, and (in the best moments) inspiration. Importantly, this approach also prevents you from trying to get every drawing principle and quality into a single drawing (an approach that I call "trying to do the *Mona Lisa*"). Always remember that drawing is a simplification process.

Constantly deepen your concept of process. Ultimately, you will want to develop your own overall process—one that works for you. This will develop naturally, as you get to know your options. This, of course, means getting busy drawing in private or public live-model sessions and actually doing as many of the techniques and exercises featured in the book as you can.

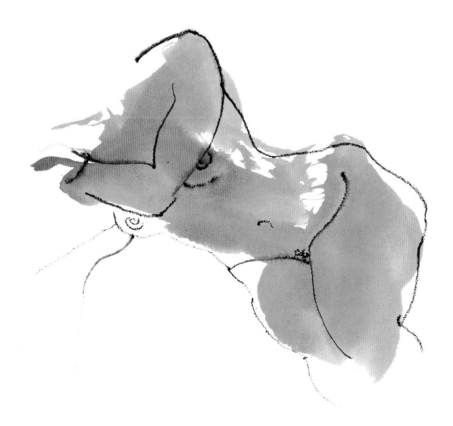

◀ *Attitude 139,* 2008, acrylic ink and water-soluble crayon on watercolor paper, 18 x 24 inches (45.7 x 61 cm), collection of the artist

The narrowed focus of this drawing, with a flat mass shape and a few descriptive overlapping contours, conveys a simple sense of form.

ONE STEP AT A TIME

We learn best when we work regularly and concentrate on learning one fundamental element at a time. That is the way this program of instruction is structured. Each drawing method trains a particular skill, offers a defined focus. In this manner, gradually, you will build a firm foundation of drawing skills, understanding, and confidence. Furthermore, these will improve as you experience how all these ingredients play their part in the figure-drawing process.

I have organized the material in this book to reflect what I think of as the ideal order of the process. Of course, the figure-drawing learning process is not a linear progression, and therefore any order of presentation is somewhat arbitrary. You may start anywhere and proceed from one area to another according to your preference. Please take the time to become familiar with the whole range of fundamentals that make up the figure-drawing process. The techniques and concepts are understandable, exciting, and doable, and I encourage you to be creative and experimental while you are learning them.

When you have learned how to apply all the various principles of drawing to your subject, you will find that you can solve any drawing problem. Follow this course faithfully, and you will be able to draw anything you want. I have seen it happen.

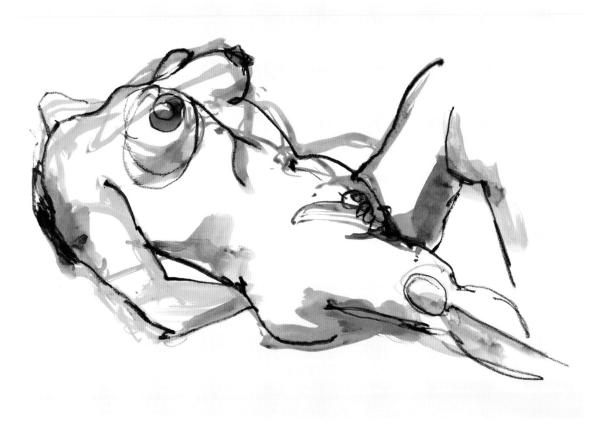

▲ *Attitude 84,* 1997, acrylic ink and water-soluble crayon on paper, 18 x 24 inches (45.7 x 61 cm), collection of the artist

Everyone who has tried it has experienced the difficulty of drawing the figure on its back. Sometimes sheer attitude plays a direct role in the drawing solution.

EYE-HAND COORDINATION EXERCISE

These are reminiscent of old-fashioned cursive hand-writing exercises, but on a much larger scale. They will help to train your hand to do what you tell it to do. The idea is to do these quickly, at a brisk tempo, in a steady rhythmic movement from the shoulder. Allow yourself fifteen to thirty seconds for each row. Make several pages where you try these left to right, right to left, top to bottom, and bottom to top with a variety of drawing implements and media. This is a very effective way to develop a strong eye-hand drawing connection.

Recommended Materials
- black Cretacolor Pastel Carré, black Cretacolor Art Chunky, Conté crayon 2B, or any other drawing implement
- Canson Biggie Sketch pad

Consistency Control
Each pattern (as below, left) should be an inch or two high, executed using the point of a Cretacolor Pastel Carré chalk. Once you set up a pattern and targets for a line, the idea is to move your hand at a steady rate and try to maintain consistency. Create your own patterns. Draw each line in different directions and at different angles to get your arm and hand used to controlling a variety of movements.

Pressure and Direction Control
Using a black Cretacolor Art Chunky broken in half and on its side, start at the top of your paper and descend (as below, right). Each stroke should have its own character. To mimic the image shown here (from left to right): 1. Make a straight stroke with even pressure. 2. Make a straight stroke smoothly transitioning to go from dark (full pressure) to light (little pressure). 3. Do the reverse. 4. Start heavy and lighten up, while gradually twisting the chalk from a wide to a narrow point. 5. Start heavy with a narrow point and smoothly transition to a light and wide stroke. 6. Alternate pressures between heavy and light at regular intervals. 7. Twist the chalk slightly (left, right, left, etc.) at regular intervals. 8. Do the same as step 7, but with an opposite motion. 9. Turn your whole hand to keep the width of the swath consistent as you descend in an S pattern. These are just examples. Make up your own variations.

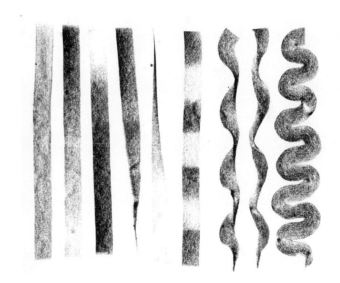

▲ Drawing these swaths is a good way to learn how to control the edge, width, and pressure of your chalks and crayons when used on their side.

▲ These loops are done by moving quickly and smoothly from the shoulder. Drawing them too slowly and carefully makes them wobbly.

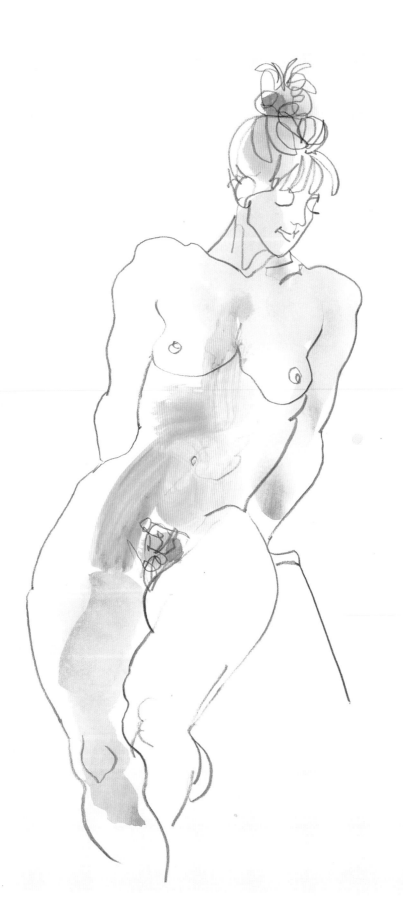

◀ *Red and Blue Lady I,* 2002, lithographic crayon and acrylic ink on paper, 24 x 18 inches (61 x 45.7 cm), collection of the artist

[THINKING ABOUT DRAWING]

Learning to draw involves psychology, philosophy, and poetry. Psychology because, to get your viewers to see what you want them to see, you have to understand how people see. Philosophy because drawing requires not only the ability to react to what you see but the ability to think about what you see and how and even why you wish to put it down. Poetry because drawing is about capturing the spirit, harmony, and meaning of the moment.

The act of drawing contains many paradoxes. This is one: *You need to have both freedom and control at the same time.* This is another: *You have to give up control to get control.*

One of the fastest ways to improve your drawing is to improve your concept of what you are trying to accomplish. In other words, to draw better, work on understanding very clearly and specifically what you are trying to do. This is the real starting point of every drawing process.

Below are some definitions and thoughts on this subject that may help to provide a focus. Try to come up with some of your own.

- Drawing is revealing three-dimensional form on a two-dimensional surface.
- Drawing is a simplification process, an approximation.
- Drawing awakens our vision.
- Drawing is a combination of observing and understanding.
- A drawing is a record of what you have seen and understood.
- Drawing is a way of thinking—or, better yet, many ways of thinking.
- Drawing is a language.
- Drawing is a form of poetry.
- Drawing is a dance.
- Drawing is about taking chances, making mistakes.
- Drawing is the way we satisfy our visual appetite, our visual curiosity.
- Drawing is not drawing. Drawing is seeing.
- Drawing is a psychological process, a mental act.
- Drawing is honesty.

- Drawing expresses a philosophy.
- Drawing is about translating what you see (or can imagine with your mind's eye) into a code of marks on a surface to create an image or effect that conveys your experience.
- A drawing can only be as good as the experience.
- A drawing translates an object into an idea.
- Drawing is about making your own code for translating what you see into something someone else can understand.
- Drawing is one of the essential methods, perhaps the most essential one we have, for making a conception of the mind understandable and communicable.
- A drawing can make an idea, a conception, or a feeling visible. It can do all three at the same time.
- Drawing is both rational and intuitive.
- Drawing is about making signs and symbols that stand for something.
- Drawing is a convention. It is about seeing and communicating an essence. It is about essentials—inclusion and omission.
- A drawing is a collection of insights.
- Trust and confidence are two of the biggest factors in drawing skill.
- Drawing is a constant learning process.
- Learning to draw is a psychological journey. (A journey means you have to keep moving.)
- Drawing is learned in steps and stages.
- Drawing involves taking risks. In fact, to draw is to risk.
- Drawing is revealing three-dimensional form on a two-dimensional surface.
- Drawing is always a simplification process.

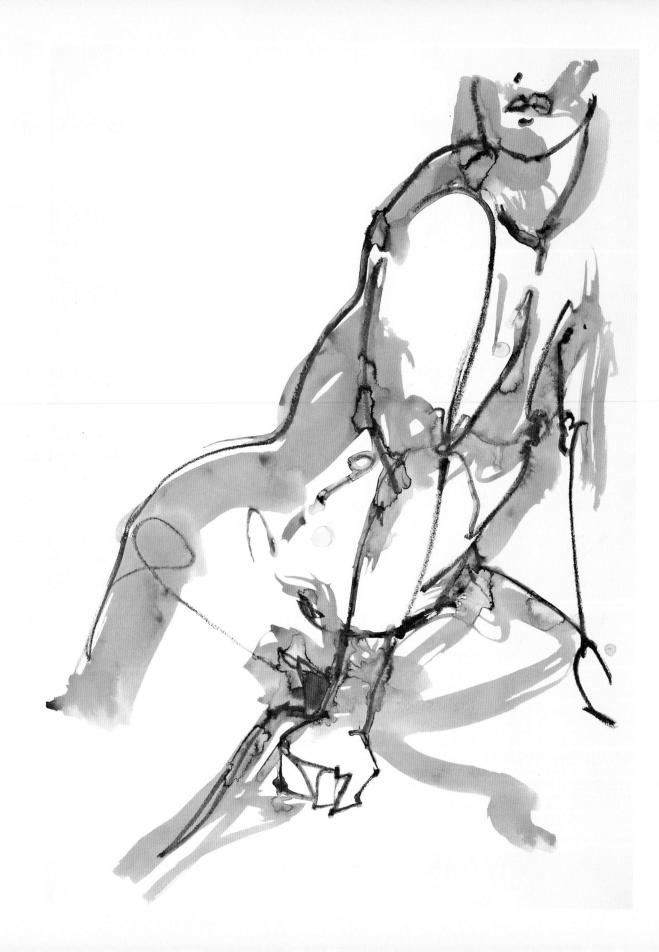

STRATEGIES FOR OBSERVATION

The concepts of orientation on the page and directionality are so powerful that, if understood and used correctly, they will enable you to make all of your drawings successful.

Although we usually don't think about it, we all have a natural awareness of the orientation of objects in space—of whether something is vertical, horizontal, or diagonal. Think of how quickly we notice if a picture on the wall is not straight. In drawing the figure, we consciously use this same natural ability to orient the figure on the page by placing the big forms in the right directional positions in relation to the horizontal and vertical sides of paper.

The horizontal and vertical edges of the paper represent the horizontal and vertical axes of the picture space of your figure. The placement of your figure relative to those edges determines whether your figure will appear to be able to stand up or appear to be falling over, whether the weight distribution will be believable.

It is easiest to conceive of the picture plane by imagining you are looking through a rectangular window at your subject. The sides of this imaginary window are perfectly horizontal and vertical. Your head and body are also positioned in a frontal and untwisted position relative to the model, so that your sense of the horizontal and vertical is uncompromised. Your paper is also positioned relative to your head and body so that the sides of the paper will be perfectly vertical and horizontal as you view it and draw on it. Then all directional readings are taken in relation to horizontal and vertical—our basic human orientation in space.

The entire human race has the common experience and instinctive understanding of gravitational forces. When our figures appear to obey these forces, our drawings are convincing. Getting the angles of the pose to be in their correct relationship to the horizontal and vertical axes of the page creates this gravitational credibility. The compass system and the clock system (discussed on the pages that follow) provide a foolproof way of capturing these angles.

Optical and perceptual principles also are universal. Understanding how to use the picture plane, which is essentially a rectangular equivalent of your field of view, enables you to take advantage of these principles to make your drawings more convincing as well.

◀ *Attitude 32,* 1992, acrylic ink and water-soluble crayon on paper, 23.5 x 16.5 inches (59.7 x 41.9 cm), collection of the artist

THE PICTURE PLANE

The most frequent question asked by beginning students is this: "Where do I start?" The beginner invariably starts right away to draw details of the figure on the page in a haphazard way. The experienced artist, however, starts by thinking about the overall layout on the page and forms an approximation of the pose in his mind's eye before ever touching the paper. This, of course, is not easy for the beginner to do, but it is a necessary skill to learn. Without this advance decision, you lose control over your possibilities before you've even begun.

To practice establishing the picture plane, you can use a piece of cardboard with a rectangle cut out of it. An empty photo slide mount (from someone's pre-digital photographic slide collection) is another convenient aid. View your figure through this window and you can then compose the image, namely by imagining the position of the figure on the page and visualizing the negative space around it. The next step is to be able to visualize this with the naked eye.

Figure Size

The size of the figure in relation to the size of the page signals to our eye the figure's distance from us. It tells us where we are standing in relation to the figure. We do not want the figure to appear too close or too far away from the viewer. Drawing the figure too small will leave no room for the details. Drawing it too large will create body areas that can never have enough details. A very general rule of thumb is to position yourself about 12 feet away from the model so you can see the totality of the figure. Then, when you draw the figure you can make it appear closer. One way to move the figure closer is to make a vignette that fills most of the page. In this case, the torso is the focus and the extremities are only hinted at or are left out. Placing the figure on the page so it appears at a chosen distance from the viewer is a key figure-drawing skill. Develop frame consciousness. Develop your own drawing Global Positioning System.

Negative Space

Another way of thinking about this figure-to-page proportion is in terms of the "white" space, or negative space, that surrounds the figure. Relate your figure to the edge of the page by placing it so that it makes interesting negative space shapes. Your figure needs to be large enough to form these interesting negative shapes and not so big that there are no significant negative shapes to make interesting.

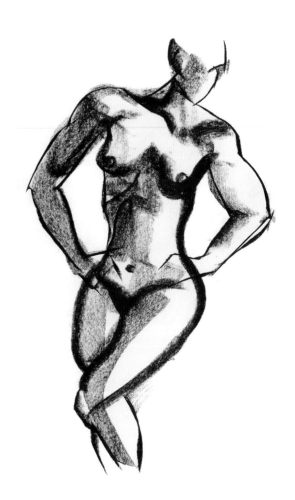

▲ *Arms Akimbo,* 2009, black chalk on paper, 18 x 12 inches (46 x 30.5 cm), collection of the artist

The negative space ideal is when the figure is positioned in such a way that it creates varied and interesting sections around it.

IMAGINARY WINDOW EXERCISE

Composition in figure drawing is about how you fit the figure on the page. This exercise will help you see the proportion of the figure to your white page with your mind's eye before you begin to draw. Allow yourself two minutes per drawing—and do these often. This is a key drawing skill and should become a habit.

Recommended Materials
- Conté crayon 2B
- Canson Biggie Sketch pad

The Page Space

As you look at the figure, imagine a window before your eyes. That imaginary window is the picture plane. Think of that window as a vertical (or horizontal) replica of the rectangle of your page. Then imagine framing the figure within the rectangle of your page.

You are the stage manager of your own visual drama. The attitudes and positions of the body are naturally expressive. When positioning the figure, look for basic geometric shapes, contrasting forms, interesting intersections that will enliven your picture, and vertical, horizontal, and vertical thrusts. Look for ways to accentuate these by the figure's positioning and size on your page and by the negative space this position creates. This will create your composition and energize your drawing. Do simple rhythmic drawings, like the one to the right, where you concentrate mainly on positioning the figure in an imaginary page space.

▲ Being able to see the pose on the page with your mind's eye before you start drawing lays the groundwork for a successful outcome before you make a single mark.

[SETTING UP]

Now we come to a purely practical consideration—the physical setup of your drawing space. Your position relative to the model and the angle from which you view your page should be in agreement. You should not sit or stand sideways to either model or page. Rather, face and view each straight on. This will enable you, your model, and your page to have the same spatial orientation. This synchronized spatial orientation will enable you to see and record the directional angles accurately. Starting off this way will also encourage calm confidence and perceptual alertness.

Whether you are working on a table or a taboret, your paper or pad should be directly in front of your body and aligned directly below the picture plane, with the top edge of the paper perpendicular to the picture plane. In this way you maintain the same frontal and upright relation with both your view of the model and your view of your page. In addition, when using a table, stand up or use a high stool to reduce distortion from viewing the page too obliquely. You may also use a prop to angle the page more toward you (if running of wet media is not an issue).

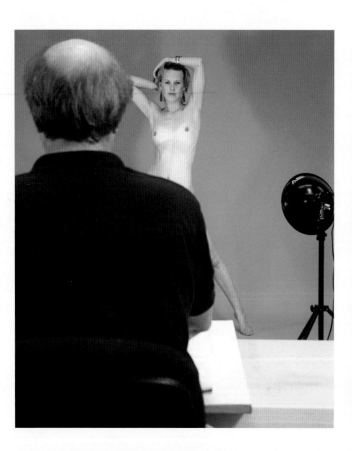 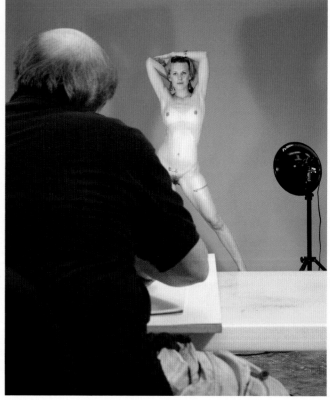

▲ As discussed in detail on the following pages, your most basic observation of each form of the figure must be simply whether it is vertical, horizontal, or leaning to the left or to the right. To do this, you should position yourself so you are facing the model squarely (as shown on the left). If your head is tilted at an angle one way and your body is twisted in your chair the other way (as shown on the right), estimating the angles of the models forms in space may prove challenging.

If you are working at an easel, you should, likewise, maintain the same frontal and vertical/horizontal relation with your view of the model and your view of your page as you shift positions. Avoid being too close or too far away from the model. If you are too close, you'll have trouble envisioning the big shapes. If you are too far away, you won't be able to see all the details. Fill the page with your drawing regardless of your distance from the model. Your actual distance to the model and the distance as it appears in your drawing of the model do not have to be the same.

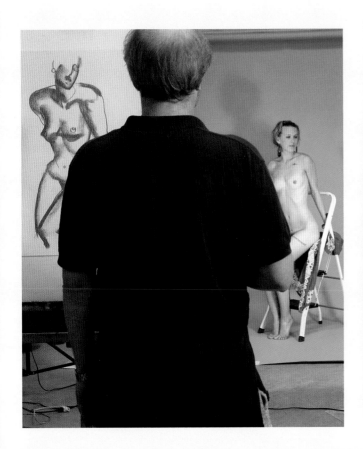 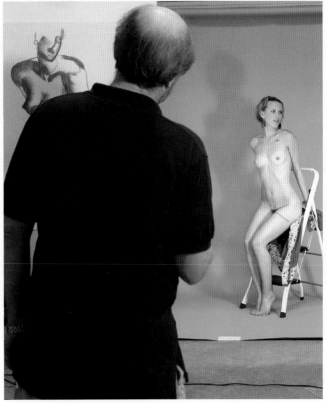

▲ Even from behind an easel, always try to view your page and model from the same straight-on angle. Step to the side to see your model (as on the left) rather than tilting your head (as on the right) if you want to have full confidence in your judgment of the directional angles.

DIRECTIONAL ANGLES OF THE FIGURE

The directional angles of the figure's forms orient it correctly in the space of our paper. There are two excellent systems for determining the directional angles—the compass system and the clock system. The latter is more involved but considerably more precise. Both are quite easy and foolproof.

The Compass System

When you observe the figure using this system, every contour or axis line is defined as being vertical, horizontal, or tilted in one of two diagonal directions. That's just four possibilities, defined as follows:

- north to south (vertical)
- east to west (horizontal)
- southwest to northeast (diagonal)
- northwest to southeast (diagonal)

Simply lining up the forms so they fall into one of these four basic directions cures a host of drawing faults. Yet, as easy as this seems, students often incline important body angles in the wrong direction. If your figure looks like it is falling, this is probably why. If you use this simple system, you will solve this problem for good.

The Clock System

The clock system is based on the same idea as the compass system, but since it has six basic positions for the angles or axes, it offers more precision. The angles are as follows:

- 6 o'clock to 12 o'clock (vertical)
- 7 o'clock to 1 o'clock (diagonal)
- 8 o'clock to 2 o'clock (diagonal)
- 9 o'clock to 3 o'clock (horizontal)
- 10 o'clock to 4 o'clock (diagonal)
- 11 o'clock to 5 o'clock (diagonal)

In the clock system, lines and forms are typically judged to be on one of these six angles. Thus, when judging an angle, you don't have to say, for example, "This angle is 7 o'clock to 1 o'clock." You can just say, "This angle is 1 o'clock." or "This angle is 7 o'clock." Both describe the same angle.

One of the beautiful things about the clock system is that it can be refined, depending on how precise you want your directional angles to be. For instance, you can define angles at the half hours (as in 2:30 to 8:30), creating finer angles in between the six basic ones. Even greater refinements (such as 2:45 or 8:45) are possible, but it is generally preferable to exaggerate subtle angles to make the distinctions more obvious.

▲ With the compass system, each contour or axis line corresponds with one of the four main directions on the compass: vertical, horizontal, and the two diagonals.

▲ With the basic clock system, each contour or axis line corresponds with the direction of one of the six lines that connect opposite numbers on a clock. One angle, 2 o'clock (or 8 o'clock), is shown here in red.

[USING THE CLOCK SYSTEM]

When using the clock system to establish the directional angles of the figure, the most important angles to determine are those of the spine, shoulders, and hips. The spine—which often goes in two different directions (and is, in reality, curved)—is indicated for our purposes as two connected straight lines. These two lines are connected to a (generally) straight shoulder axis and a straight hip axis. Together, these three body parts create what is known as the "hinged I," so called because it resembles the capital letter I with a hinge in the middle. (This concept is explored in greater detail on page 36 and 100 to 101.) All the other major appendages of the body are attached to these axes.

Establishing the correct directional angles:
- creates orientation in space and solves a host of drawing problems
- conveys a convincing sense of weight
- enables you to get the various parts of the body to meet and connect
- gives a drawing strength and credibility

The clock system can also be used to help make your contours. Once you get used to relating the contour lines of your figure to the axes of your clock angles, you can record contours with great accuracy and confidence. This concept is explored in the image to the right. For example, the two main outer contours describing the model's right thigh (on our left) are at approximately 7 o'clock (upper) and 5 o'clock (lower). Can you identify the clock angles of the other contours?

A great deal of the visual interest, expressiveness, and rhythm in a figure drawing is created by the sense of movement conveyed by the angles, directions, and thrusts of a good pose. This is what creates the composition.

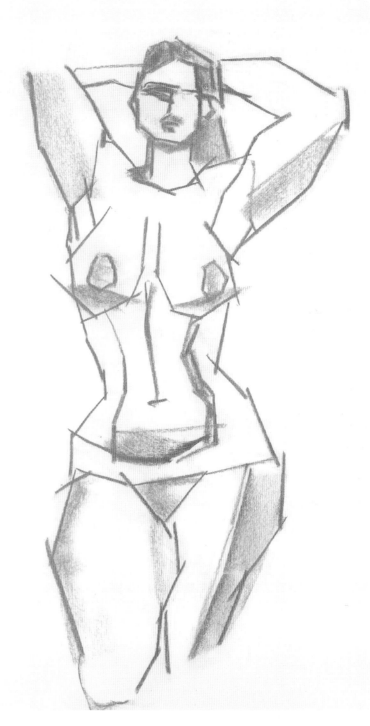

▲ *Red Earth Mama,* 2009, red earth Art Chunky on paper, 25½ x 20 inches (64.8 x 50.8 cm), collection of the artist

This drawing is made of entirely of directional angles, visible and invisible, that can be understood in terms of the clock angles. The shoulders are at about 3:30, the upper spine is at about 6:30, the lower spine is at about 5:30, and the hips are at about 2:30. This gives the pose a subtle lilt.

DIRECTIONAL SWATHS EXERCISE

By encouraging you to reduce a pose to its basic directional swaths, as defined by the clock system, this exercise will help you gain control over your figure. Allow two minutes to render the figure. Do this simple exercise again and again until it becomes natural for you to see what the figure is doing on this fundamental directional level.

Recommended Materials
- Sumi brush with a 1- or 2-inch head
- Sumi ink
- Canson Biggie Sketch pad

The Hinged I

There are fourteen angles based on fourteen body segments. Count 'em. This calculates the spine and the neck (which are, physiologically speaking, actually all one piece) as three. At this stage of the study of the figure, disregard the hands and the feet.

Load the Sumi brush with some diluted Sumi ink, and, estimating the clock angles, put in the hinged I (the core of the body, which includes the shoulders, spine, and hips). Then add the other segments. Push down with the brush to make a thick, even stroke.

Use your X-ray vision to imagine the axis at the center of each form. The lines connect where the bones connect. Make sure you use two separate strokes for the upper and lower spine as well as for the arms and legs. All segments must be connected (touching), and all must be based on your observation of the clock angles.

▶ Simple Sumi brushstrokes capture the essence of the action and the structure by analyzing the clock angles of the inner armature.

DIRECTIONAL FEEL EXERCISE

This exercise will help you instill the directional sense directly to your hand and eye. It will also show you what a powerful drawing concept direction is. Allow three to five minutes to render the figure in this manner.

Recommended Materials
- Conté crayon 2B
- Canson Biggie Sketch pad

Zigzag Contours

Unless they are evenly distributed around a center, forms have a long and a short axis. They also have surface directions and edge directions. This means that every form can be read in terms of these axes and directions.

Without lifting your Conté crayon from the page, move the point in a zigzag fashion that faithfully mimics whatever directional movements you sense as your eye travels around the figure. Do not specifically attempt to make the figure appear; it will appear naturally if you concentrate on the process.

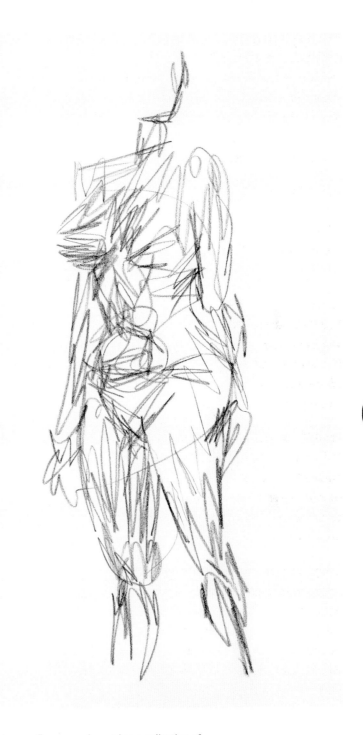

▲ The human figure may be read as a collection of directions. Seeing and recording directional responses is a big part of what drawing is about.

When rendering the figure, there is another important aspect to consider: the psychology of perception as it pertains to you and your viewer. The human mind has a powerful ability to understand and envision complete images and ideas from the implications of partial or fragmented images and visual cues. In perceptual psychology, this tendency is known as *closure*—and it is one of the reasons that "realistic" artwork convinces us so easily. Although an image may actually be far from photographic, once it passes a certain threshold of providing realistic cues, it is recognized as being both three-dimensional and lifelike.

This powerful tendency of the mind to complete the image is a factor that every artist must consider when drawing. It explains the reason why too many visual cues in a drawing may sometimes spoil the effect. The concept of closure makes clear why it is perhaps not a good idea to draw everything your eye falls upon. Drawing is about providing the right cues.

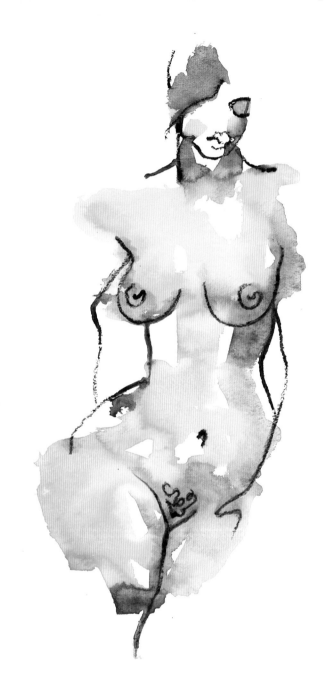

▲ This drawing relies on the viewer's mind to complete, or "close," the image. Notice in particular that little visual information is provided for the location of the arms, yet you know where they are.

CLOSURE EXERCISE

This exercise provides excellent practice at focusing on drawing only what is essential. The hardest part is stopping before you do too much. Allow yourself five to seven minutes to complete the image.

Recommended Materials
- Sumi brush with a 2-inch head
- acrylic ink
- water-soluble crayon
- watercolor paper, 24 x 18 inches (61 x 45.7 cm)

Only Essentials
Using diluted acrylic ink and the Sumi brush, begin by laying down some delicate shadow shapes. While the ink is still wet, add a few overlapping contours with a dark water-soluble crayon, taking care only to include what is absolutely essential to hint at the action of the figure. Try to see how much you can leave out and still have the image readable. In any case, leave out more than you put in, and then put the crayon down.

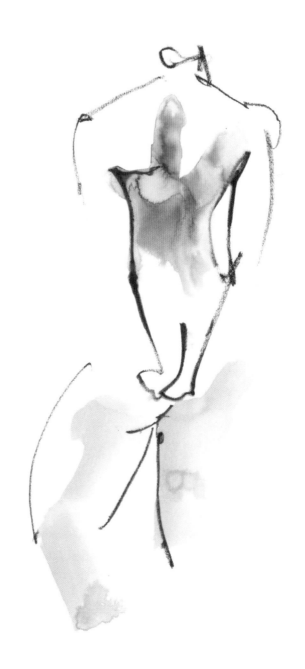

▲ In every pose, certain lines, shapes, and shadows are more significant than the others. Always look for these. Sometimes they can tell the whole story.

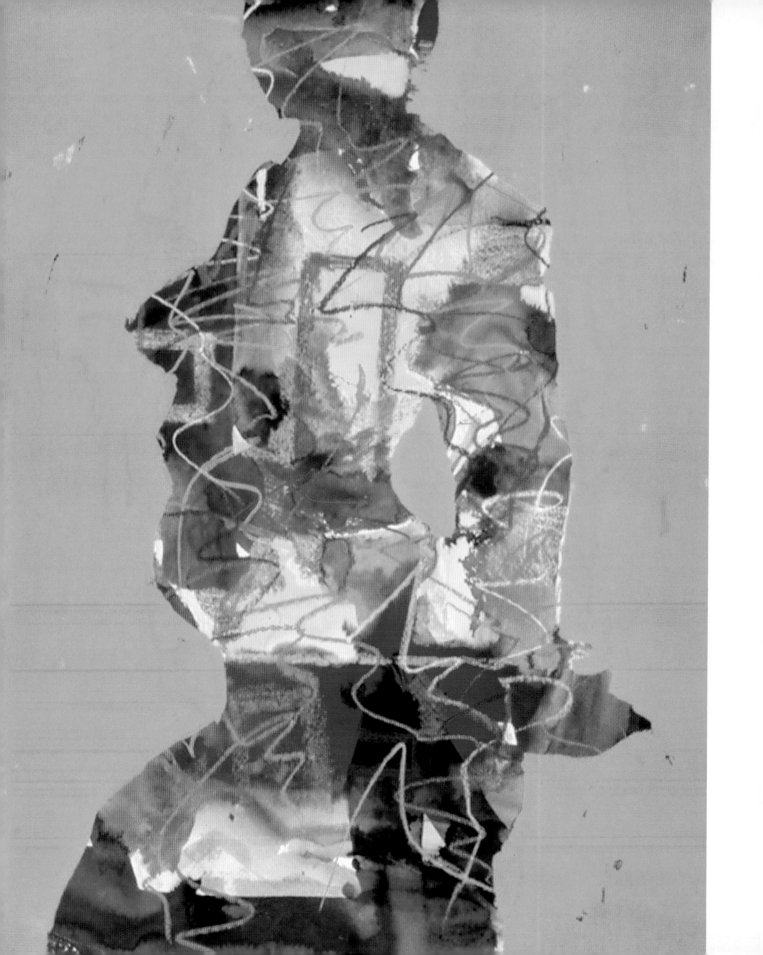

PART II: Materials

The moment of excitement and passion in the drawing process is when the medium hits the page. To bring out the characteristics and qualities inherent in the various materials, you need to become familiar with them and how they respond when handled in different ways. Taking advantage of the natural characteristics of your tools and materials is vital to the inspired approach. This is where a lot of the enjoyment of drawing the figure lies.

Artists, craftsmen, chemists, engineers, textile makers, biologists, geologists, physicists, botanists, zoologists, and a lot of other inventive people have been creating and refining materials for making art since the beginning of time. Today when you use quality art materials, you are working with highly advanced technological devices that are based on many hundreds and even thousands of years of development. In today's high-tech world, manufacturers are reaching new heights of excellence and offering art materials well advanced of those of any previous era. Artists of the past would weep with joy to be able to work with the array of materials that are readily available today.

Good materials will do nearly anything you ask of them. The more you learn to respect, love, and even revere them, the better you will do. The key is to explore them—learn what they can do and then take advantage of their qualities in your work. Learning to think strategically with your materials will bring the most out of them and yourself.

◀ *New Nude III,* 2008, watercolor, acrylic, and oil pastel on watercolor paper, 24 x 18 inches (61 x 45.7 cm), private collection

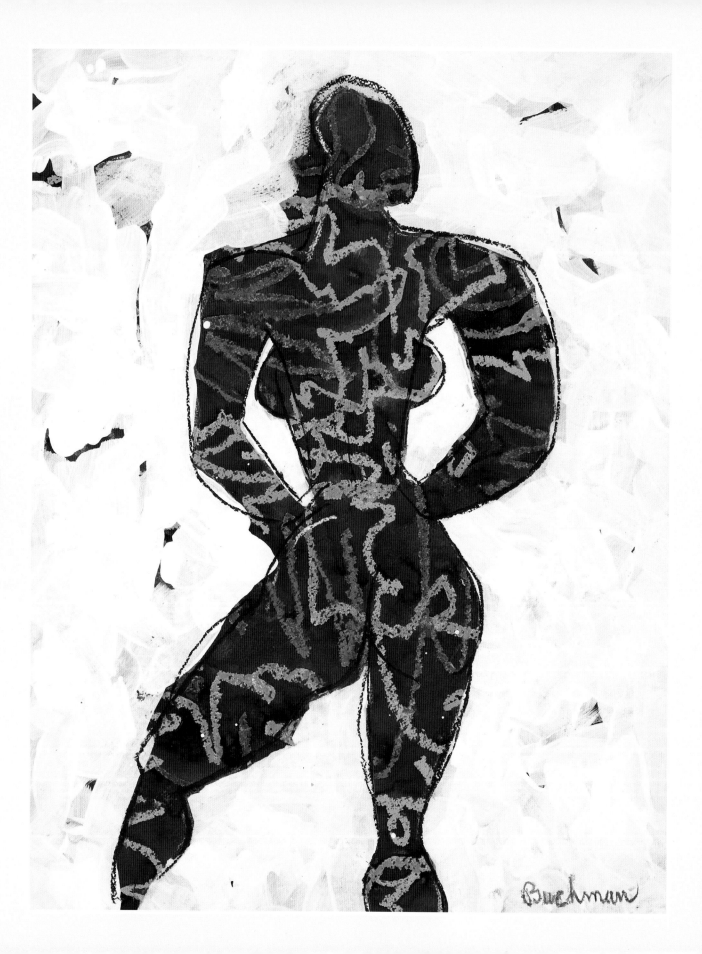

EXPRESSIVE DRAWING SUPPLIES

The relationship that you cultivate with your materials and implements plays a major role in how your drawing develops and should constantly be mined as an important source of inspiration that will bring your drawings alive.

Imagine going to cooking school and trying to learn how to cook using week-old vegetables, inferior cuts of meat, and year-old seasonings. Likewise, using poor, cheap, and old, even dried out, materials practically guarantees a poor result. Your art is made out of the ingredients you use. If you want to make good art, use good materials. If you want to make great art, use great materials. It's a matter of sending your inner artist the right message. When you use good materials, you are saying that you believe in your talent and are going to give it your best shot.

Rather than expound on the almost infinite variety of drawing materials available, I am going concentrate on specific materials that are ideal for learning and developing basic techniques of the expressive approach of figure drawing. Becoming familiar with these will prepare you to explore any kind of materials and bring out their qualities.

Drawings comprise three main components: the support (the surface on which you draw), the media (the substances that you apply to the support to create your image), and the applicators (the holders and deliverers of the medium to your support). On the following pages, let's examine each in turn.

Note

Over the years I have used a variety of American and European papers—marketed as "drawing" or "sketch" papers—that work well with both dry drawing media and ink. In the captions throughout the book, I have used the term paper when my drawing is on one of these supports. In the captions I have only specified the support as "watercolor paper" when it is specifically designed as such.

◄ *Blue Silhouette*, 2008, watercolor, acrylic, and oil pastel on watercolor paper, 24 x 18 inches (61 x 45.7 cm), private collection

SUPPORTS

Most figure drawing is done on paper, and that is surely the best support to use for developing your skills. Your biggest concerns when choosing your paper should be these: How heavy is it? How rough or smooth is it? Can it take ink and other water media? Is it acid-free?

When it comes to papers, you should experiment a good deal to find ones that are suitable for you. The different qualities and characteristics of the papers and what they bring out of your materials are at the very heart of the artistic process. On the pages that follow, I list the materials that I have used to create the images that appear in this book. However, there is no substitute for this personal research and experience.

Drawing Paper

Studying the figure entails doing a great many drawings on a great deal of paper. A large sketch pad with a lot of paper is desirable, but I strongly recommend always using a better-quality paper than newsprint. Its flimsiness, poor surface, and impermanence undermine any artistic endeavor, even quick sketches. Always use a paper that is at least 50 lb. Working large encourages freedom, so I also recommend using paper that is at least 18 x 24 inches. As long as the paper can handle ink and is acid-free, it is fine for your basic studies. My favorite economical everyday sketching papers is:

- Canson Biggie Sketch pad, 50 lb. (74 g), 18 x 24 inches (45.7 x 61 cm)

For higher quality, but still affordable all-around drawing papers in sheets, I like:

- Fabriano Eco-White, 56 and 94 lb. (120 g and 200 g), 20 x 25½ inches (50.8 x 64.8 cm)

And for papers in a pad, I favor:

- Strathmore drawing paper medium 400 series, 80 lb. (130 g), 18 x 24 inches (45.7 x 61 cm)

And finally, here is an economical watercolor paper with a lot of tooth, making it excellent for drawings with dry media:

- Fabriano Studio watercolor paper 94 lb. (200 g), 20 x 27½ inches (50 x 70 cm)

Watercolor Paper

When you feel you are going to do your best work in watercolor and other water media, its time to turn to higher-quality watercolor paper. These papers are designed to bring out the richest brush effects and color effects, greatly enhancing the appearance of your finished work.

Watercolor papers are manufactured with different types of surfaces for different uses. Hot-press papers are smooth. They are good for careful, detailed work where precise lines are desired. Cold-press papers have a rough surface that is ideal for free and expressive work; the pits and ruts give an unevenness and texture to lines and colors that is extremely attractive. *Torchon* is a term to describe extra-rough watercolor paper with wide ruts. The heavier the weight of the paper, the richer the drawing media will appear. Also, the heavier weights are extra durable and can take more abuse.

Strathmore makes some excellent watercolor papers in pads that are still somewhat economical. Fabriano Studio offers excellent economical watercolor papers in large sheets. Fabriano Artistico and Arches make top-quality, highly durable heavyweight watercolor papers, which although more costly, give superior results. The watercolor papers I like are:

- Fabriano Studio watercolor sheets, cold press, 140 lb. (300 g), 19½ x 27½ inches (49.5 x 69.9 cm)
- Fabriano Studio watercolor sheets, torchon 130 lb. (270 g), 19½ x 27½ inches (56 x 76 cm)
- Fabriano Artistico watercolor paper, traditional white, 90, 156, and 300 lb. (200, 330, and 640 g), 22 x 30 inches (55.9 x 76.2 cm)
- Arches watercolor paper, cold press, 140 and 300 lb. (300 and 640 g), 19½ x 27½ inches (56 x 76 cm)
- Strathmore watercolor paper 400 series, 140 lb. (300 g) 18 x 24 inches
- Strathmore watercolor paper (pad), P400 and P300 series, 140 lb. (300 g), 18 x 24 inches (45.7 x 61 cm)

[DEFINING YOUR GOALS]

The most fundamental point—one that I stress throughout this book—is that you need to know what you are trying to accomplish before you start. Once you have a goal in mind, you are then in a position to decide which materials will enable you to achieve the result that you are seeking. The supports, media, and applicators you choose will determine in great degree the character of your work—the thickness and texture of your lines, the boldness or subtlety of the colors, and the softness or crispness of your image.

If you want to make a stark, bold statement in black and white, then Sumi ink applied with a reed pen on bright white paper, such as the image below, might be the way to go. If you want to make a drawing that is a subtle, moody, and rich study in tonal values, such as the image on page 124, then you might choose to use toned paper and pastel pencils. Or you may want to work with a mixed-media approach to achieve a drawing with several layers of formal and expressive qualities, such as the image on page 42. Whatever your goal, choosing the right materials will help you to achieve it.

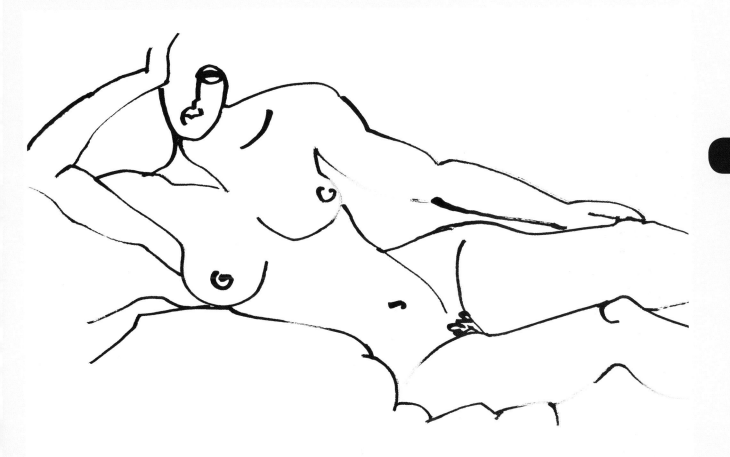

▲ *Nude Study 35,* 2009, Sumi ink on paper, 18 x 24 inches (45.7 x 61 cm), collection of the artist

The reed pen gives a rough line that is a little hard to control. This gives the lines their unique aesthetic flavor.

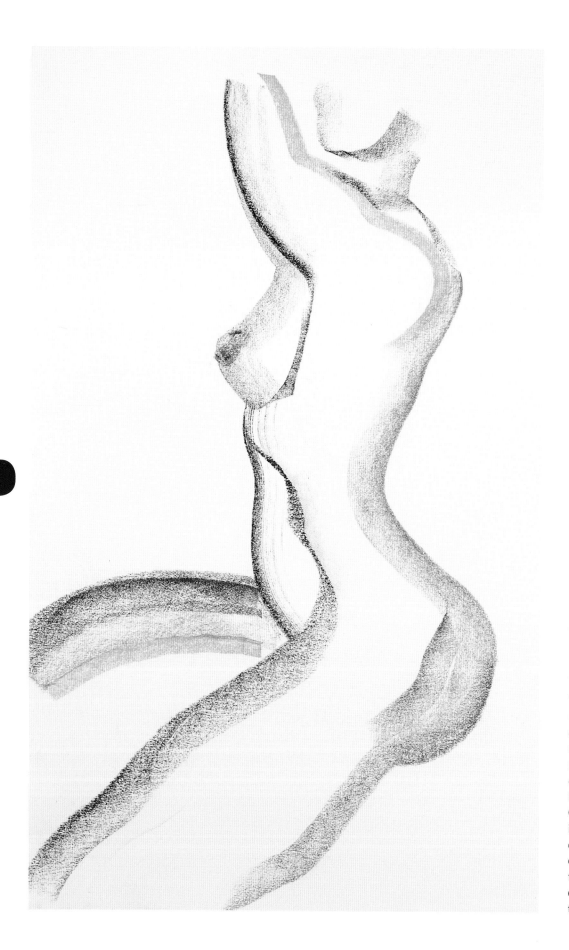

◀ *Material Girl,* 2009,
oil pastel on paper, 24 x
18 inches (61 x 45.7 cm),
collection of the artist

When selecting your
materials, identify the
qualities that the support,
media, and applicator
naturally provide and then
exploit these qualities.
Here I used my Sennelier La
Grande oil pastels, broken
in smaller pieces and turned
on their sides. With these I
can generate thick swaths
that function as both
contours and shadows at
the same time.

MEDIA

The medium is what your drawing is really made of. It is the substance that is deposited on the support. Each medium consists primarily of a pigment (which is the actual substance that gives the tone or color) and a binder (in which the pigment is suspended and which helps bind the pigment to the support). Drawing media fall into three categories: dry or abrasive media, wet or fluid media, and hybrid media (dry media that, because they are water soluble, can be used both wet and dry). Dry media are deposited on the support by friction. Wet media are deposited by gravity and governed by the laws of fluid mechanics. Hybrid media may be applied with a brush but are usually applied or spread by friction. The precise manner in which you apply your media to the paper is the way you express yourself as an artist. Cultivate an awareness of this in your drawing practice to reap big artistic dividends.

Dry Media

Dry or abrasive media usually come in some variation of a stick or pencil. They sometimes are used with a holder, which allows more control and provides cleaner fingers. Dry media can more or less be separated into the following four general types: charcoals, chalks, greasy crayons, and graphite. However, some media, such as Conté crayons, fall somewhere in between (in this case, between chalks and greasy crayons).

The variations of each type are practically without number today and often come in different grades of softness and hardness. The softest grade will give the darkest tone, and progressively harder grades will deliver progressively lighter tones. Although dry media can be applied quite quickly and freely, they tend to be slower and more controlled compared to the fluid media. This is especially true when you have to cover a large area. In addition, because the dry media are applied by friction, the nature of the surface of the support will greatly influence how they appear when applied.

Charcoals

This category includes charcoal sticks, compressed charcoal sticks, charcoal pencils, charcoal chunks, and powdered charcoal. My favorite forms of charcoal are among the largest and the darkest:

- Cretacolor Art Chunky charcoal
- General's Charcoal Chunk

▲ Cretacolor Art Chunky charcoal (left) and General's Charcoal Chunk (right) are two of the blackest and boldest charcoals available. Because of its giant irregular shape, the Charcoal Chunk can provide many dramatic and spontaneous effects. The Art Chunky is an all-around drawing charcoal that is excellent for smooth swaths and audacious lines.

Chalks

This category includes soft and hard pastels as well as a great variety of powdery sticks, leads, and pencils. My favorite chalks include:

- Cretacolor Pastel Carré (medium-hard pastels)
- Cretacolor pastel chalk fired deep black (extra soft chalks)
- Cretacolor Art Chunky (colored chalks)
- Sennelier soft pastels (both standard and La Grande)

Greasy Crayons

This category includes oil pastels, wax crayons, lithographic crayons, China markers, colored pencils, and Conté-type crayons. My list of preferred greasy crayons is very long, and it includes these:

- Sennelier oil pastels (both standard and La Grande)
- Conté crayon 2B

Graphite

The graphite family comes in a large variety of hardnesses in both pencil and woodless forms, such as sticks, chunks, and powders. My favorite forms of graphite are the following:

- Cretacolor Monolith graphite pencil (various hardnesses, particularly 2B to 8B)
- Cretacolor Art Chunky graphite
- Cretacolor 5.6mm graphite leads with holders (various hardnesses, particularly 2B to 8B)

Wet Media

The wet drawing media flow easily onto the drawing surface and lend themselves to speed and freedom, even in their most careful applications. They can cover large areas quickly. Some can be dissolved again after drying and some cannot. The main categories of liquid media for drawing are inks, watercolors, and acrylic gouache. Oils may be used as well, although they require powerful solvents and treated supports that can resist the long-term destructive effect of the acidic binder.

Inks

Inks are the most traditional of the fluid drawing media. Sumi ink and India ink (also called China ink) both give dark, rich blacks. Sumi ink has a certain softness and subtlety, whereas India ink has a harder, more severe appearance. Sumi ink comes both as a solid cake (which needs to be dissolved) and in a bottled, ready-to-use

◀ The highly pigmented Cretacolor Pastel Carré sticks have sharp edges that facilitate precise control and create a great many interesting drawing effects.

◀ The Conté crayon comes in a variety of colors and is an excellent all-around drawing medium. Their waxy consistency means they produce little dust and their firmness allows for precision and control.

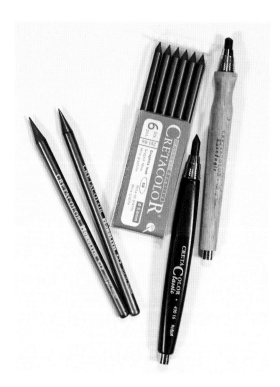

▲ Cretacolor Monolith graphite pencils (left) and graphite 5.6mm leads and holders (right). These leads in holders are especially versatile and offer a sturdy, thick point. The holder enables you to press harder and work bolder than with a standard graphite pencil.

liquid; both can be applied with a long-haired, soft Sumi brush. India ink comes only as a liquid and often is used with dip pens that have a great variety of interchangeable points. India ink can also be used with a brush. Both Sumi and India ink are highly concentrated and waterproof. A special water-soluble India ink is available for use with fountain pens. These inks are often diluted, and when they are, they offer a rich variety of values and incidental textures.

Acrylic inks, also known as tech inks or airbrush colors, offer a rich variety of values and textures but with powerful, highly concentrated, transparent and opaque colors that are also waterproof. A few of my favorite inks include these:
- Yasutomo Sumi ink (liquid)
- Sennelier India ink
- Pelikan Fount India ink (for fountain pens)

I also find these acrylic inks very useful:
- Dr. Ph. Martin's Spectralite and tech inks
- Golden airbrush colors

The acrylic inks, tech inks, or airbrush colors (as they are variously known) are essentially acrylic paints in their most liquid form. They behave generally like watercolors. The difference is that they are a great deal more concentrated and the colors are more intense. Also, not all the colors are transparent. Some are quite opaque. I use acrylic inks when I want maximum color power in thin washes. They can also be used in combination with watercolor. They are good in highly diluted form for creating soft backgrounds.

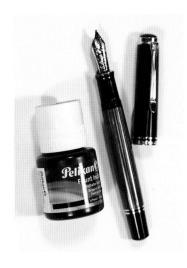

◀ The oversize Pelikan Souverän M1000 is a top-of-the-line artist's fountain pen with an interchangeable 18K gold nib. I use the B nib. This M series includes several smaller sized barrels that take the same superb nibs but are more economical. I use Pelikan Fount India ink for the deepest black.

Watercolors

Watercolors come in the familiar small blocks, known as pans, or in tubes. The pans offer portability and speed of use in small quantities, while the tube colors have the advantage of being able to quickly yield large quantities of color. Watercolor hues vary somewhat from color to color in their degree of transparency, intensity, and even texture. Familiarity with the unique characteristics of each color (and even each brand's version of each color) comes with frequent use. I recommend purchasing an empty watercolor tin, selecting your own pans of color, and making your own palette.

It is very popular and convenient to put tube watercolor paints on a palette and let them dry, to be redissolved as needed, but I don't approve of this method. Tube watercolors are manufactured to be extracted from the tube, diluted, immediately used, and then allowed to dry forever on the paper. They are not meant to be repeatedly dried and rewetted. When dried tube watercolor is repeatedly rewetted and used, the binder becomes weak and the color more grainy. As a rule of thumb, the purest tones are created from watercolor that comes in pan form or is mixed fresh from the tube.

The great attraction of watercolors is their gentleness and delicacy. They are also resoluble, which means they can be lifted and manipulated to a degree after they are dry. Watercolors, being less insistent than the inks, do not overwhelm other media. Rather, they blend well when used in conjunction with the various dry media. A relatively new product, liquid watercolor, is quite unlike regular watercolors and offers uniformly bright and transparent colors. The same colors made by different brands often differ greatly. My favorite watercolors, in both tubes and pans, are these:
- Sennelier watercolors
- Winsor-Newton watercolors
- Schmincke watercolors

Gouache

The word *gouache* actually refers to several different things. There are gouache colors that come in tubes and are simply watercolors with larger granules of pigment.

These colors are more opaque and concentrated than regular watercolors and are often favored by illustrators and designers. Then there is the painting technique called gouache, which refers to mixing opaque white with watercolor to achieve a flat color. And finally there is a relatively new product, acrylic gouache, which is extraordinarily flexible. It is transparent, yet intense when diluted; when used more thickly, it can be highly opaque and brilliant and can impart three-dimensional impasto effects. Even more unusual is that some brands, although waterproof, can be dissolved, lifted, and modified during the first few hours while they dry.

These are my two favorite acrylic gouaches:
• Lascaux acrylic gouache
• Turner acrylic gouache

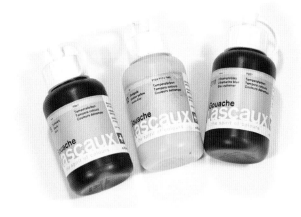

▲ The Lascaux acrylic gouache is unique among acrylics in its expressive range. The brilliant colors when used thickly have opaque covering capabilities yet they can also be thinned down to watercolor-like transparent washes.

Hybrid Media

As with every other industry, there have been great technological advances recently in the realm of art materials. This has led to the creation of many innovative products that offer exceptional new possibilities. The main development has been a proliferation of hybrid drawing materials that can be used both wet and dry. This has given us drawing media that can yield two dramatically different types of effects. These include water-soluble graphite pencils, water-soluble wax crayons, water-soluble colored pencils, woodless water-soluble colored pencils, Cretacolor Aqua Briques (which look like watercolor pans but are water-soluble waxy chunks of intense color that are more powerful than their cousins, the water-soluble crayons), and even water-soluble chalks and pastels.

These water-soluble dry media may either be dipped in water before use or be applied directly onto a wet surface. Once wet, they move more easily, the marks generally become darker, and the colors become more vivid. One of the biggest advantages of hybrid media is that you can draw with them into areas of wet paint. The effects vary greatly and can lead to interesting blending and bleeding possibilities. Another interesting option is to manipulate your drawing with a wet brush after the hybrid drawing media have been applied dry to the page. The colors may get more delicate or more vivid and blend in unexpected ways. You can also use a wet brush to pick up color directly off of your drawing media and apply it to the paper. The possibilities are endless. Naturally, learning what to expect and how to control these effects comes through experimentation and with experience.

My favorite hybrid media are these:
• Cretacolor Aquastics (water-soluble crayons)
• Caran d'Ache Neocolor II (water-soluble crayons)
• Cretacolor AquaMonoliths (water-soluble and woodless colored pencils)
• Cretacolor Aqua Briques (watercolor drawing bricks)

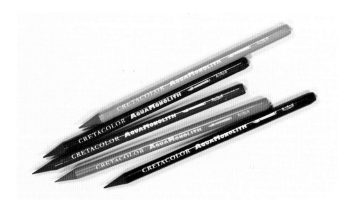

▲ The Cretacolor AquaMonoliths are woodless colored pencils that are essentially solid sticks of water-soluble pigment. These hybrids are great for combining drawing and watercolor effects.

[WORKING LARGE]

Some implements have unique properties by virtue of their large size. These include Cretacolor Art Chunky, Sennelier La Grande oil pastels, Sennelier La Grande soft pastels, General's Charcoal Chunk, and General's Graphite Chunk. Along with the many other aesthetic qualities discussed on the previous pages, these media all offer intensely thick strokes and lines and quick coverage of large areas. Working with large media encourages you to work quickly and boldly and quite naturally will force you to stick with generalities and be more abstract. These are desirable qualities to develop in your pursuit of the expressive way.

▲ Cretacolor Art Chunkys are naturally bold and expressive drawing implements. You can easily transition from a thick line to a fine one just by adjusting the angle of the tip in contact with the paper.

▲ The Sennelier La Grande oil pastels (on the right) are great for thick, flowing, and confident strokes. The standard ones (on the left) are good for a thinner, more controlled line, for details, and for getting a feel for the possibilities of oil pastels.

APPLICATORS

Dry media, being solid, normally serve as their own applicator (although, for added convenience, holders are made for many of them). Wet media are generally applied with either brushes or pens but may also be sprayed, poured, dripped, and applied with an enormous variety of other implements and applicators.

Sumi Brushes

The variety of brushes, each with its own unique characteristics, is a study in itself (one that I recommend every artist undertake). I use Sumi brushes nearly exclusively because I find them to be the most expressive.

Sumi brushes have a history dating back to antiquity. Whereas Western brushes are designed to hold their shape and do as they are told, the Eastern brush changes shape with every stroke and has a mind of its own. Becoming sensitive to the possibilities inherent in the shape and condition of the brush after every stroke and being mindful of the exact amount and opacity of the ink remaining in the brush head are the keys to mastery of the Sumi brush. Yet even for the beginner, the Sumi brush is a generous artistic tool.

Since locating good, large Sumi brushes and reed pens is quite difficult, I favor a line of Zen brushes (imported

by Jerry's Artarama), which I use with Sumi ink, India ink, and all the water media. In short, my favorite Sumi brush is the Zen brush (assorted sizes).

◀ Sumi brushes are first and foremost writing instruments, and in China and Japan calligraphy (literally, "beautiful writing") is valued as the highest form of art. Even before you fully understand its artistic behavior, a Sumi brush can lend, by its nature, aesthetic qualities to your work.

Reed Pens

The reed pen is one of the most ancient writing and drawing instruments. It is a dip pen made of bamboo or other reed-type materials and holds a limited amount of ink. As the ink runs out the line becomes thinner and more textured. The wooden point offers a lot of resistance to the page, and therefore drawing with it requires force. Its unwieldiness and quirkiness cause it to yield an emotive line of great variety. My favorite is the Zen pen (assorted sizes).

Artist-Quality Fountain Pens

An artist-quality fountain pen with a 14K or 18K gold nib is an expensive investment, but it will last a lifetime and enables you to draw with a high-quality drawing instrument that gives a distinctive line anywhere and anytime. Its advantage over ordinary fountain pens, disposable rollerball pens, and the like is that, due to the flexible gold nib, it gives you variable thicknesses of line according to your hand pressure. The nibs are interchangeable and generally made in five basic size designation: extra fine (XF), fine (F), medium (M), broad (B), and double broad (BB). The points come in a variety of different shapes as well for different purposes. There are two main types: broad nibs and pointed nibs. The broad nibs are for calligraphy and the pointed ones are for

drawing. Use only water-soluble ink in a fountain pen. My favorite artist's fountain pen for drawing is Pelikan Souveran M1000 fountain pen, B nib.

Rollerball Pens

There are innumerable disposable artist markers, gel pens, and the like. For quick gesture drawings or mass drawings made of continuous lines, I want a pen that can deliver the ink to the page in a clear line smoothly at very fast speeds. The best pen I have found for this is Zebra GR8 medium-point rollerball pen, 0.7mm.

Odd Materials

As previously mentioned, art media, especially liquid media, can be applied with an enormous variety of implements and applicators. Beyond brushes, pens with assorted points, and holders, these include toothbrushes, sticks, twigs, gloves, rollers, crumpled paper, cloth, droppers, dowels, linoleum strips, fingers, hands, and spoons—all to varying effect. I highly recommend exploring as many of the above as you can and then try to come up with your own.

ACCESSORIES

Countless drawing accessories are available and useful for artists. There are three, however, that I find especially indispensable: soap to gently clean your Sumi brushes, fixatives to protect your drawings, and a good hand cleaner. My favorites are:

- General's "The Masters" brush cleaner and preserver
- Sennelier Delacroix fixative for pencil and charcoal
- Sennelier Latour pastel fixative for soft pastels
- Grumbacher matte final fixative
- Gojo hand cleaner

◀ With practice, the reed pen (such as this Zen pen) can be used to create many interesting qualities.

[EXPERIMENTING FREELY]

Experiment as much as you can with a wide variety of materials. Familiarize yourself with the choices available. This will increase your repertoire and enable you to discover new possibilities. It's stimulating to experiment with odd materials, too, but make sure that the media you put on the page are lightfast and permanent. When you find something that works well for you, delve into it as deeply as you can and make it part of you. It is worth noting that a shift in materials, from time to time, also helps keep your attitude fresh.

▼ *Linoleum Strip Tease,* 1998, Sumi ink on paper, 18 x 24 inches (45.7 x 61 cm), collection of the artist

These drawings are the result of a lucky find. I was at a drawing studio where there had been some construction, and I found strips of linoleum and felt lying on the floor. I decided to see how these would work as drawing implements by dipping them in Sumi ink and drawing with the edges, points, and flat sides. It was a challenge to control such strange materials, but the process brought out a surprising sense of freedom.

▲ Simple materials—such as (from left to right) a strip of linoleum, Masonite, or felt—that are dipped in ink can be the starting point for a very exciting drawing adventure. Using such unusual applicators forces you to be creative and often leads to surprisingly good results.

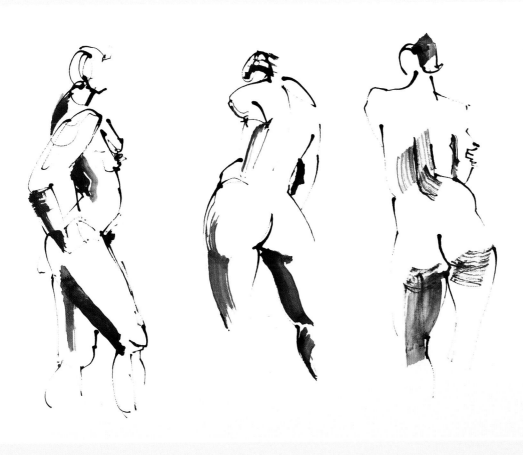

DEMO > Reed Pen Contour Drawing

The reed pen has a power like no other implement—and a venerable history. Picasso, Matisse, and van Gogh, to name just a few, used it a great deal. It gives a strong line that is naturally lively and varied. Its directness can, at first use, seem challenging, but working with a reed pen is one of the shortest paths to learning how to draw simply and effectively.

1

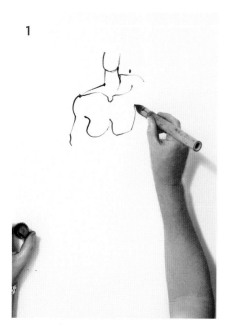

2

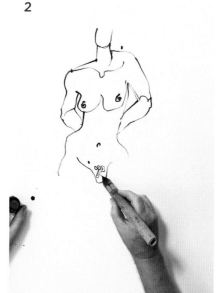

3

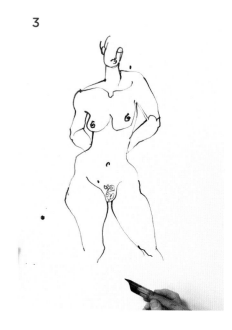

4

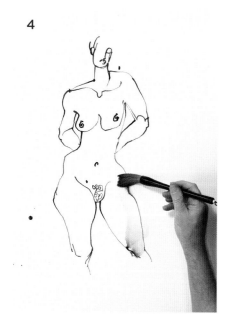

Step 1: The reed pen doesn't usually hold a lot of ink, so I drew a new section of the figure each time I dipped the pen. The dark blue acrylic ink quickly got lighter as it ran out, which gave a pleasing variety to the lines.

Step 2: I added basic details in a simple but rhythmic manner. Confidence with working with such an indelible material comes by doing it repeatedly.

Step 3: When the urge came to start fiddling with small details in the image, I knew it was time to stop.

Step 4: Quickly, while the ink in the lines was still wet, I moistened a Sumi brush with water. I then picked up color from the ink already on the paper, freely indicating shadow areas with remarkably varied shades of blue.

Result: The reed pen lines retain their boldness while the shadows are free and delicate. The fact that this loose technique defies control makes it so effective and expressive.

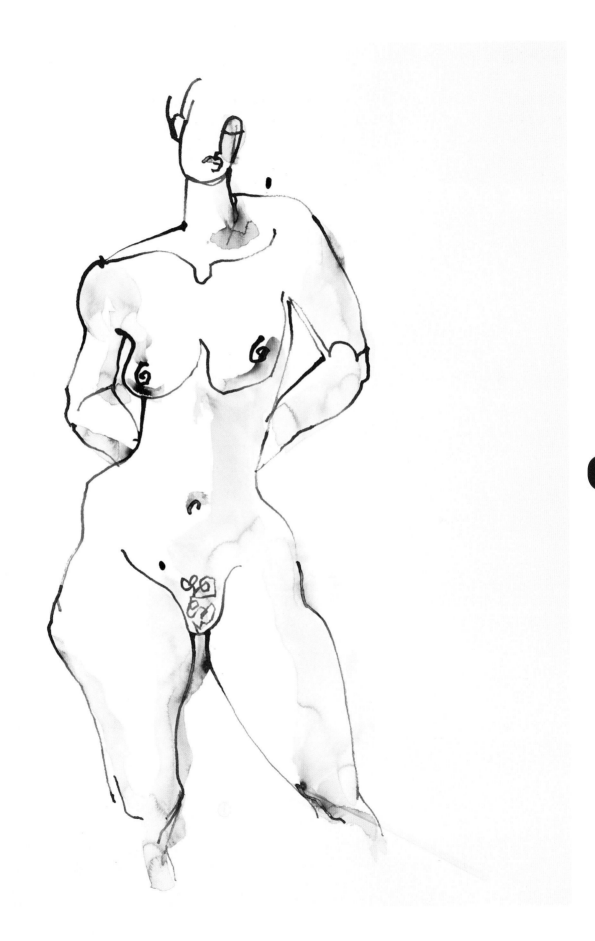

DEMO > Water-Soluble Crayon Contour Drawing

Water-soluble crayons are designed to be a hybrid medium, capable of being manipulated with water to create stunning effects. Since I knew from the beginning that I would soften the lines with a brush and water, I put my contour lines in thickly. This enabled me to relax and enjoy myself while I created the initial contour drawing.

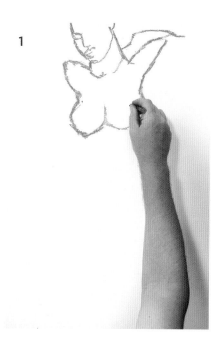

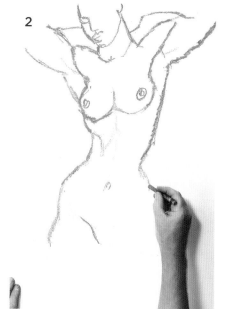

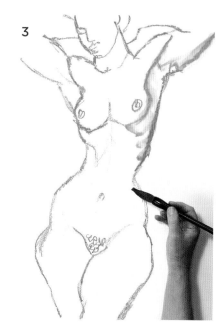

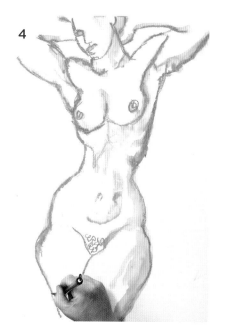

Step 1: As I drew in the contour lines I was very aware of the masses these lines were creating. I exaggerated them to avoid the unfortunate natural tendency we all have to understate the angles and distances.

Step 2: I was intent on getting the directional angles of the contour lines right. I also knew that the figure would appear lifeless unless I got the waist significantly narrower than the shoulders and hips.

Step 3: Once the contour drawing was completed, I took a Sumi brush loaded with water and picked up the color from the contour lines, spreading it around where I wanted the shadows to be.

Step 4: As the water touched the dull crayon line, it immediately became luminous. This effect was very enjoyable to watch. The process softened the line and added rich color to the image.

Result: Voilà! What an easy way to create rich lines and soft, pleasing shadows. The beauty of this technique is that it works equally well with much looser approaches.

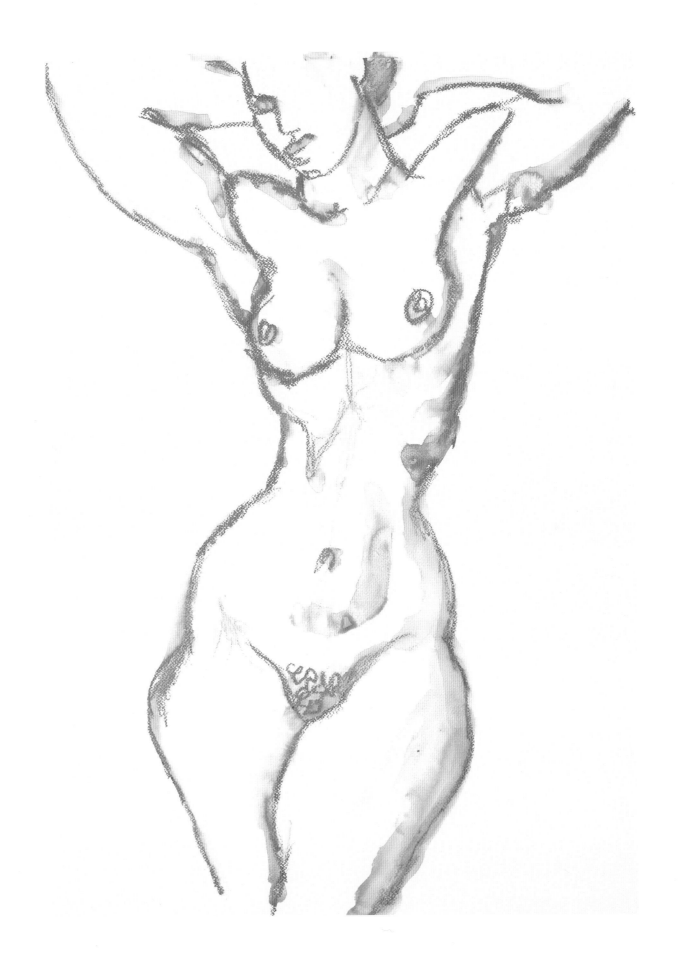

DEMO > Oil Pastel Layered Contour Drawing

As a medium, oil pastels have unique qualities. They are called pastels, but they are actually more like soft, intense crayons. The colors are powerful like oil paint, yet they come in a stick that can be used on paper. Starting with the lightest color and using increasingly darker colors as the work evolved allowed me to articulate the contours more decisively with each consecutive layer.

1

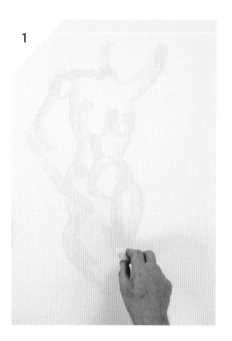

2

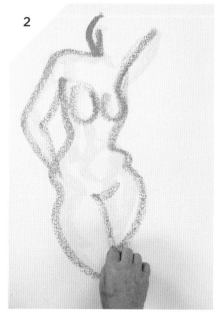

3

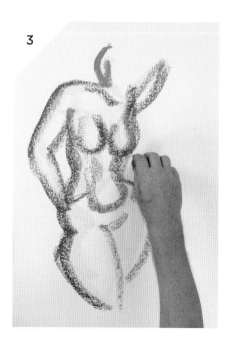

4

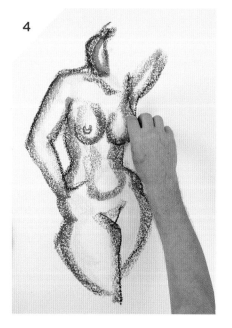

Step 1: I peeled some quarter sticks of a few colors of the Sennelier La Grande Oil Pastels and began by doing a combination mass/contour underdrawing with a yellow crayon.

Step 2: Next, I added a new layer of contours, freshly observing the figure in light blue. Because oil pastels are somewhat transparent and because the colors blend easily, the two colors created green in some areas.

Step 3: The magenta layer was even darker, so the contours I made with it were more decisive. The magenta combined with the blue to appear purple in some areas and combined with the yellow to appear orange in others.

Step 4: I made the fourth and final pass with a dark ultramarine blue, using the point to make finer, more defined contours than I had done in the previous layers. I kept my focus on the torso.

Result: Working from light to dark, the blending effects of the jazzy oil pastel colors lead to an interesting and unusual overall effect.

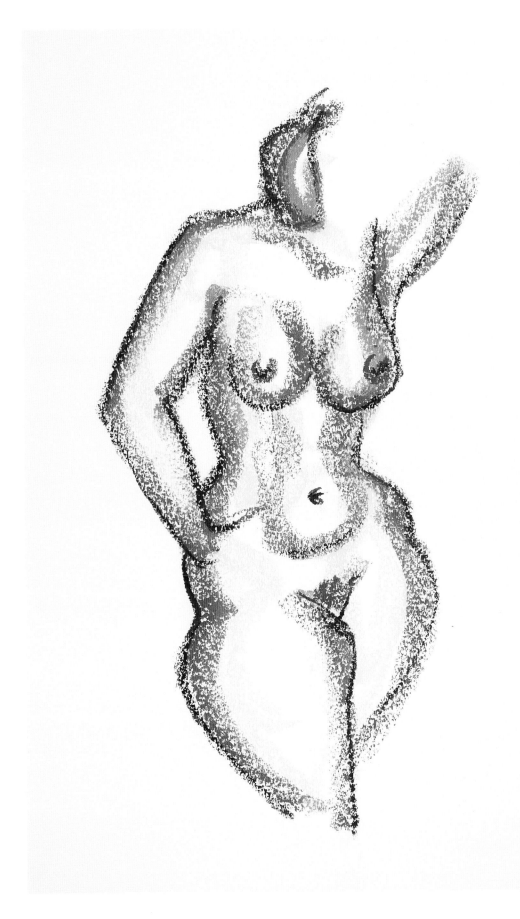

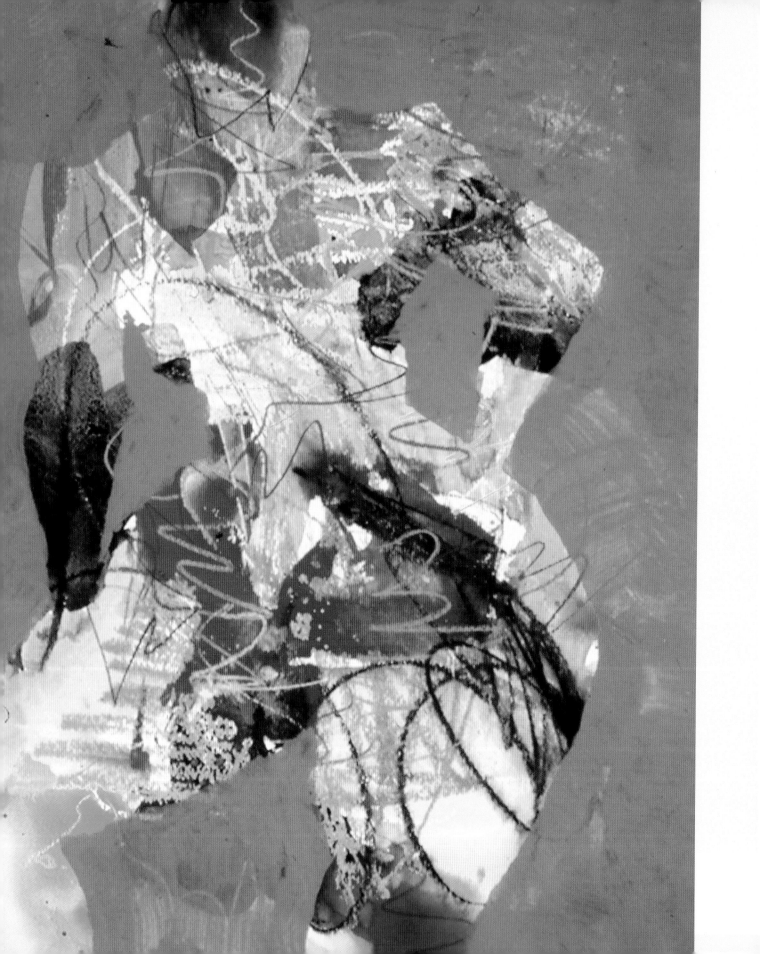

PART III: Drawing Concepts and Techniques

Learning to draw is a journey. Part III contains my system of drawing concepts and techniques, organized into seven key categories. These will provide you with entry points and guidelines for exploring and enjoying the pleasures and mysteries of expressive figure drawing and, through this study, of all else that you would draw.

As you study these, bear in mind that drawing is always a selection process, a series of decisions. Form the habit of making artistic decisions. What you choose *not* to draw is often more important than what you include. Drawing is about recognizing what is essential, so always be looking for the significant indicators. Strive to leave out all that is insignificant and unnecessary and learn the difference. Simplify.

Keep an open mind about your drawing—in spite of definite ideas about how you want your drawing to appear and the effects you wish to achieve. Drawings often seem to have lives of their own. If a drawing starts to develop in an unexpected way that looks interesting, try to go with the flow. No artist ends up with precisely what he expected and quite often ends up with a result that is very different from what he expected. It might even be better than planned. The hand knows things the mind does not. Now explore . . . and enjoy!

◀ *New Nude III,* 2008, watercolor, acrylic, and oil pastel on watercolor paper, 24 x 18 inches (61 x 45.7 cm), private collection

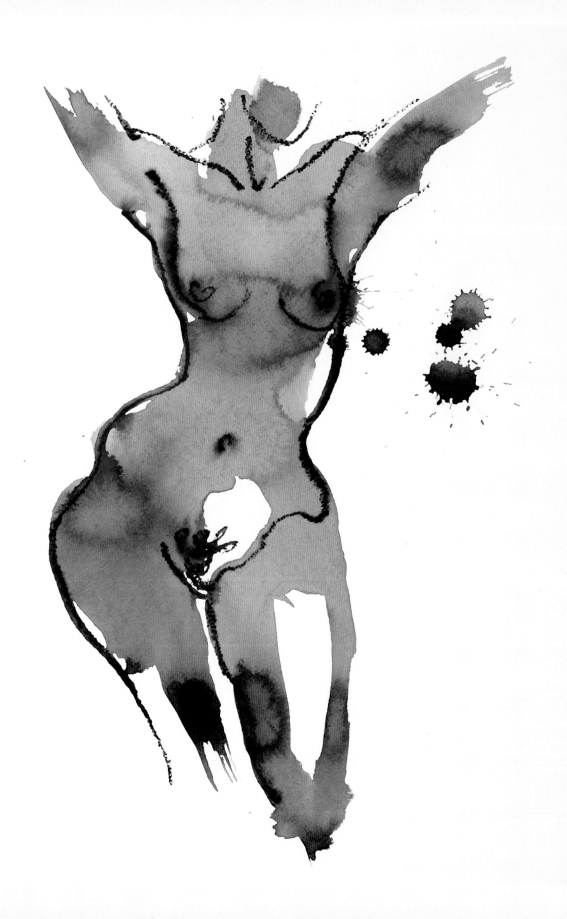

GESTURE

The starting point of figure drawing skill is the gesture drawing. It is the centerpiece and the foundation of good technique.

When you make a gesture drawing, you set out to capture an essential feeling, meaning, or action—or all three. You are looking for the most expressive lines, shapes, and movements—those that define the essence of the pose. The idea is to work lightning fast in order to eliminate all but the essential elements. You must look for, find, and record these elements in only a few short moments. In this way, you develop the important skill of seeing the general features first and learn to capture the essence of a pose through simplification. The gesture trains you to see and react quickly.

The gesture drawing can be described best, perhaps, as capturing the energy of the interacting forms rather than depicting the forms themselves. You must feel the dynamic pushes and pulls implied by the forms and their spatial positions and contours. The gesture drawing, because it encourages free and uninhibited movement, is the shortest and the best path to developing a really free and confident style.

Starting with the gesture gives you the framework for your proportions and relationships of scale. The gesture enables you to get loose. It encourages fluidity and directness. If you master the gesture approach, your drawing technique will be free and alive.

The gesture solves the problem of where to start by beginning with an overall impression. Starting with the gesture approach trains you to focus on generalities and prevents you from being hung up in the details. When you succeed in capturing even a single significant aspect of a pose, you invariably end up with an interesting work that can be a satisfying artistic statement in and of itself. Moreover, it provides the basis for further studies for more finished drawings or paintings of the pose. All in all, the gesture drawing includes an incredibly wide scope of possibilities.

◀ *Attitude 112*, 2006, acrylic, ink, and water-soluble crayon on watercolor paper, 24 x 18 inches (61 x 45.7 cm), collection of the artist

THE GESTURE DRAWING AS TEACHER

Working with the gesture teaches many things. It teaches spontaneity. It teaches you to look for the essence, the "spirit," of the pose. It teaches how to use a line or a shape to express this spirit. It teaches you to mimic the aliveness and action of the figure with your own movements rather than to render the body with slow and tedious movements. It teaches you to be selective. It teaches you to leave out everything that is not essential. It teaches you to capture the Tao, the essence of the figure as an idea.

TWO GESTURES TO CONSIDER

In gesture drawing you must consider two different gestures: the gesture of the model and your own gesture as an artist. The goal in the gesture drawing is for these two elements to become one.

Gesture of the Model

The gesture drawing is not about what the figure looks like but what the figure is doing. Gesture drawing enables you to put a kinetic sense into your drawings. The sense of movement in an artwork is what makes it live. The gesture puts life into the drawing and keeps it there. Today, professional artists of every stripe routinely make gesture drawings to work out their ideas and to keep their skills sharp and fresh.

Gesture of the Artist

The gesture drawing is also about how you move your hand. What is the gesture really? I like this definition, which comes from the *New Oxford American Dictionary:*

> Gesture: "a movement of part of the body, especially a hand . . . to express an idea or meaning"

Your lines and marks on the paper are a mirror image of how you move your hand. If you move your hand in

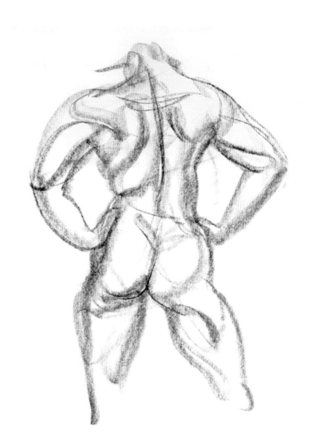

▲ *Nude Study 45,* 2004, Conté crayon on paper, 24 x 18 inches (61 x 45.72 cm), collection of the artist

This drawing shows how the movement of the hand translates onto the page. By attentively mimicking the fluid muscles of this pose with the flowing movement of my crayon the forms just appeared.

a vague or tentative manner, then that is what will be expressed on the paper. Conversely, if you move your hand with a defined focus in a sure manner, then that will come through and give life and interest to your drawing. To draw the body you need to be in touch with your own body movements—in particular, those of your hand and arm.

The gesture of the pose often will suggest what materials to use as well as the type of movement to make with your drawing implement. If you wish to convey grace, you must move gracefully yourself; if you wish to convey strength, you must move your implement powerfully and confidently. Be sure to choose the drawing tool and surface that match the intent of your message.

[LEARNING TO RELINQUISH CONTROL]

You've heard of action painting. Think of gesture drawing as action drawing. You must move fast to make a gesture drawing. Thus you will give up some control. This is a good thing! What you lose in control you gain in expressivity and freedom. It's one of the main reasons the gesture technique is so important to develop. Even when you think you lose control, you don't really—because you can't. It just becomes a different, looser kind of control. This is an important skill to cultivate.

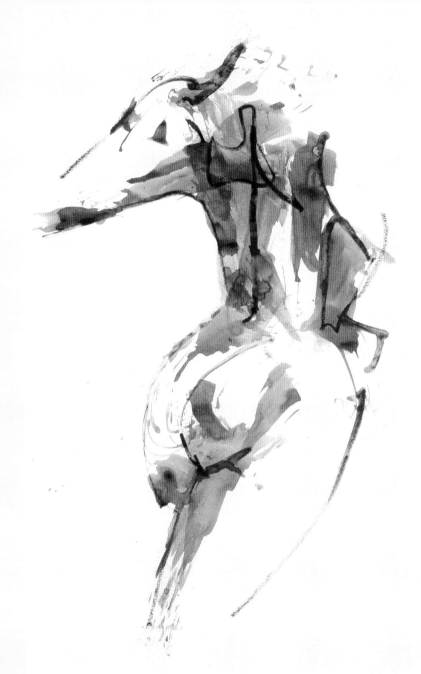

▶ *Attitude 83*, 2000, acrylic ink and water-soluble crayon on watercolor paper, 23½ x 16½ inches (60 x 42 cm), collection of the artist

In this gesture drawing, everything is subordinated to the movement of the pose, which is thrusting forward almost violently. The rough quality of the lines and brush marks and the placement of the deep ocher shadow all contribute to the sense of movement and surprise.

BRUSH GESTURE EXERCISE

This exercise—which comprises four distinct parts—will train you to be able to react instantly to what is in front of you. Focus on translating what your eyes see and your mind feels through light and airy movements with the Sumi brush. Each gesture drawing should be completed within thirty seconds or one minute. The one-minute sessions will allow you to observe and include more detail.

Recommended Materials
- Sumi brush with a 2-inch head
- Sumi ink
- Canson Biggie Sketch pad

Continuous Elliptical Movements
Orient your paper horizontally so you can fit two drawings to a page. Concentrate on creating very quick swirling motions that approximate where the large masses are located. Note in the image below that some of the contours and a powerful spine line emerged during this rapid process.

Mass and Line
Now, right beside the first drawing, do a new drawing in the same size and vary the depth of pressure on the brush so that you create both solid masses and thinner lines. The thick lines create areas of mass. The thin lines contribute defining contours.

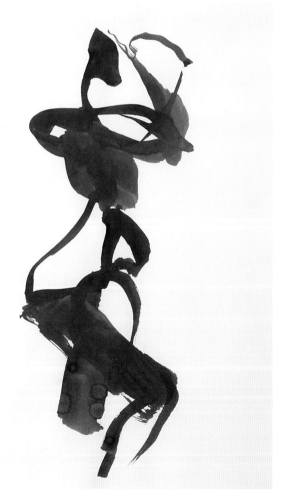

▲ A thirty-second gesture drawing, focusing on continuous elliptical movements.

▲ A thirty-second gesture drawing, focusing simultaneously on mass and line.

Fluid Lines

Hold your brush at a fairly constant distance from the page to maintain a fairly constant line width. The small differences in the line width will create depth and visual interest. The pose featured below suggested fluidity, so I moved the brush as though I were drawing waves, feeling the gentle movement of the pose as I freely interpreted the contours.

Contours and Structure

Now, in a new drawing right beside the previous one and in the same size, pay more attention to recording the contours and structural elements. For example, in the image below, note the definition where the left leg meets the hip, the articulation of the rib cage, the indications of a visible median line down the upper abdomen, and the imaginary ones on the surface of both legs. These details enhance the fact that different parts of the body are pointing in different directions, which creates a sense of roundness and depth not seen in the previous three drawings.

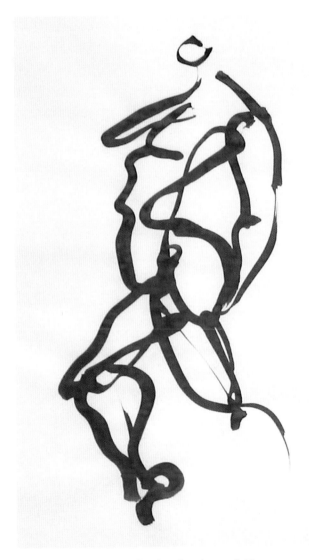

▲ A one-minute gesture drawing, focusing on fluid lines and controlled brush width.

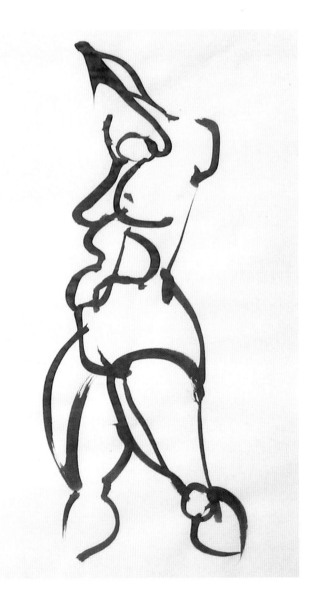

▶ A one-minute gesture drawing, focusing on contours and structure.

OVERSIZE GESTURE EXERCISE

This exercise is executed on very large drawing paper with an enormous and irregularly shaped piece of charcoal. This material makes the outcome impossible to completely control, which leads to fascinating and unexpected expressive effects. Each gesture drawing should be completed within two minutes.

Recommended Materials
- General's Charcoal Chunk
- heavyweight drawing paper, 40 x 60 inches (101.6 x 152.4 cm), cut from a 60-inch (152.4 cm) roll
- drafting tape
- extra-large drawing board or surface

Broad Movements
As you work, note how you can make both comparatively thin contour lines and broad textural swaths of tone simply by altering the manner in which you hold the charcoal. Concentrate on mimicking, with your hand and arm, the most conspicuous line, mass, and structural aspects of the pose. Working quickly, your hand should record at the same time as your eye sees.

When working in this size, forget about being finicky. Focus on matching the size of the drawings to each other and the page space. Move freely from the shoulder. Since you cannot control the multiple edges where the Charcoal Chunk hits the page, your ability to translate the rhythms of the figure's forms into your own arm and hand movements will determine the outcome of the drawing. Twisting and turning the Chunk will give unexpected and interesting results. You will need to be able to respond quickly to incorporate these incidental effects into the overall design and outcome as you go.

▼ Three two-minute gesture drawings, focusing on line, mass, and structure.

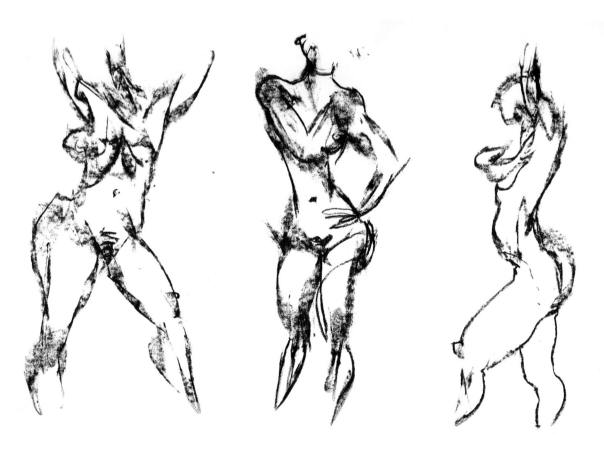

DANCING MOVEMENTS EXERCISE

This exercise allows you to get in touch with your own body, encouraging your arm and hand to change direction as you render the body you are observing. The model should plan to strike two consecutive poses that are suggestive of a ballet position. Each gesture drawing should be completed within about six minutes.

Recommended Materials
- turquoise blue acrylic ink
- water-soluble crayon
- Sumi brush with a 2- or 3-inch head
- heavyweight drawing paper or watercolor paper, 18 x 24 inches (45.7 x 61 cm) or larger

Light and Swinging Movements
Apply light blue brushstrokes of acrylic ink rapidly with a free motion, capturing mass, line, and even structural elements. Allow your hand to dance in response to the dancelike pose.

Once you have captured a general impression of the movements and forms, switch to the water-soluble crayon and, drawing into the wet wash, add just enough overlapping contours to bring out the position of the figure. Take care not to overwork the image. Rather, let the feeling of the movement and the contours suggest the action to the viewer's imagination.

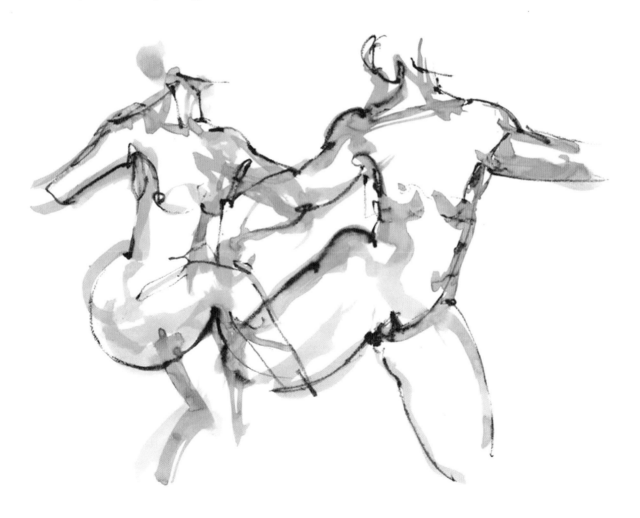

▲ To capture dynamic poses, feel and imagine the movements and gestures of the forms in your own body and mind. Then let that feeling inform the movements of your brush and crayon.

DEMO > Gesture Drawing with Black Pastel Chalk

Working from the general to the specific, you can use gestural indications to build up a drawing in stages. The idea is to move your focus around and record observations in different areas without getting too detailed in any one place.

1

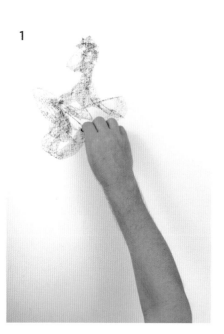

2

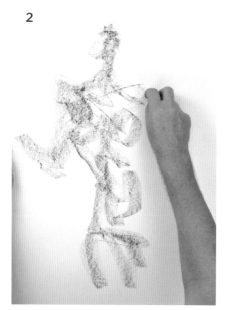

3

4

Step 1: Using quick, sweeping gestural motions, I began with simple mass shapes. These indicated the head, shoulders, and breast regions.

Step 2: The mass/gesture approach enabled me to be loose and get a feel for the basic locations of forms and angles.

Step 3: Once I had the basic forms on the page, I added definition with some light contour lines. I refined my observations and made new, more confident decisions about the locations of key edges and forms as I went along. I did not feel as though I were making a finished drawing at this stage but rather just indications and definitions.

Step 4: In this pose, the head and the body faced in two different directions. The head enhanced the expressiveness of the pose, so I tried to establish its position early on but with only a few structural indications.

Result: The final image features more definition with both shading and contours. Notice the X-ray vision effect in two areas—you can see the back muscles through the neck and the hip right through the arm.

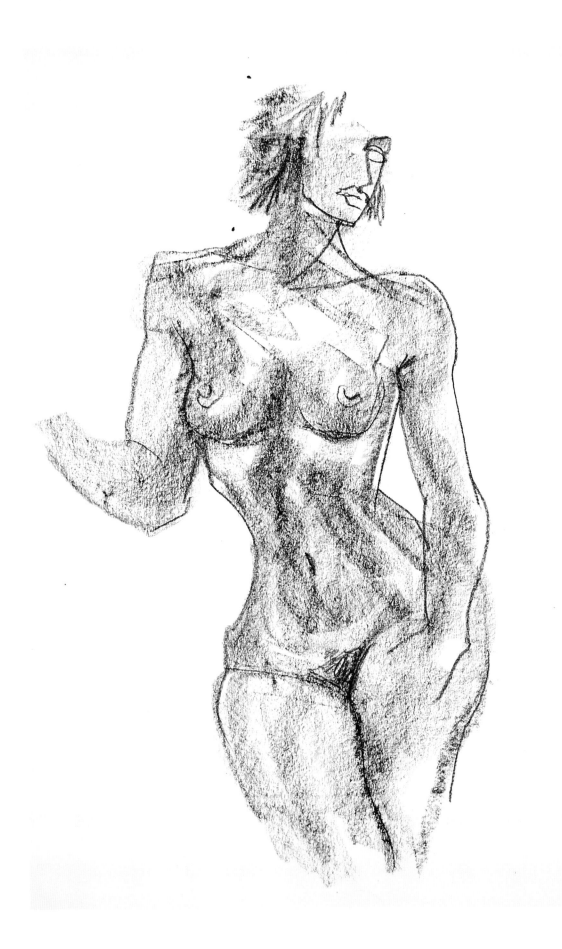

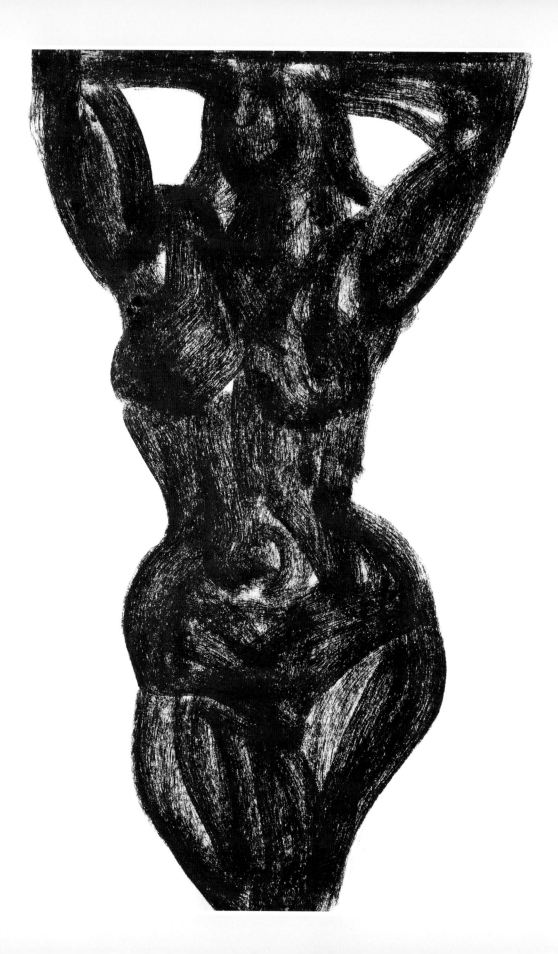

MASS

It is much more crucial to be able to render mass than intricate details. Accurately sensing mass greatly improves the chances of creating a successful figure drawing.

The term *mass* refers to our sense of how a body fills or occupies three-dimensional space. This sense is not only for volume but also for weight and solidity. We can get a limited idea of the mass of an object by thinking of it as a flat shape. However, when we envision this shape as also having volume, weight, and substance, then we start to imagine mass more vividly.

The sense of mass is akin to the sense of touch. Imagine being in a darkened room and wanting to find out where things are located. You would use your hands to feel your way around. Likewise with mass, but when we draw we use our eyes instead of our hands to acquire this information. This process involves the same sense that we use to guess how many jellybeans there are in a jar—or whether a bed frame will fit through a doorway.

Rendering mass involves evoking these qualities— volume, weight, and substance—on the paper. When you draw the figure with a sense of mass, you use both your visual acuity of the solidity of things as well as your ability to approximate volume within a space. Many artists describe this as something they feel in their body. When working in this mode, strive to create a feeling of roundness and bulk on the paper using your sense of the volume of each main body segment as well as the overall shape. As you draw, try to feel as though you are literally building up the figure. To do this, it often helps to imagine that you are using a material such as wool or cotton or clay instead of ink or graphite or Conté crayon. This helps you to sense what you are drawing as something substantial.

It is interesting to note that mass can never be totally divorced from line (the subject of the next chapter). This is because mass is determined by the surrounding contours. The drawing thought process is always a matter of emphasis. As we shall see, there are many ways to evoke the quality of mass.

◀ *Caryatid*, 2009, Cretacolor Art Chunky on paper, 25 ½ x 20 inches (64.8 x 50.8 cm), collection of the artist

[FOCUSING ON NEGATIVE SPACE]

As we will see on the following pages, mass can be captured in a wide variety of ways—largely by focusing intensely on aspects of the figure before us. Interestingly, one can also evoke mass by emphasizing what is *not* present. The drawing to the right started with the shading in of the (negative) space around the figure. Adding some cues—in the form of contours, a few details, and touches of shadow—was all it took to allow the illusion of mass and solidity to spring forth out of the page. The perspective device of overlapping contours contributes greatly to this illusion. Please note that the contours easily override some of the inconsistencies of the negative-space areas.

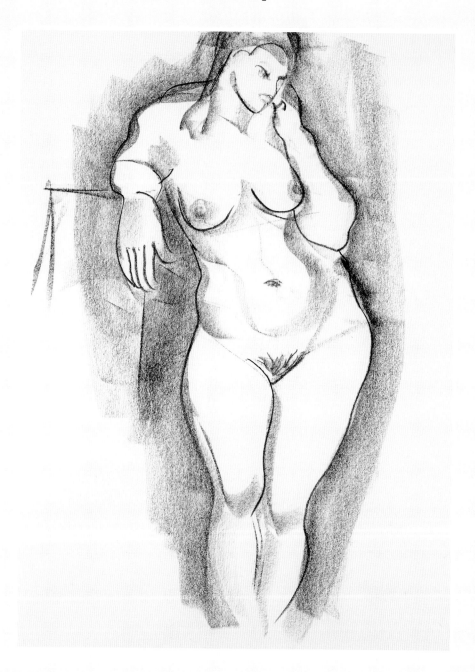

▲ This drawing, completed in fifteen minutes, focused on defining the mass of the figure by articulating the negative space around her. As those boundaries became defined, the solidity of the figure emerged in the untouched white areas of the paper.

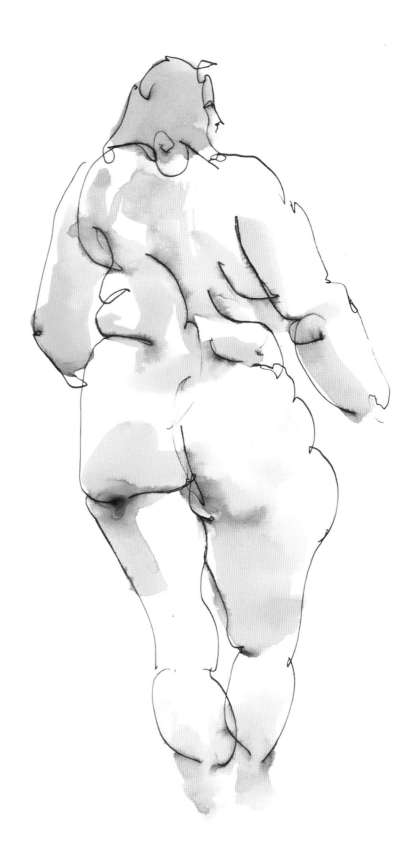

▶ *Dulce de Leche,* 1998, ink and acrylic wash on paper, 16½ x 11½ inches (41.9 x 29.2 cm), collection of the artist

This traditional pen-and-wash drawing demonstrates that contours and simple shadow shapes are quite effective ways to create a sense of mass. Notice that the shadows added to the calves are an attempt to override the contours, but the lines remain dominant.

MASS GESTURE EXERCISE

The most basic way to begin to understand the mass of the figure is to see the shapes it is made of and the totality that those shapes create. This process is not the same as rendering a silhouette. Rather, it is a process of imagining the segments of the body as three-dimensional chunks existing in space. I like to think of these chunks as pieces of a three-dimensional puzzle. Each mass gesture drawing takes between thirty seconds and one minute.

Recommended Materials
- Sumi brush with a 2-inch head
- Sumi ink
- Canson Biggie Sketch pad

Thick, Chunky Brushstrokes
Before you begin, slightly dilute your ink. This will generate a slight transparency. If you look closely at the images below, you will see how the slightly transparent chunky brushstrokes build up and express the masses of the figure. As you work, concentrate on building the figure out of individual brush strokes that are shaped by the way you twist, pull, and push the brush around. Each brushstroke should represent a felt chunk of solid body mass.

▼ Controlling the shape of the brush as it contacts the paper helps to imply three-dimensional form.

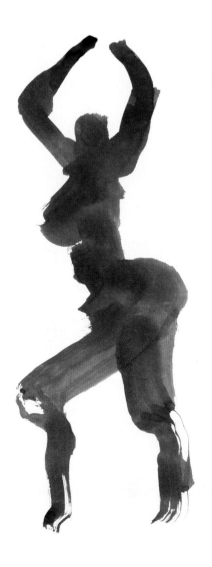

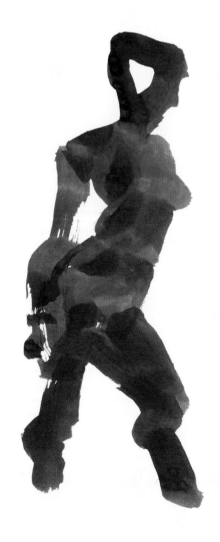

PART III: Drawing Concepts and Techniques

BUILDING MASS WITH LINE EXERCISE

This exercise focuses on a fundamental way of building up the sensation of mass in a drawing. By moving the pen in a continuous but varied motion that mimics the overall shape of the figure, an impression of the solidity of the figure in space will gradually appear. Allow yourself five to eight minutes to build up each drawing, moving at an even pace.

Recommended Materials
- Zebra GR8 medium-point rollerball pen, 0.7mm
- Canson Biggie Sketch pad

▼ Developing the ability to build up mass with continuous line helps you to think of the figure as a volume. It frees you from being overly dependent on contours.

Free-Flowing Movements

Do two or three of these drawings side by side on a horizontal sheet. Try to match the size. Build up the mass of the figure gradually using a free-flowing pen. The movement of your arm and hand should come from the shoulder and be light and free, frequently changing direction in an elliptical pattern. As the ink comes out of the pen and onto the paper, try to feel your way around the three-dimensional forms with your eyes. This is a touchy-feely process. I like to imagine I am using a three-dimensional material, such as wool or wire or even gobs of clay, to build up the mass, instead of a pen. You can also do one of these full size on a vertical page. This may take up to twenty minutes and use a lot of ink and elbow grease, but it is great training.

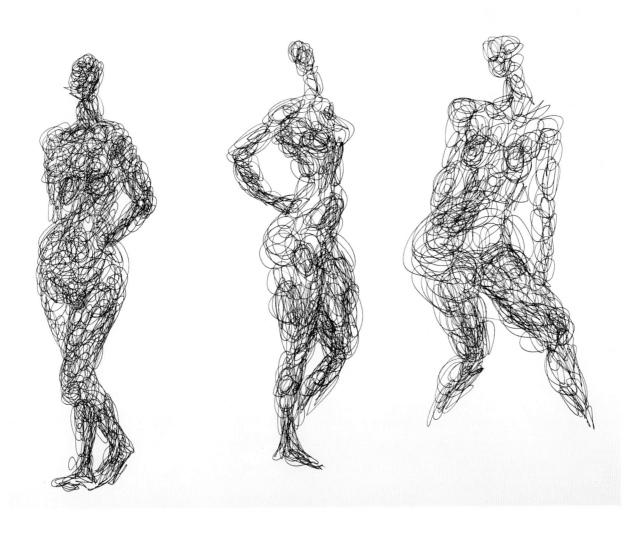

MASS AND LINE IN TWO LAYERS EXERCISE

This exercise—as it focuses on the interplay of mass and line—is a cornerstone for building solid drawing skills. Focus on laying down the masses first, then add the (freshly observed) contours. Allow yourself fifteen minutes to render the figure.

Recommended Materials
• Conté crayon 2B
• Canson Biggie Sketch pad

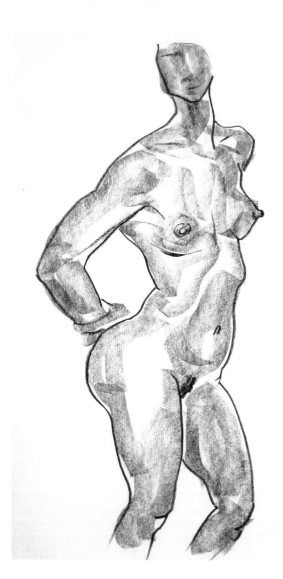

▲ A fluid interpretation of the structural and muscular masses, created with the side of the Conté crayon, provides a solid foundation over which to place freshly observed contours.

Brush-Like Strokes

This exercise works best with a model with good muscle definition, or at least very distinct forms. Start by imagining the placement of the figure on your page. Holding a half stick of Conté crayon on its side, make brush-like strokes that mimic your careful observation of the structural and muscular masses. Vary the pressure and twist the crayon to carve out the shapes. Lift your crayon only rarely as you move from one form to the next.

Next, use the tip of the crayon to do an entirely fresh drawing on top of the first, this time observing anew the contours. In some areas, the two drawing layers will coincide. In other areas, they will not. This is fine. In the image below, the coincidence of the two layers is high. But if you look closely, you will see white areas inside the lines and dark areas outside the lines that show the adjustments made with the contours. Note that the lines take precedence in the final impression. Note, too, how the mass elements of the drawing imbue the figure with a solid and fleshy feeling.

▶ *Attitude 31,* 1995, acrylic wash and water-soluble ink on paper, 23 x 16½ inches (58.4 x 41.9 cm), collection of the artist

The robustness of this drawing is the result of combining several devices. The underpainting in acrylic ink is done with the thought of slightly exaggerating every bulge of the masses. The thick contours added in water-soluble crayon accentuate these bulky angular shapes. A layer of dark shadows then further emphasizes the weighty impression of this figure.

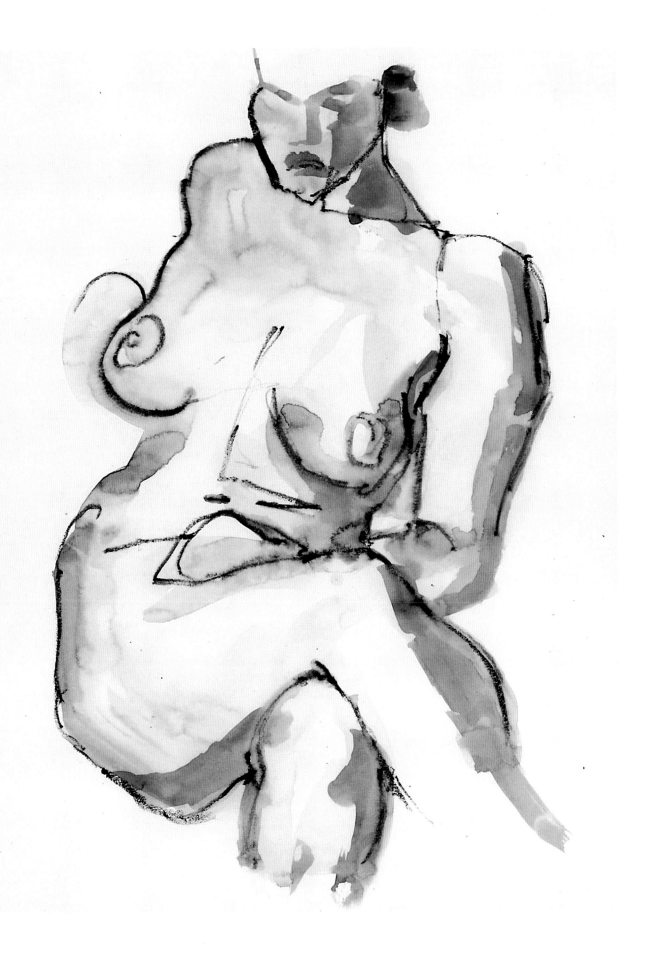

DEMO > Mass and Line Drawing with Acrylic Gouache and Water-Soluble Crayon

This technique looks easier than it is. The acrylic gouache or ink should be applied very loosely to approximate some of the mass of the pose. Then significant contours are drawn in water-soluble crayon. Doing this successfully involves knowing what to leave out as much as it does what to put in. The main thing is not to put in all that you see.

80

1

2

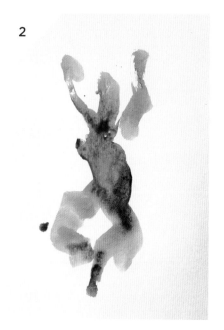

3

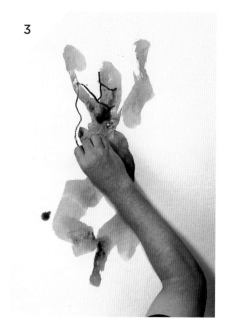

4

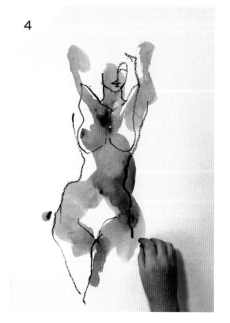

Step 1: I carefully loaded the Sumi brush with acrylic gouache thinned to the consistency of ink. The color was just dark enough to have some power yet just transparent enough to give variety to the strokes. Twisting and turning the brush, I created the shapes and tones.

Step 2: I continued in the same manner, with a new and contrasting color on my brush. This second pass had to be done while the first brushstrokes were still good and wet so the colors would bleed into one another. In terms of mass, I left out as much as I put in.

Step 3: While the ink was still wet, I drew some of the key contours with a water-soluble crayon. Before the acrylic ink had dried, I began to draw in some contours. I articulated only the contours that I felt were necessary to reveal the pose. Interesting effects are generated where the crayon contacts the wet ink.

Step 4: My contours were not guided by the masses indicated on the page but rather by what I directly observed. The mass and the lines are out of sync in some areas.

Result: Knowing when to stop is one of the hardest things. My rule is to stop before I think I should. This allows viewers to complete the picture with their imagination.

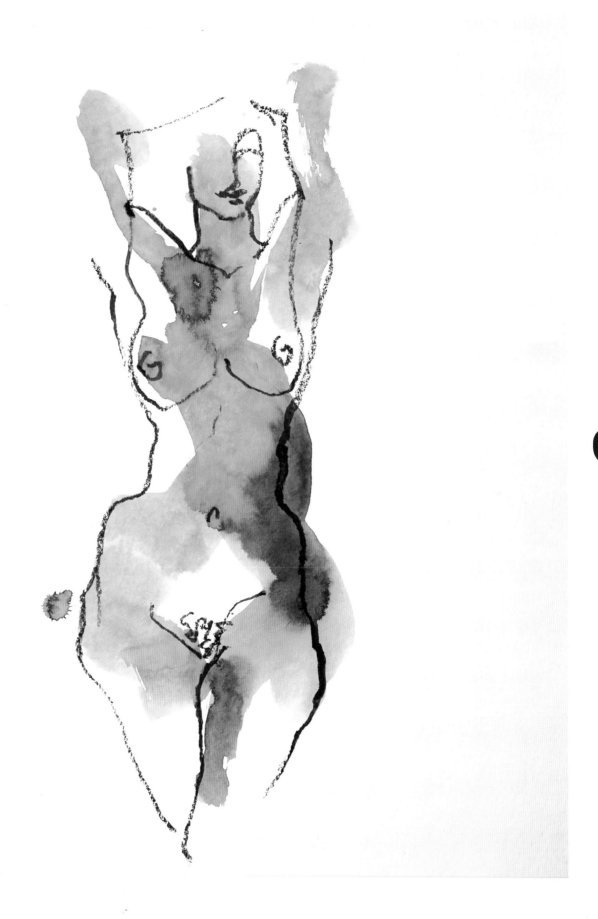

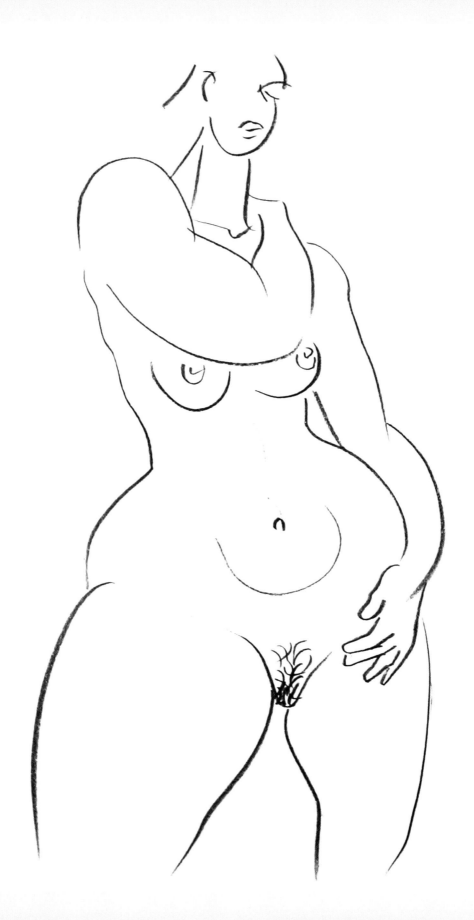

LINE

Line is the most essential, the most powerful, the most abstract, and the most versatile means we have for conveying our responses and ideas. Because line is abstract, it appeals to our imagination—and has great power to move us.

Think of line as edge and direction consciousness. While mass is an intuitive sense of volume and substance, a line precisely describes an edge or a contour. It defines where a mass begins, changes, or ends. A line records your understanding of what an edge is doing, or what directional changes it makes relative to your position. To sense and draw a line is to feel that edge. But a line can also indicate a path or direction where there is no edge—just an imaginary path along a surface or even just traveling through space.

You use lines to explore, investigate, suggest, describe, define, divide, connect, separate, surround, contain, and point. With lines, you can show how forms work together and interact. Lines can suggest structure or lines can describe structure. You can use them to communicate all kinds of information. Lines can show boundaries, routes, surface changes, endings, beginnings, interruptions, divisions, edges, positions, and directions. You can create tones, textures, and surfaces with them. They enable you to see inside and through things and allow you to depict things behind or out of view. Lines can communicate just about everything about the structure of your subject, including degrees of shading and color placement. A single line often performs any number of these functions at the same time.

◀ *Arcs,* 2005, Conté crayon on paper, 24 x 18 inches (61 x 45.7 cm), collection of the artist

THE PERSONALITY OF LINE

Lines have visual personalities—and they behave according to the way they are executed. Your line is an exact replica of how you move your drawing instrument. Move it in a lively, feeling manner and it will put life into your line. Variations in speed and pressure are your main means of creating the quality of your line. Consistency of line quality creates unity. Variety of line quality gives vitality.

Lines can be thick or thin, light or dark, fluid or awkward, smooth or jagged, delicate or coarse, flexible or stiff, light or heavy, translucent or opaque, and so forth. Every combination of support, medium, and applicator presents numerous unique possibilities for giving your lines these and many other characteristics.

The most amazing thing about lines is that they can define forms and space and suggest emotion and feeling at the same time. For instance, lines can express emotive qualities such as nervousness or confidence, strength or tentativeness, smoothness or roughness, violence or tenderness, eroticism or chasteness, anger or joy, awe or disdain, sweetness or bitterness, sensitivity or brutality. An endless spectrum of moods and emotions are possible—all through the movement and energy of your hand and the line it creates.

The ultimate traits of lines are their versatility and their power to communicate. Your lines convey your attitude and intent. Your lines reflect your temperament and your mood. They are like a lie-detector test. If you are deeply involved with and excited about your observations, your lines will reflect this. Interesting and emotive line qualities give your drawings energy and life. Give your lines personality; use them to express what you feel.

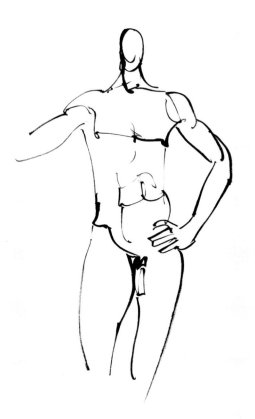

▲ The male figure is more angular than the female. In this fountain pen drawing, fluid lines become angular at key junctures to bring this out.

▲ Using a fine-pointed Sumi brush and Sumi ink, the focus here is on using varied thick and thin brushstrokes to give depth to the forms.

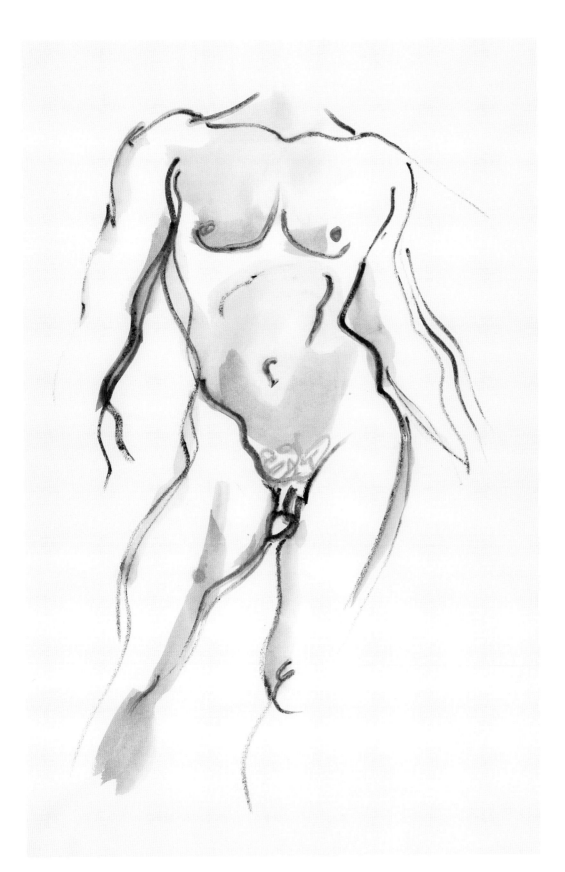

◀ *Male Nude 2,* 2002, acrylic ink and water-soluble crayon on paper, 24 x 18 inches (61 x 45.7 cm), collection of the artist

These thick water-soluble crayon lines, drawn over light washes of mass and shadow, state and restate, in an easy flow, the rhythmic character of the body's supple forms.

CONTOUR LINES

A contour line is used to record the fluctuations of an edge. It is worth noting that a contour is different—and far more functional—than an outline. An outline is a record of the outer edge of a form, yet it doesn't imply any three-dimensional aspect of that form. Police coroners draw outlines. Artists draw contours. A contour line is drawn with the intention of implying three-dimensional and structural qualities. This is done by accurately recording the subtle changes in direction of the undulating edges of the body's forms. This three-dimensional quality may also be suggested by subtle variations in the thickness, tone, and texture of the contour line.

There are two types of contour lines: edge contours and surface contours. Edge contours (which are really side views of surfaces) appear as visible lines to our eyes. Surface contours are imaginary paths along surfaces that can be indicated with lines. External (or outer) contours appear along the outer edges of the figure. Internal (or inner) contours are visible along the forms contained within the figure.

To draw a contour, you need to move the hand holding the drawing implement so that it mimics the changes of direction you observe in the contour. This mimicking action of the hand informed by the eye in the creation of a line is a key drawing skill.

As the drawing on the facing page shows, lines, without the help of other elements, can perform a great host of functions in an image. The edge contour lines, which are strong, pure colors, have a consistently fluid rhythm. Some edge contours feature a variety of colors, making them vibrate. The surface contours around the shoulders, breasts, and navel record highlights and contribute to the sense of volume and depth. The undulating rhythms of the hair echo those of the robe. The head and face provide the additional expressive element of mood. Supporting it all, the toned paper creates an environment in which both the dark- and light-colored lines nearly glow.

LINES AND SPACE

A basic consideration when drawing the figure with lines is that all lines, relative to one another, either converge, diverge, or are parallel. As they do so, they enclose and define space and create shapes and mass. Developing a strong sense of the space and mass that forms between the lines we draw is one of the prime drawing skills we desire.

◀ *Nude Study 37,* 2007, Sumi ink on paper, 24 x 18 inches (61 x 45.7 cm), collection of the artist

This drawing shows how the edge contours define solidity and space. The enclosed areas evoke solid forms surrounded by space. Where the contours are open-ended the forms dissolve into the surrounding space.

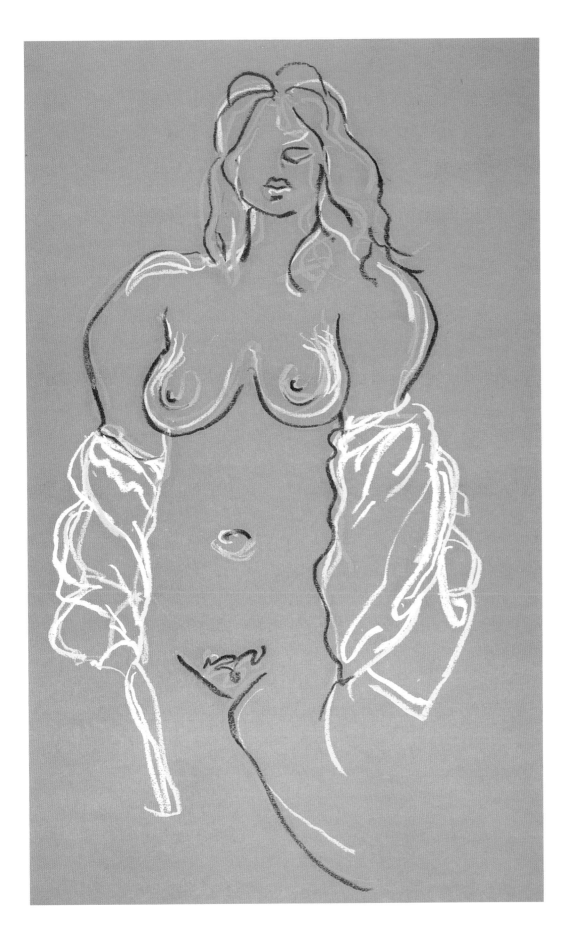

◀ *Oil Pastel Study,* 2008,
oil pastel on gray paper, 26
x 20 inches (66 x 50.8 cm),
collection of the artist

The lines in this drawing
resonate powerfully and
create depth, in part,
simply because the oil
pastels contrast so strongly
with the colored paper.

[DETERMINING SIGNIFICANT LINES]

When we look at the figure, it is important to realize that all the readily visible lines are not created equal. Some of them are far more important than others. The drawing process is about finding and drawing the significant lines and omitting the less important ones. The fact that some significant lines may be barely visible makes this quite a challenge.

Learning which lines are significant involves trial and error. When trying to determine the significance of a line or edge that you see on the figure, it can be helpful to ask questions such as: Does it contribute to an understanding of structure, direction, or location? Does it convey a movement, a tension, or an emotion? Or does it, perhaps, take away clarity from any of these? Answering these questions will usually let you know whether a line should be in your drawing.

◄ The contours along the outer edge of this pose are clear, but one must look very closely to see where the significant edges of the internal contours are.

► Here the significant inner and outer contours have been traced in. Train yourself to find and record the significant lines—the ones that define the forms.

▲ Here we see how clearly these lines read when they stand alone.

◄ Here is a quick, freehand sketch done of the same pose with more fluid lines. Only lines essential to defining the basic forms and action were included.

STRAIGHT–LINE EDGE CONTOUR EXERCISE

This powerful exercise teaches you to see the contours as a series of distinct changes of direction in space. Reducing the curves to straight lines enables you to see these directions in relation to horizontal and vertical axes of the picture plane, which should always be close to the forefront of your awareness. This exercise reinforces the fact that contours actually are the edges of planes and enables you and the viewer to understand those planes more clearly. It forces you to learn to generalize. This technique yields very effective drawings because it embraces and exploits the fundamentally abstract nature of the drawing process. Allow yourself ten minute to observe and render the figure.

Recommended Materials
- Zebra GR8 or other medium-point rollerball or gel pen
- Canson Biggie Sketch pad

Curved Illusion
There is one main rule in this careful technique: The contours can only be expressed with straight lines. This means there will be an abrupt transition at each major change of direction. It normally takes two or three straight lines to indicate what one curve can indicate; for an especially long arc, use four or five. If you use too many very short lines, the effect will be lost. Rarely lift the pen from the paper and proceed with firm, straight movements. You should have the sensation of cutting or carving a sculpture as you reduce the figure to a series of planes.

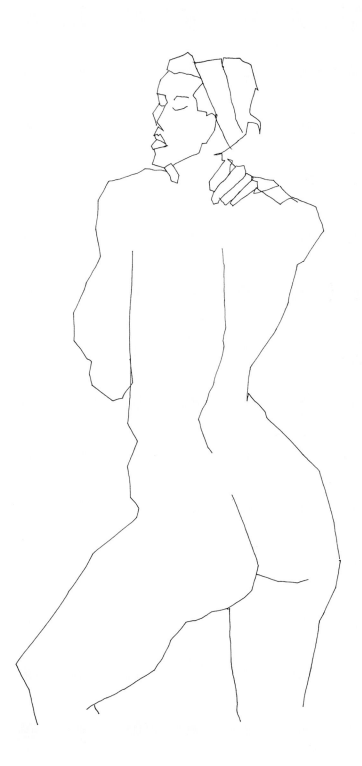

▲ The abrupt changes of direction give sharp definition to the undulating forms of the figure.

THE BLIND CONTOUR EXERCISE

The mother of all drawing exercises, the blind contour will develop your hand-eye drawing coordination, teach you to see the contours of the figure, and familiarize you with the ins and outs of the figure very quickly. If you go the right speed and fill the page, you should be able to do one of these in six to seven minutes.

Recommended Materials
• Zebra GR8 or other medium-point rollerball or gel pen
• Canson Biggie Sketch pad

Inner and Outer Contours

This exercise is infamous because the process requires so much trust and yields such unexpected results. Here's how it's done: First, you have to commit to not looking at the page and not lifting your pen off the page. Now, observe and follow the contours, both inner and outer, of the model as faithfully as you can. Every time there is a change of direction along a contour, follow it with your pen. (Remember: No looking down or away!)

The process of making a blind contour drawing is like driving a sports car on a mountain road with lots of hairpin turns. You cling to the road and hang on for dear life until you get down the mountain. You have to try to remember where you've been, and when you get backed into a corner you can either follow the contours back out to a new area or invent a surface contour to travel on to get where you need to be.

Every one of these drawings is a unique experience. Size is important because you need a lot of room. (Make sure to use the whole page.) Speed is also very important. You have to find the right speed and go at a steady rate. If you go too slow, you will never finish. If you go too fast, you will miss a lot of the changes of direction of the contours and lose the whole point of the exercise.

A step-by-step demonstration of this technique can be found on pages 92 to 93.

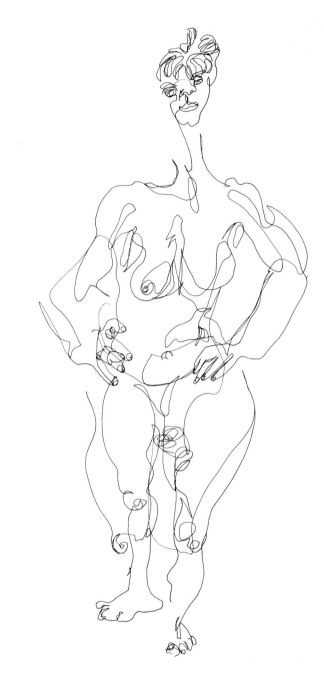

▲ The blind contour exercise should actually be called the "seeing" contour, because it trains you to keep your eye on the model rather than on your page.

THICK, CONTINUOUS LINE EXERCISE

In this exercise you use your line to record edge and surface contours as well as structural elements all at once. Not lifting the colored chalk from the paper keeps you concentrated on the task at hand and forces you to find creative solutions for getting from one place to another. Allow yourself two minutes to complete a drawing.

Recommended Materials
- Cretacolor Art Chunky
- Fabriano Eco-White drawing paper

Thick and Thin Lines

Continuous line drawings can be created with a number of different drawing implements. For this one, use a black Cretacolor Art Chunky, which generates very thick lines. The thickness and blackness of the Chunky combined with the impressive size of the page give these freely interpreted rhythmic forms a powerful impact.

As you draw, feel your way around both inside and outside the forms in a typical gesture-drawing fashion. Look for and record structural and directional elements as well as mass, line, and shape. Twist the Chunky to vary the thickness of line. The thicker lines will imply flatness. The thinner ones will appear to evoke a sense of volume. Varying the pressure to create darker and lighter passages, depending on their relationship to the forms, will create levels of depth as well.

A step-by-step demonstration of this technique can be found on pages 94 to 95.

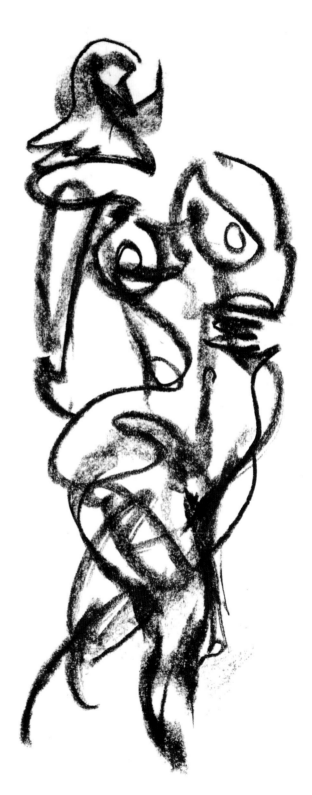

▶ Drawing with an uninterrupted line will teach you how to abstract your impressions of the form.

DEMO > Blind Contour Drawing with Pen and Ink

The "blind" contour exercise is one of the most fun figure drawing exercises of all. I don't know why so many people dread it. It literally teaches you how to see. Your pen should record every turn, no matter how slight, as you move steadily over the forms. It should almost feel as though you are tracing.

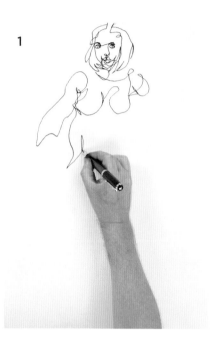

1

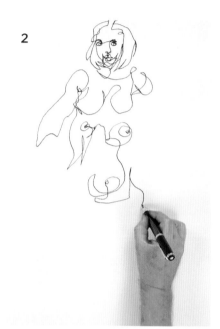

2

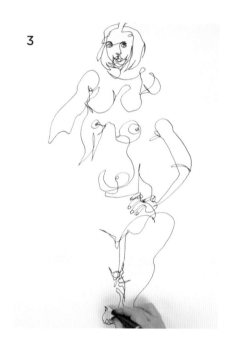

3

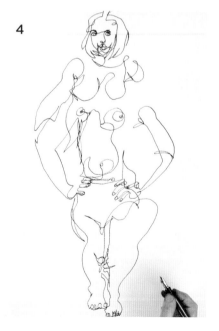

4

Step 1: Starting with the head and face, I tried to record every detail. It was particularly challenging to remember where I had been and what remained. I kept track of where I was on the page by feel alone.

Step 2: It was inevitable that lines would not meet up and body segments would be disjointed. The important thing was for me to keep moving at a steady pace and to react to every change of direction I saw.

Step 3: I stayed focused on not following the outline of the figure. Instead, I followed the contours as they moved inside, in front, behind, and around each other.

Step 4: I was sure the drawing looked pretty strange at this point, but so what! This exercise forces detachment from results. It made me focus on process instead of product.

Result: Three arms and four breasts later, I had gotten all around, inside, and outside the figure and hadn't left out any important pieces. The result always gets a chuckle, but more important, my hand-eye connection was sharper for the rest of my drawing session. This exercise is not optional. It's essential.

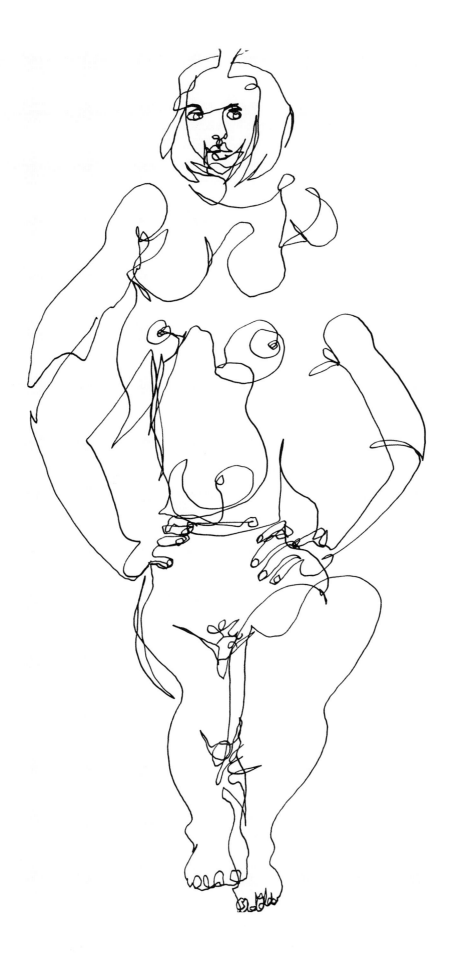

DEMO > Continuous Line Drawing with Pen and Ink Wash

Contours are not just outlines. Even though you are drawing with lines, you should be sensing the mass of the forms so that the lines contain a sense of volume, weight, and structure of the figure. The indelible nature of the pen-and-ink-wash technique forces you to commit fully to the act of drawing. This is what makes it such great practice.

1
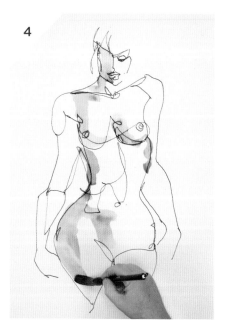

2
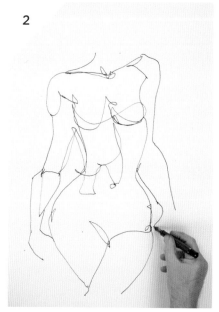

3
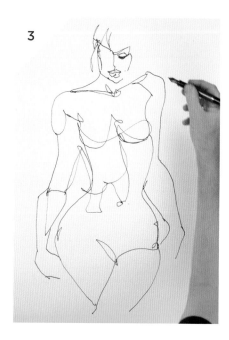

4
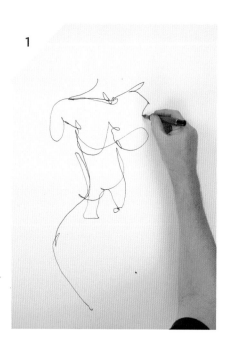

Step 1: With my fountain pen I moved freely, trying to give a sense of the forms without lifting my pen. This freedom gave the line a living quality. I was making marks to indicate very basic forms and establish a size and position on the page.

Step 2: I added the arms, maintaining the loose and lively feel in the lines. I tried to achieve a sense of depth by emphasizing the position of the limbs away from and partially behind the torso.

Step 3: I added the head—a risky procedure. If it didn't fit with the body, the drawing would not survive. I concentrated on establishing the downward-looking angle by the position of the jaw and lips. The visage is not based on facial clichés but rather on structural observations and lines.

Step 4: Keeping the ink nice and translucent, I quickly laid in the irregular shapes of some of the most telling shadows. Pushing down widened the brushstroke. Lifting made it narrower.

Result: Adding a final touch of contrasting color brought the drawing more to life and unified it. The difficult thing was to stop before I had added too much.

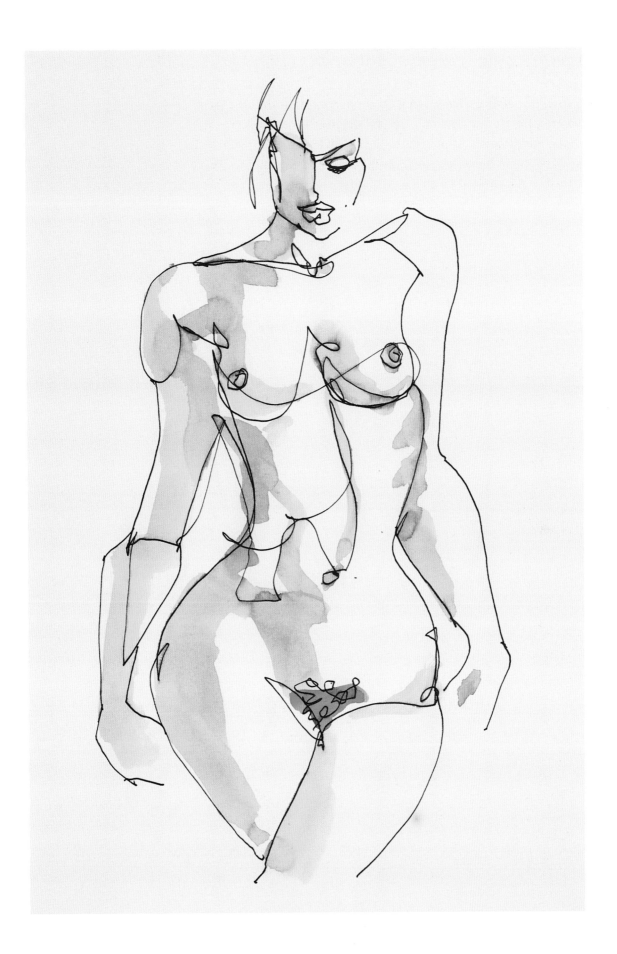

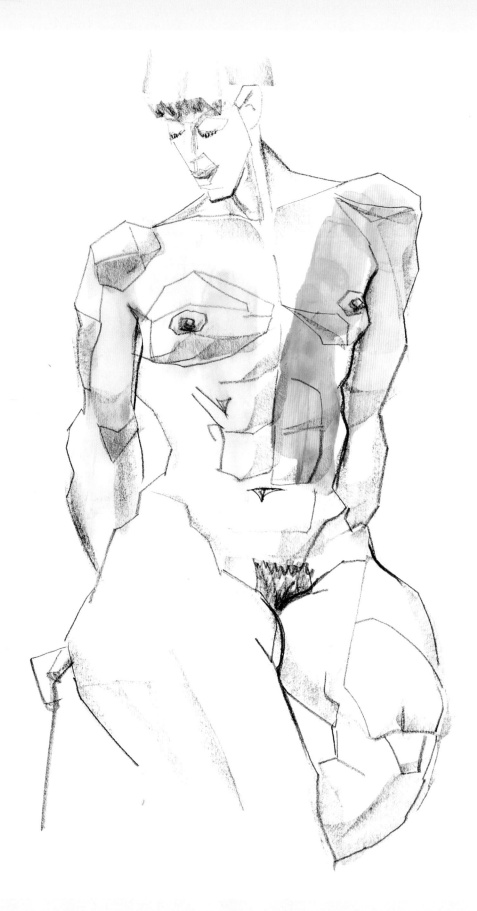

STRUCTURE

Learning how to draw the figure is, among other things, getting to know intimately the body as a collection of visual facts. The structural method of drawing, because it is based on simplifying forms, is the most direct way to understand the logic behind these facts.

The human body is not a just a pile of flesh and bones. It is a harmony of ideas. Each body part has a purpose that is inherent in its form. The various parts not only fit together in a functional flow, but there is a grand logic to how these parts work with each other. Together, they make up a coherent whole.

Structural drawing has to do with observing, understanding, and recording how forms interact, interlock, and work together in three dimensions. It is a way of drawing that develops and uses formulas for how things are constructed. These formulas give you paradigms that help you to see how the forms of the body flow together. After you internalize these formulas, you don't have to reinvent the wheel every time you draw.

The structural approach takes into account the internal support system of bones and muscles in a simplified way, enabling you to portray the body convincingly without requiring detailed anatomical knowledge of the human body. It is by far the most widely used and commonly relied upon method for professional artists and illustrators.

With the structural drawing approach, you use lines to understand, reveal, and indicate how the three-dimensional forms of the body are related in space—the way they interact. Forms settle on top of one another, press into one another, wrap around one another, flow into one another, and grow out of one another. Simplifying these forms enables you to gain a truly three-dimensional understanding, literally a "deeper" understanding, of what you are seeing. At the same time, this simplification process helps you to eliminate the nonessential.

Once you begin to understand the basic structure of the human body, you will grasp the fact that the figure is an organized whole whose pieces fit together like an interlocking three-dimensional puzzle. The challenge is to get these different pieces to work together in a harmonious arrangement on the page—in a manner akin to a choreographed dance or a piece of music.

◀ *Lady in Red and Blue*, 2002, lithographic crayon and watercolor on paper, 24 x 18 inches (61 x 45.72 cm), collection of the artist

A SYMPHONY OF FORMS

The beginner frequently starts out by looking at the body as an undulating surface of skin bound into a single shape. But the body is better understood as a collection of shapes. Would anyone try to talk about a Mozart symphony as just having a single shape (even though it does have one)? Of course not! It's made up of sections. So, too, the human body. The body is also a symphony—a symphony of forms that fit together.

Intuitively we sense that there is a meaningful logic to the bends, bumps, swells, and indentations of the human body. They correspond, of course, to anatomical structure—the muscles, bones, cartilage, and ligaments that animate this surface from within. It is certainly possible to bring out the sense of what you see through modeling and outlines. Another possibility is to use the anatomical approach to understand and bring out the interplay of the forms, but this requires learning anatomy first, which is a roundabout and time-consuming affair. This is where the structural approach comes to the rescue—with a simpler, quicker, and surer way. With the structural approach, you familiarize yourself with the body's discrete number of major parts (head, neck, upper torso, abdomen, pelvis, and so forth), practice rendering them using seven simplified shapes (including cylinders, wedges, and cups), and learn how the parts fit and function together. Structure is not the same thing as anatomy, but it will help you to understand anatomy in a rudimentary way.

THE PARTS

The structural approach is based on a very simple idea: The human body can be reduced to a relatively small number of distinct sections, each of which tends to function as a unit. These units can be understood and drawn as elementary three-dimensional shapes (or even solids) that are, with only a few exceptions, fundamentally cylindrical.

Basic Body Parts

The schematic diagram on page 100 presents the human body, viewed from the front, as consisting of twenty-two basic body components for the male form. (The female form has twenty-four components, including two additional cup-shaped forms for the breasts.) As you can see, simple three-dimensional geometric shapes represent the sections of the body. The most fundamental shape of the human body is the tapered cylinder, which can also be thought of as a lampshade or a vase shape. These body parts (and shapes), from top to bottom, are as follows:

- 1 head (oval)
- 1 neck (cylinder)
- 1 upper back (cylinder)
- 2 shoulders (half cups)
- 2 upper arms (cylinders)
- 2 lower arms (cylinders)
- 2 hands (wedges)
- 1 upper torso or rib cage (cylinder)
- 2 breasts (cups, not illustrated here)
- 1 lower torso or abdomen (cylinder)
- 1 pelvis (modified cylinder)
- 2 upper legs or thighs (cylinders)
- 2 kneecaps (balls)
- 2 lower leg or calves (cylinders)
- 2 feet (triangular solids)

Basic Body Shapes

Once you realize that the shapes on one side mirror those on the other, then you can see that really only seven different shapes are needed to depict the basic three-dimensional structure of the human body. These are as follows:

- 1 oval (head)
- 4 cups (shoulders, female breasts)
- 2 balls (kneecaps)
- 12 cylinders (neck, upper back, torso, arms, legs)
- 1 modified cylinder (pelvis)
- 2 wedges (hands)
- 2 triangular solids (feet)

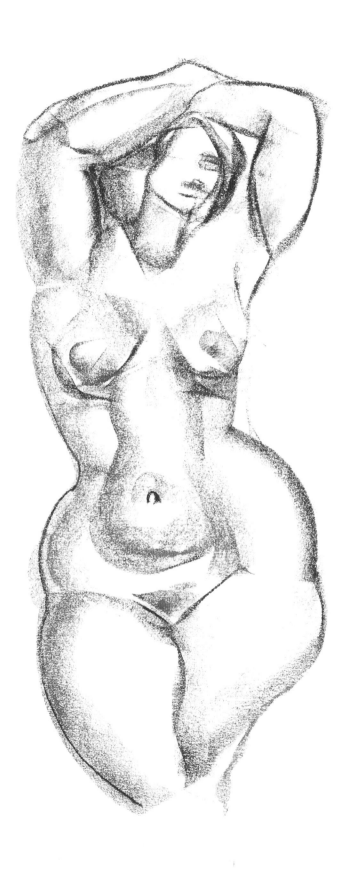

◄ *Nude Study 50,* 2008, Cretacolor
Pastel Carré on paper, 20 x 25½
inches (50.8 x 64.8 cm), collection of
the artist

The ultimate goal of the structural
approach is to give your figure
drawing—no matter how delicate,
expressive, or abstract—an intrinsic
feeling of a strong and credible inner
structure. This is accomplished by
seeing and feeling the structural
elements as you draw, regardless of
whether you put them in.

THE STRUCTURAL SYSTEM AND CONTRAPPOSTO

Study the red lines on the second schematic diagram below. You will quickly see that each body part has an internal axis. These connected axes represent, in highly simplified form, the internal bone structure. The core of this structure is the spine, the shoulders, and the pelvis (or hips). The upper and lower torso regions are represented by tapered cylinders that are supported at the rear by the flexible spine. Connected to the spine at the top of the torso are the shoulders, and at its base is the pelvis or hips. The arms, legs, and head (via the neck) are all attached to and dependent upon the shoulders, torso, and hips for their action. Therefore, we need to understand the positioning and action of this trio to successfully handle any part of the pose. If we were to draw a tree, we would establish the trunk before adding the branches. This same principle applies to drawing the figure. Trunk (torso) first, then the branches (appendages).

As we shall see, we can easily apply this principle by using the device known as the "hinged I," which stands for the angles of the spine, shoulders, and hips. The importance of this concept cannot be overstated. In most poses, the upper and lower spine, accompanied by the upper and lower torso, naturally twist and lean in different directions. This spinal twist is the basis of contrapposto, the contrast of opposing body forms that is a leading concept of the Classical and Renaissance figurative ideal and is a central key to understanding how to give your figures that living quality.

There are innumerable structural drawing systems. The one presented here is my own updating and synthesis of several different systems. Once you begin to master this structural system, you may vary it to suit your own discoveries and needs. The great advantage of structural drawing as opposed to the anatomical approach is that because of its simplicity, it allows you to concentrate more on concepts such as fluidity, sensitivity, power, and expression. The structural approach is about reducing the complexity of the human form into simple and

understandable three-dimensional shapes. Drawing with this approach is the act of showing what you know about the structure. A characteristic of structural drawing is that it should yield a drawing that could easily be used as the basis for a sculpture.

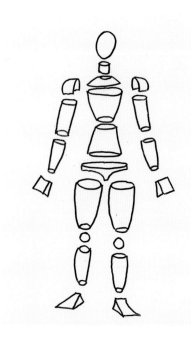

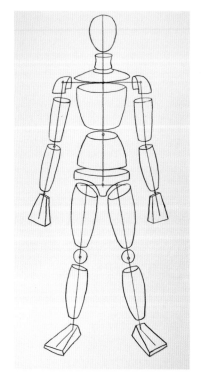

▲ The human body can be reduced to twenty-two basic parts. After you become familiar with this breakdown, you can make your own variations.

◀ The red line that runs through the three axes of the spine, shoulders, and hips is known as the "hinged I." Seeing the position of these three axes is the key to every pose and will help you to accurately understand and render the body in action and at rest.

PART III: Drawing Concepts and Techniques

[COMBINING THE CLOCK SYSTEM WITH THE STRUCTURAL SYSTEM]

The clock system (introduced on page 34) and the structural system may be used together as a single system. When you combine an understanding of the directions of the internal axes of the main body segments with an understanding of the basic three-dimensional forms of the surrounding body segments, you take the guesswork out of what the figure is doing.

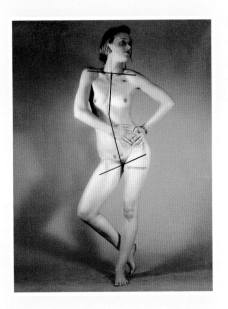

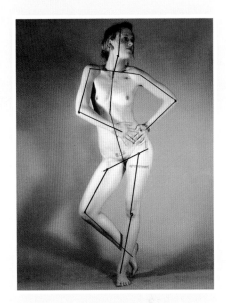

▲ When analyzing a pose, start by looking for the angles of the spine, shoulders, and hips—the hinged I. This will indicate what the human torso is doing. Use the clock system to estimate the angles. Here the axis of the shoulders is tilted just above 9 o'clock (or just below 3 o'clock). The axis of the hips appears to be right on the 8:00 o'clock (or 2:00 o'clock) angle. The lower spine is just after 11:00 (or 5:00), and the upper spine is at about 12:15 (or 6:15).

▲ Once you have established the hinged I, estimate the clock angles for the directional axes of the arms, legs, and head as you put them in.

▲ These directional axes establish, in quite a foolproof way, the position of the figure. Surprisingly, even the swing and elegance of the pose come through in this stick figure. This makes plain where the expressive power in a drawing comes from—its faithfulness to the internal structure. This agrees thoroughly with the principle of Ka (meaning "bone structure") in Chinese drawing and painting.

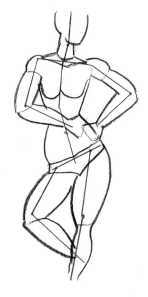

◄ To create a simplified structural drawing, simply piece together tapered cylinders and the other basic body shapes around the directional axes. Although doing this exercise does not often produce pretty drawings, it does teach you how to understand the body in terms of the internal and three-dimensional structure. Mastering this system will give power and confidence to your figure drawing.

STRUCTURAL SHAPES EXERCISE

This exercise, which emphasizes the abstract qualities of the structural arrangement of muscles and bones, provides an interesting match of goal and materials, as it is executed with a medium-point Sharpie. The unvaried thick line of this ordinary writing implement makes it a good tool for making forceful shape statements. Each structure drawing should be completed within thirty seconds or one minute.

Recommended Materials
- medium-point Sharpie
- Canson Biggie Sketch pad

Continuous Line, Structural Gesture

This exercise requires a model with well-defined muscles. The thick, even line of the marker is good for boldly delineating the divisions between the various muscles and bone structures visible at the surface. Try to bring out the connected nature of the body's forms by not lifting the pen from the paper as you find creative solutions with your line for getting from one place to another. See how these shapes fit together to give the internal directional angles as well. Doing two matched drawings to a page encourages you to develop control of the size and the placement of the figure—both important considerations.

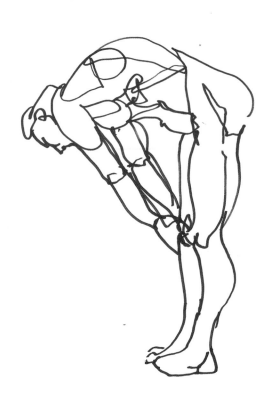

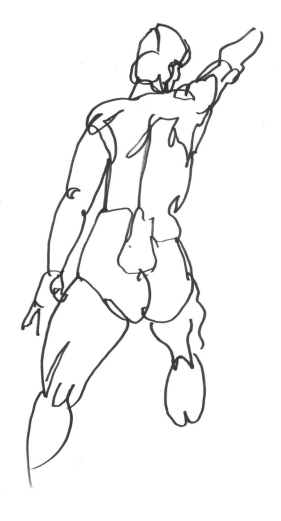

▲ Powerful muscular tensions can be suggested by boldly delineating structural shapes and contours in a thick, continuous gestural line.

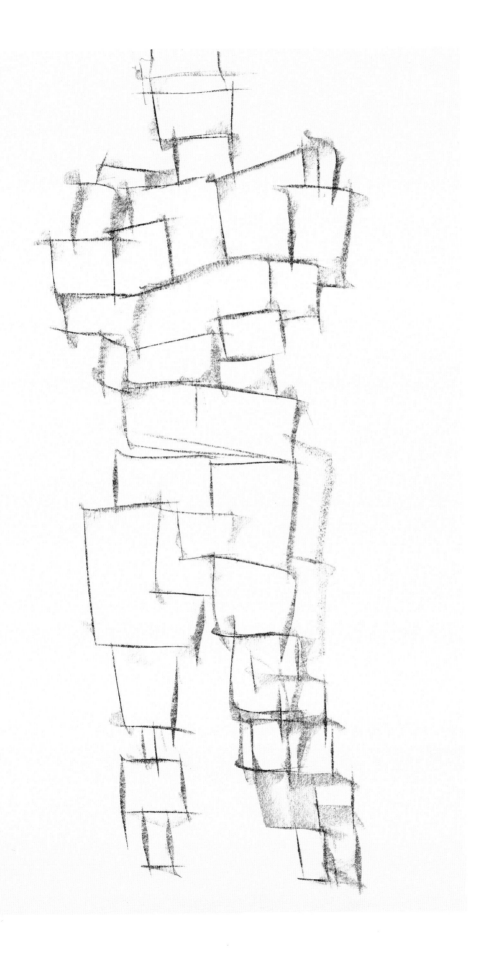

◀ *Hip to Be Square,* 2003,
Conté crayon on paper, 24
x 18 inches (61 x 45.7 cm),
collection of the artist

The structural approach is
all about finding ways to
conceptualize the figure,
no matter how abstractly,
that will help you to better
understand and express how
it is put together. You may
create your own language of
forms to do this.

STRUCTURAL EMPHASIS EXERCISE

Structural drawing involves finding ways to clearly define the three-dimensional forms of a figure. This exercise forces you to reduce the contours to straight lines, and in so doing it will help you to become sensitive to and articulate the surface planes of the figure. Furthermore, using a lithographic crayon, which cannot be erased, trains you to commit yourself fully to the drawing process. Allow yourself ten to fifteen minutes to render the figure.

Recommended Materials
• lithographic crayon
• Canson Biggie Sketch pad

Straight Lines, Structural Forms
Sometimes you have a pose or a model with strong sculptural qualities that cries out for a structural approach. A good strategy in these situations is to reduce all the contours to straight lines. This accentuates the directional changes of these contours. This abstracting process gives heightened definition to the shapes and the planes.

When drawing the figure, enhance the three-dimensional effect by making some of the lines thicker and darker and others thinner and lighter. (Normally thick, dark lines are for areas that recede or are in shadow; thin, light lines describe areas that advance and are exposed to the light.) Then, turning the crayon on its side and twisting it to vary its width, freely add a few very generalized shadows. This will further augment the sense of structural volume. Please note, however, that too many shadows will destroy the effect of the lines. You may also use a few selective curves, like the prominent one seen here on the left shoulder blade, for variety and emphasis.

▼ Sharply delineating contours with straight lines elucidates the forms and accentuates key structural points and junctions.

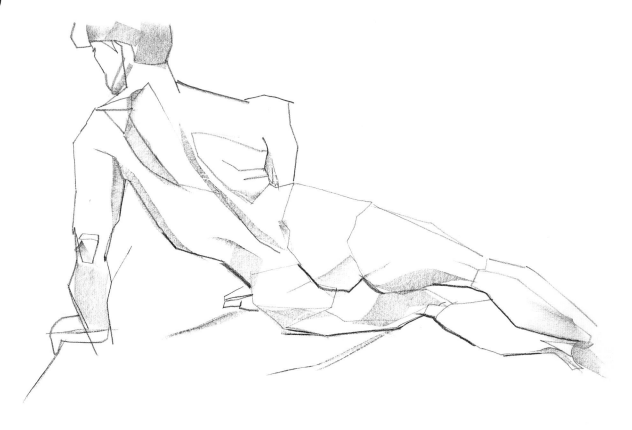

STRUCTURAL STRENGTH EXERCISE

This exercise, characterized by extra-bold contours that evoke strength, shows you how to simplify your figures and make them appear rock solid. Allow ten to fifteen minutes to complete this exercise.

Recommended Materials
- black Cretacolor Art Chunky
- red earth Cretacolor Art Chunky
- Fabriano Eco-White drawing paper

Straight Contours, Cylindrical Shadows
Using the red earth Art Chunky on its side, do a full-page mass/gesture drawing that emphasizes, with implied shadows, the cylindrical character of the body's segments. Then, on top of this, using the tip of the black Art Chunky, firmly do an overlapping contour drawing, with all the contours reduced to straight lines. These straight-line contours simplify the structure of the three-dimensional forms and bring out their sculptural quality. Make sure the contours are freshly observed and independent of the underlying mass drawing. Finally, use your finger to pick up some tone off the black edges and blend in some unifying shadows that will further boost the structural solidity of the forms. The simplified warm tones of the red mass underdrawing will contrast with the thick, straight, black contour lines to create a stylized and compelling effect.

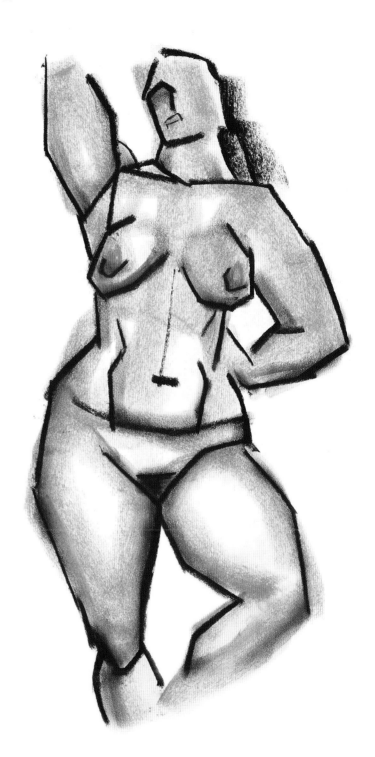

▲ Because the structural approach involves the simplification of forms, it inevitably leads to a stylized result.

DEMO > Structure Drawing with Conté Crayon

The hinged I is both a directional and structural concept. While integral to the structural approach, the hinged I is a basic observational tool that should be applied or implied in virtually all approaches. This demonstration shows how to ingrain the habit of incorporating this concept as a starting point in your practice by observing and recording the angles of the shoulders, spine, hips, and then appendages with bold underlying strokes.

1

2

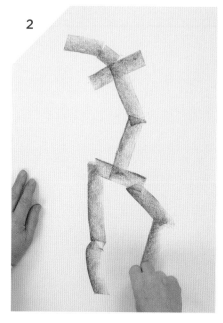

3

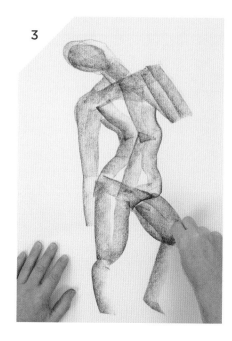

4

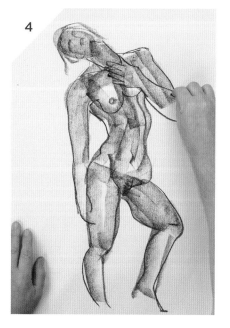

Step 1: Turning the Conté crayon on its side, I first put the angles of the hinged I down in broad, straight strokes. Note the strong contrapposto position.

Step 2: Having defined the basic position of the torso, I was able to start adding the appendages with confidence. More than any other consideration, at this stage I was interested in getting the angles right.

Step 3: Still using the crayon on its side, I massed in the large forms in a general way. Note that each form mass corresponded to the nuances and variations of actual body shapes, which mostly are tapered cylinders.

Step 4: Using the point of the crayon, I then added overlapping contours based on fresh observations of the figure. If you look closely around the edges, you can see many differences between the masses and the newly added contours. Note how the contours immediately take precedence over the mass in defining the figure.

Result: The details on the head established its direction and position. These marks indicate structure, cavities, and edges (not explicitly eyes, nose, and chin).

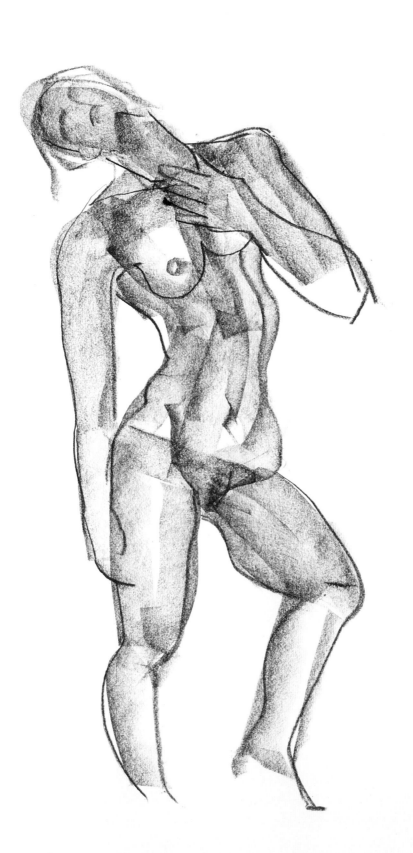

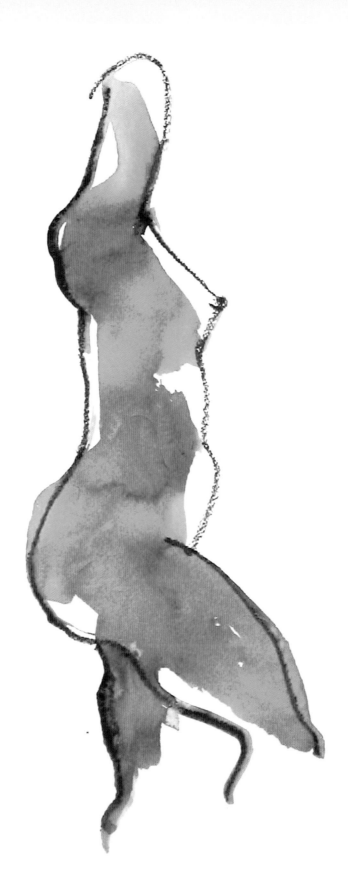

SHAPE

Think of the figure as a collection of shapes that can be seen and drawn both two-dimensionally and three-dimensionally. Take full advantage of the power of shape in your drawing by learning to alternate between these views.

Both in real life and on the page, shapes lead a double life. A real-life object can be seen three-dimensionally or imagined as being two-dimensional. Conversely, a shape on the page may be seen two-dimensionally or imagined as being three-dimensional. This concept is really the whole basis of the phenomenon of drawing.

When we draw the figure we reduce the three-dimensional shapes that we see into flat, two-dimensional shape equivalents on the page. To the eye these two-dimensional equivalents translate back into the appearance or suggestion of a three-dimensional object or shape. The fact that our mind does all of this for us is the miracle of drawing.

We tend to rely on outlines to convey our ideas about what we see. Real drawing strength, however, comes from being able use those outlines to create shapes that speak three-dimensionally. You want your shapes to imply planes and surfaces. You want your shapes to suggest volumes.

This switching back and forth between two and three dimensions also has importance in terms of the psychology of the viewer. Beginning in the Renaissance, artists began to understand the fact that the mind enjoys the two-dimensional abstract quality of a picture as well as the more concrete sensations of the suggestion of three-dimensionality. These artists understood that you could dramatize a picture by varying the size, shape, direction, and position of the various forms—that you could communicate a sense of excitement by composing the picture in terms of the layout and organization just as you would on a theatrical stage. Shapes establish direction and position. Their interactions convey energy and create a sense of movement in your composition. They have emotive power. So in composing your picture, try to see the energy and movement that your flat shapes (both negative and positive) create.

◀ *Attitude 68,* 2005, acrylic ink and water-soluble crayon on watercolor paper, 24 x 18 inches (61 x 45.7 cm), collection of the artist

THE LANGUAGE OF SHAPE

The word *shape* may refer to a flat area enclosed (or nearly enclosed) by lines or to a flat area of solid tone. Or it may refer to a three-dimensional mass or form. In this chapter we are primarily interested in understanding flat, two-dimensional shapes and their ability to appear three-dimensional on paper and thus convey the idea of the three-dimensional form of the figure.

Learning to draw the body involves learning the language of the shapes of the body. The most familiar and easy shapes for us to understand are simple, flat geometric shapes, such as rectangles, trapezoids, triangles, and semicircles. It is very useful to develop a vocabulary of flat shapes to go along with our three-dimensional structural ones. Drawing the figure with flat shapes is a matter of being able to visually divide the figure into manageable chunks and then record these chunks as flat shapes. Sometimes these shapes are determined by the natural divisions of the figure, such as where the neck joins the torso. In other instances, the shapes are determined by where the body segments are interrupted by other overlapping body segments. Being able to see the flat shapes is particularly helpful for solving foreshortening problems, which appear where body segments recede away from or project sharply toward the viewer.

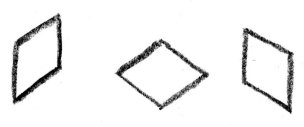

▲ By themselves, these three shapes may appear either two- or three-dimensional.

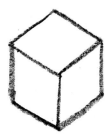

▲ However, when these same three shapes are connected, it is almost impossible to see them as anything but three-dimensional. This is because we tend to see combined flat shapes that remind us of three-dimensional objects as three-dimensional.

▶ This principle carries over to figure drawing. Notice how two (rough) pentagons when positioned side by side in the right figural context immediately suggest three-dimensional buttocks.

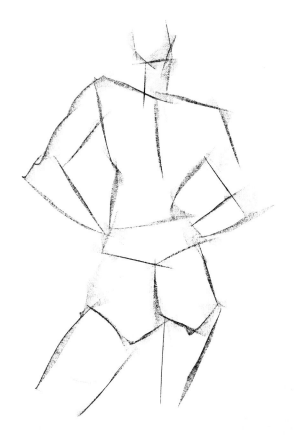

PART III: Drawing Concepts and Techniques

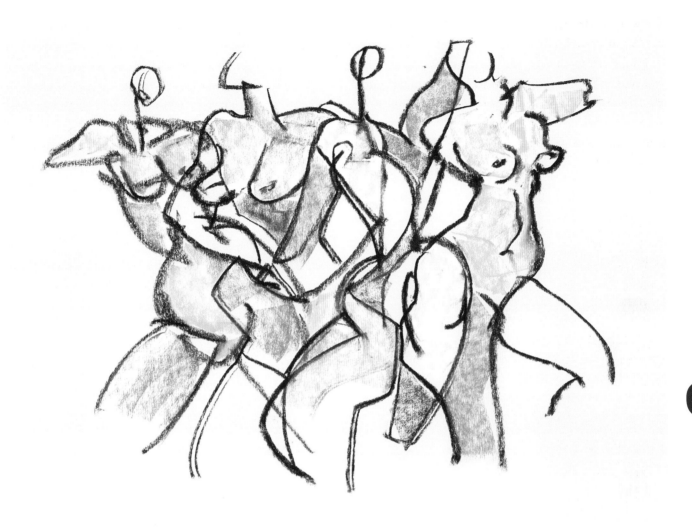

▲ *Nude Figures 35,* 2007, black chalk and pastel on paper, 18 x 24 inches
(45.7 x 61 cm), collection of the artist

To explore the abstract design possibilities inherent in body shapes, four
consecutive poses were drawn so they intersected. The resulting incidental
shapes were then brought out with colors to make a lively abstraction.

SHAPE CONSCIOUSNESS

Seeing, understanding, and drawing three-dimensional shapes boils down to being able to simplify the shapes and see them as if they were flat. This "shape consciousness" is key to drawing success. When you are able to draw with a keen sense of shape consciousness, you are getting "in the zone."

Seeing shapes is the basic way we understand what we see. Shapes are the basis of our visual perception. When we read, we understand what we read by interpreting the small shapes of the letters. Likewise, we see and understand our physical world in terms of shapes. Shapes have primitive suggestive power. This is why a mannequin or a clothes tree in a darkened room can be so shocking and menacing. Shape is emotionally suggestive. Different types of shapes suggest different types of emotions. A sharply pointed shape may suggest aggression, while a softly rounded shape may be inviting and even cuddly.

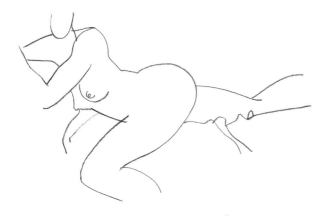

▲ *Nude Study 27,* 2007, Conté crayon on paper, 18 x 24 inches (45.7 x 61 cm), collection of the artist

The highly defined shapes and the overlapping contours in this drawing combine to provide recognizable cues, which create the illusion of volume. Notice, too, that the figure's position and size on the page incorporate the shapes of the surrounding space to clearly indicate a foreground, middle ground, and background. This enhances the impression of three dimensions.

Big Shapes

It is of the utmost importance to learn to see and draw the big shapes of the figure. This is a necessity. When studying a model, always say to yourself, "Big shapes first, then little shapes." Locating the big shapes enables you to place the small ones where they belong. Also, the big shapes can help you establish your composition and relate the figure to your page. As you do this, remember that drawing a positive shape always creates accompanying negative space shapes.

Pieces of the Puzzle

Although it is helpful to see the overall or general shape of the pose, it is also crucial not to think of the body as being just a single shape. Starting out with one overall shape and then adding the details inside limits your drawing from the outset and will most likely produce shapes that are static. This is because, as mentioned earlier, shapes are emotive and they interact. You need to massage your shapes in a flexible manner—exaggerating here, underemphasizing there—to bring out their best qualities and make them speak.

To do this, it is helpful to think of the body as being a collection of shapes. Seeing these relationships and understanding them is the key. The shapes relate to each other intelligently like pieces in a puzzle. Try to understand the way these shapes interweave, overlap, and fit together. Remember there are two ways to see, conceive of, and interpret shape: first, as three-dimensional structures existing and interacting in space, and second, as flat shapes adjacent to one another on an imaginary two-dimensional visual plane. Acquiring these two skills will help you immensely in your quest to master the figure.

[PLAYING WITH DIMENSIONALITY]

Modernist artists in the early twentieth century began to play with the two-dimensional/three-dimensional paradigm in a new way. Not only did many of them make two-dimensional designs out of their pictures, but some would deliberately alternate in a single picture between elements that provided both three-dimensional shape cues and two-dimensional shape cues.

Sometimes these artists would emphasize one kind of cue more than the other. Sometimes they made pictures or areas of their pictures that were somewhere in between. Sometimes they created deliberately ambiguous volumes, allowing the surrounding space to be relatively shallow.

This sense of dimensionality is fun to play around with. It toys with your perceptions. It's like spicy food. Some people find it disorienting, while many others find it stimulating and enjoyable.

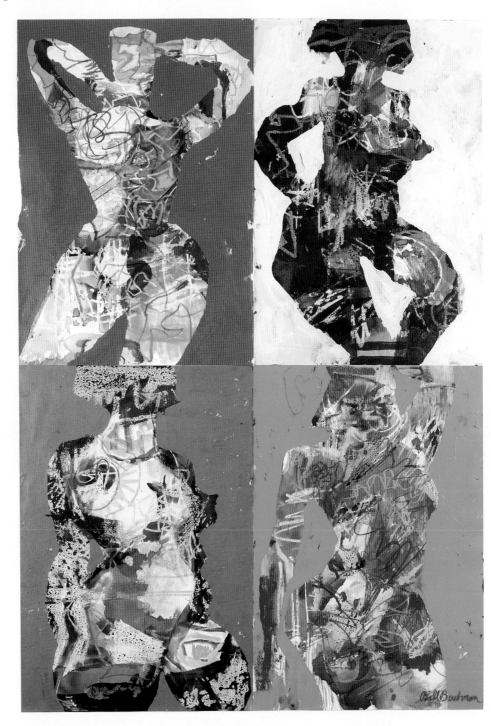

▲ *Nude Dimensions I,* 2005, watercolor, acrylic, and oil pastel on watercolor paper, 48 x 36 inches (121.9 x 91.4 cm), collection of Scott Osborne and Jeffrey Schwartz

Notice in this image how some areas appear more three-dimensional and some less so—and that this switches back and forth. The contrasting backgrounds are nearly flat. This keeps the picture space shallow and the eye close to the surface, where it can experience the abstract interplay of color and form.

BIG SHAPES EXERCISE

The body is a collection of shapes. Distilling the big shapes into familiar geometric ones will teach you how to see and draw the big shapes, which is fundamental to being able to draw the figure. Allow yourself two minutes to render each of four poses.

Recommended Materials
- black Cretacolor pastel chalk or Conté crayon 2B
- Canson Biggie Sketch pad

Simplified, Overlapping Shapes

It is easiest to learn how to capture the big shapes when drawing in a smaller format. And reducing the big shapes into simplified geometric shapes is a great way to solve tricky poses, such as convoluted, reclining, and semireclining ones. This exercise combines both learning goals in a rapid technique. The model should assume four consecutive semireclining (or other complicated) poses, allowing more than just the feet to touch the floor.

Turn the chalk on its side so that you are drawing with its long edge. By changing the angle of the chalk as you draw, you can create a variety of interesting strokes. Rather than drawing the body parts, try to see and record the interesting geometric shapes these poses suggest. Let the shapes create the figure and the pose for you. Drawing is a simplification process. This process can lead to interesting, abstract results, which can be the basis for all kinds of paintings, sculptures, and so forth.

▼ Concentrating on rendering the pose with simple, geometric shapes is a good way to solve particularly difficult poses.

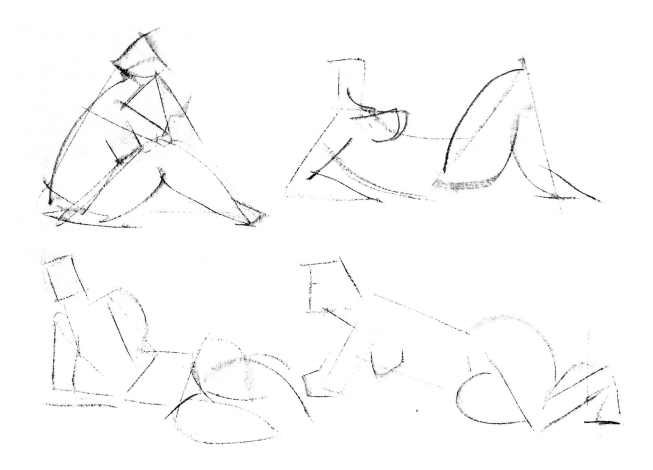

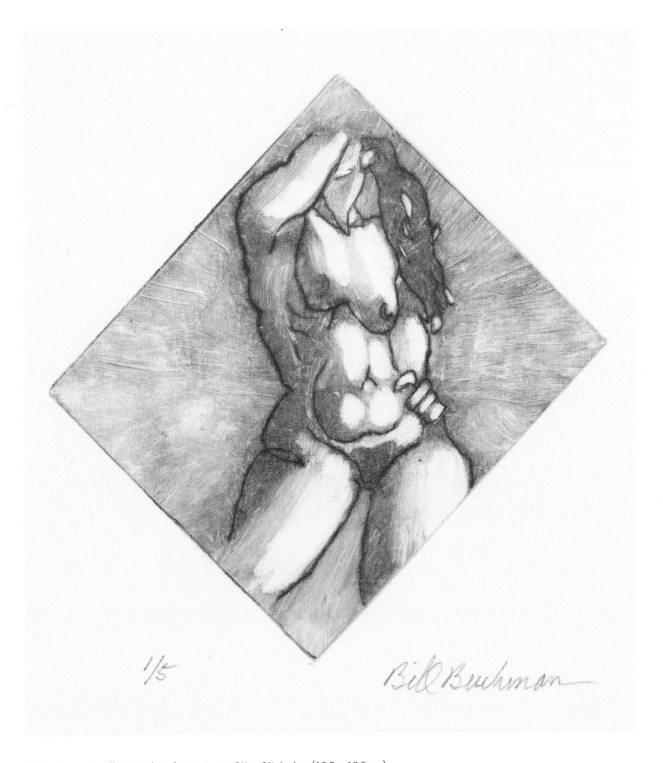

1/5 Bill Buchman

▲ *Contrapposto II,* 1995, drypoint on paper, 6½ x 6½ inches (16.5 x 16.5 cm), collection of the artist

Shapes that echo one another reinforce each another's tendencies. Shapes that contrast and counteract each other create energy and tension. This is the basis of the Renaissance concept known as *contrapposto* in which the upper and lower parts of the body are turned in opposite directions. This opposing of forms gives the torso a sense of swing and power. This dynamism carries over into the contrasting shapes and directions of the arms, legs, and head as well.

ABSTRACT SHAPES EXERCISE

In daily life we think with words, but when drawing we want to be able to think with shapes. Working from a live pose, try to represent the muscles, limbs, and other body parts using only rectangles, triangles, semicircles, or any combination of shapes. This exercise will help you to explore and develop the essential skill of thinking with shapes. Allow yourself five to ten minutes to render each drawing, and draw the same pose using different shapes.

Recommended Materials
- black Cretacolor pastel chalk or Conté crayon 2B
- Canson Biggie Sketch pad

Rectangular Shapes
Representing the figure with a collection of rectangles (including squares) is a process of trial and error. This approach is much like the mass exercise on page 76, where you pile marks wherever you sense the masses are located. Here you pile rectangles. Don't be disappointed with your first attempt. With practice, you can develop quite a bit of control over this fun, experimental process.

Triangular Shapes
Now repeat the same process using triangles. You may wish to use a few rectangles. Even though these two drawings are of the same pose, notice the different feeling each one conveys. Triangles send a distinctly different message than rectangles. How would you describe that difference?

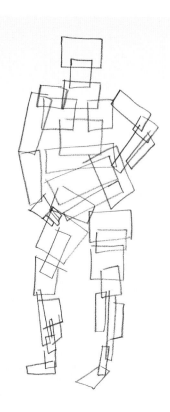

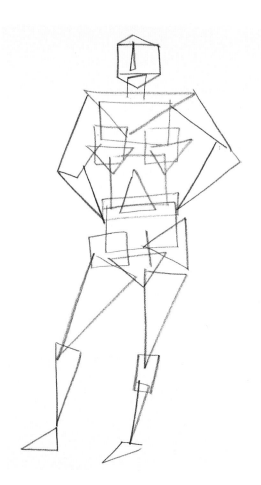

▲ The directional angles of the spine, shoulders, and hips as well as the axes of the other body segments determine the placement of the rectangles. This enables the weight distribution of the figure to be convincing.

▲ Representing the figure with triangles is more challenging because the triangles (with their three acute angles) do not resemble very many body parts. Therefore, you might want to include at least a few rectangles to make the image work.

SUMI SHAPES EXERCISE

This exercise is worth practicing a great deal, as it simultaneously teaches brush control and sensitivity, hand control, how to make committed individual strokes, size and position control, ink control, awareness of the significant lines, sense of mass, and how to simplify forms. It also develops confidence. Before you start, dilute the Sumi ink slightly with water so that it is ever so slightly transparent and not sticky. Allow yourself five or six minutes to render each pose.

Recommended Materials
- Sumi brush with a 2-inch head
- Sumi ink
- Canson Biggie Sketch pad

Thick Strokes, Big Shapes
Start with a U-shaped stroke for the head that runs off the top of the page. Make the figure big enough so the legs will run off the bottom of the page. As you work, press the brush down against the paper to give a thick stroke (except in detailed areas, such as the fingers, which demand a thinner stroke). Delineate each form segment by a single well-shaped stroke. Ink concentrations and width variations will naturally vary.

The big shapes of the figure will emerge when this procedure is followed with no preliminary underdrawing. The idea is to observe and record the most fundamental contours of the figure, paying particular attention to which form is in front of the other. At the same time, keep careful track of and leave room for what is still to come. As you work, feel the masses that your lines are defining and make the mass shapes roomy enough to accommodate the forms. These are your big shapes.

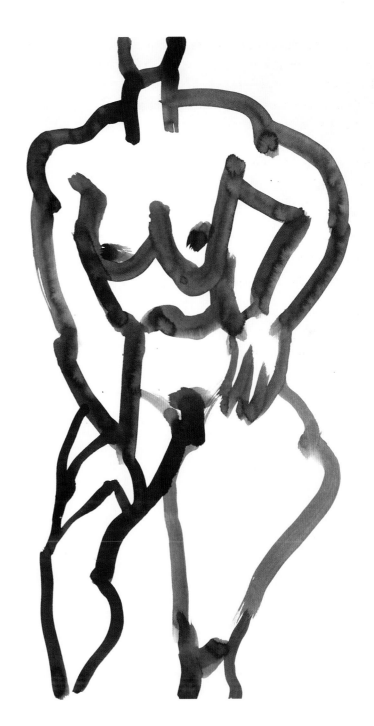

▲ I first encountered this technique many years ago in Robert Kaupelis's *Learning to Draw* and later noticed drawings by Matisse and also by certain German Expressionists done with a similar approach. This is still one of the most powerful and fundamental exercises I know.

DEMO > Capturing the Big Shapes with Charcoal

The drawing implement was a broken piece of Cretacolor Art Chunky charcoal. Using the side of the chalk meant that I couldn't render details. Rather, I concentrated on making one or two strokes for each body segment, reducing each form to a nearly geometric equivalent. The key (as with all drawing strategies) was to remain consistent in approach from start to finish.

1

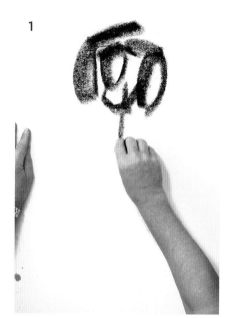

2

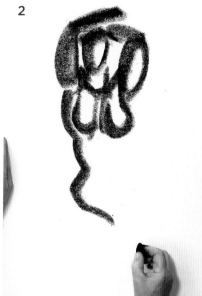

3

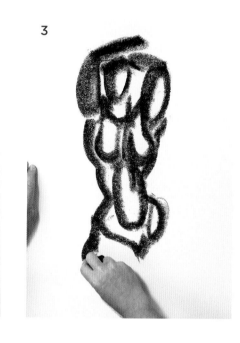

4

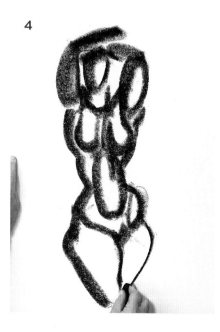

Step 1: The arms and head seemed to be the key to this pose, so I chose to work my way down from the top. I often start with the area I feel most sure of, because if I get that right I have something upon which I can build the rest of the drawing.

Step 2: With a single move, I put in a contour line that described the position of the rib cage and upper and lower abdomen. I have trained myself to commit to risky lines that may or may not work out. In this case, it's "so far so good."

Step 3: The invisible axis of the ellipse that describes the abdomen leaned to the left (in contrasts with the shoulders, which leaned to the right). I am already planning for the hips, which will be tilted to the left on the same line as the abdomen.

Step 4: Artists tend to underestimate the significant differences in proportions found along the length of the torso. To avoid this, I made sure that the shoulders and hips were significantly wider than the waist. This gave the figure a dynamic feel.

Result: I was thinking about shape and contour as I made bold strokes, defining each form as simply as possible. The thickness of the lines held the drawing in between the representational and the abstract.

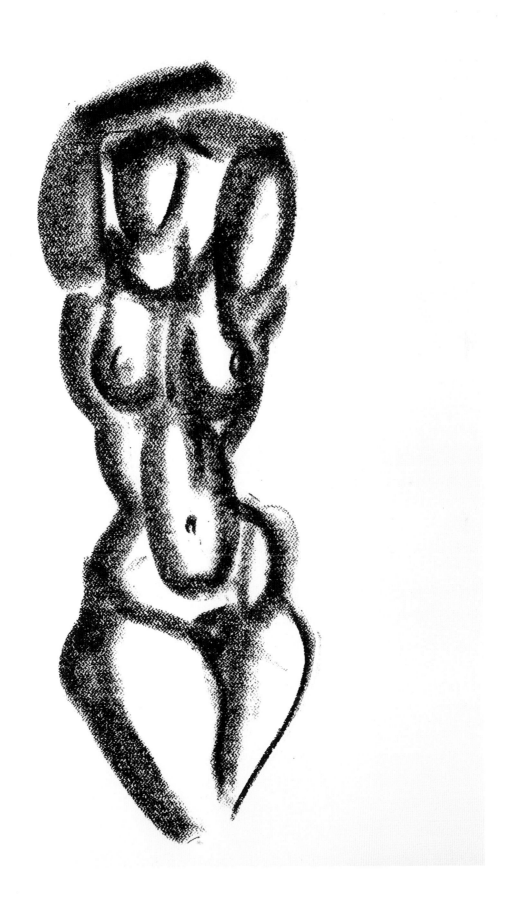

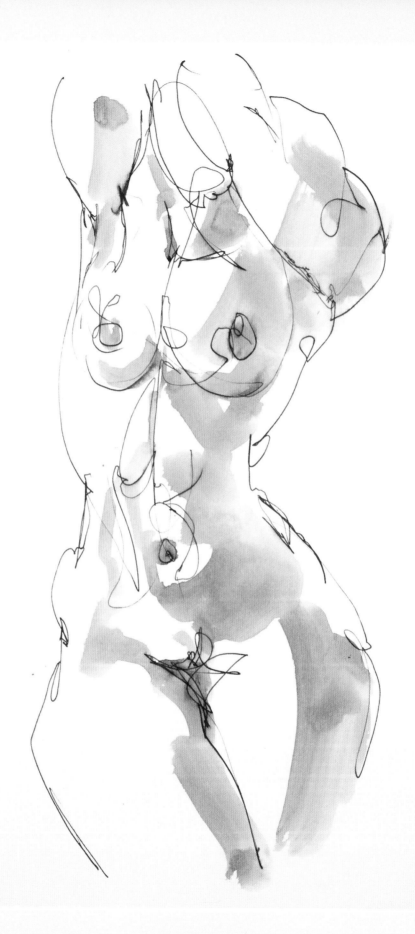

VOLUME

Making things look round and creating depth is one of the great pleasures of the drawing process. When done well, it is also one of the things that is most appreciated by the viewer.

When the sense of volume is successfully conveyed in a drawing, it creates the impression that the forms rendered actually do exist in space. The words *depth* and *roundness* are also used to describe this same phenomenon in drawings.

As discussed in earlier chapters, the illusion of volume in space can be created by simply using overlapping contours or by juxtaposing suggestive flat shapes. Alternatively, volume may be effectively produced by describing elements of texture and surface through the manipulation of shading, colors, and surface contours. In addition, for the three-dimensional impression of the figure on the page to be convincing, appear solid, and have weight, it must have good directional angles. In short, many drawing principles and procedures can produce the appearance of three-dimensionality. Each is a type of perspective device. These perspective methods take advantage of the principles of optics and perceptual psychology to work their magic.

When a figure drawing makes us believe that its subject exists in space, it is the result of a successful use of either a single principle or a combination of principles.

When a drawing fails to convince us in this regard, it is because it violates or ignores these principles.

It is worth noting that the expressive success of a figure drawing (or any artwork) is not necessarily dependent on conveying volume and depth. Indeed, countless successful works make their expressive case in other ways. Still and all, there is no question that the methods for conveying three dimensions, when used effectively, have been and always will be wonderful tools with great power to engage and charm the viewer.

◀ *Study for Figure in Blue and Figure in Red Earth,* 1993, pen and acrylic wash on paper, 18 x 12 inches (45.7 x 30.5 cm), collection of the artist

PERSPECTIVE DEVICES

The principles of perspective are essentially a collection of different ways to fool the eye into imagining it is seeing a three-dimensional object on a two-dimensional surface. These principles enable us to suggest the appearance of something solid as seen from a particular point of view. They fall into two basic categories—linear devices and tonal devices.

Used alone, any one of the following methods of creating depth can be quite effective. Alternatively, they can be used in various combinations. However, the mind's ability to complete the illusion means we don't have to use them all—or even very many. Depth can be suggested successfully with only partial indications and clues. In fact, using too many perspective cues and devices in a single drawing will frequently produce a stilted look.

Linear Positioning Devices

The following perspective techniques can help you to make your figure appear three-dimensional. All rely on line alone.

Overlapping Contours

Overlapping is all about what is in front and what is behind. This principle is based on the fact that when we see one line cut off by another line, our mind assumes that the cut-off line continues on unseen behind the other line.

See-Through Lines

When parts of the body (or any object) are out of view, they may be drawn in or partially indicated as they would appear if you had X-ray vision or if your subject were transparent.

Surface Contours

Surface contours are imaginary lines or indicator lines that travel across the surface to show changes along that surface. They are also sometimes referred to as *cross-contours*. These lines may also be used to construct shadows. This process is called *hatching*. Shadows

made of contour lines then have a double function: They convey information about the directional flow of the surface as well as its illumination. Surface contour lines in different directions may be superimposed on one another to create shadows that imply multiple directions of surface flow. This is the technique known as cross-hatching.

Foreshortening

Foreshortening is a perspective phenomenon whereby the shapes and contours of body segments (or any other objects) appear dramatically altered when they recede away from or project toward the viewer. As discussed in chapter 7, the figure is made of forms that are fundamentally similar to simple geometric solids. Doing freehand line drawings of wooden children's blocks (cylinders, spheres, cubes, and so forth) positioned at various angles is useful in understanding and solving the principles of foreshortening. This process, which is

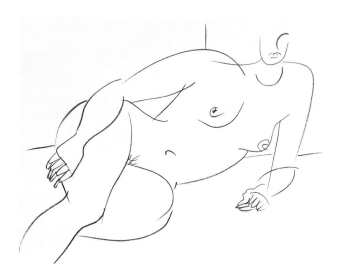

▲ *Commitment,* 2004, Conté crayon on paper, 18 x 24 inches (45.7 x 61 cm), collection of the artist

This drawing was created using lightning-fast fluid lines that overlap or intersect to create a sense of depth. Most important, the body forms are foreshortened. This, combined with the secondary spatial cues provided by the wall and floor indications behind the figure, produces a distinct foreground, middle ground, and background.

a form of structural drawing, may include see-through lines. It can help you to see and think three-dimensionally—and to be aware that what you are looking at has a front, back, top, bottom, and sides.

Adjacent Flat Shapes

As we have seen, lines describing multiple flat shapes can be combined to suggest depth. Seeing and recording the flat shapes of a figure that are visible supplies spatial and associative cues that are effective in implying depth. This method is also highly useful for solving foreshortening problems.

Converging Lines

When drawing the figure, one-, two-, and three-point perspective (which are more commonly associated with landscape and architecture drawing) can be simulated.

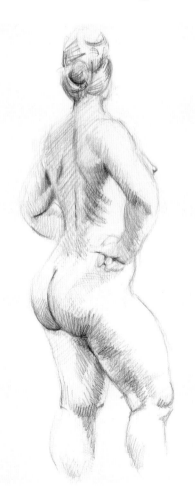

By exaggerating the convergence of receding parallel lines that are based on an imaginary vanishing point, you can create an enhanced sense of scale.

Secondary Spatial Cues

A foreground, middle ground, and background can be implied simply by placing the figure in relation to other objects. The single presence of lines indicating the corner of a stool, the edge of a couch, or a piece of drapery that overlaps or is overlapped by the figure introduces an emphatic spatial cue. In addition, the presence of lines that suggest simple objects, both in front and behind the figure, will accentuate the illusion of depth even more.

Tonal Positioning Devices

Alternatively, you can create the appearance of depth and roundness by modeling with tone. Gradations of value not only simulate the effects of light on a surface but also indicate the topography of the surface. As such, gradually modulating shadows indicate gradual surface changes. Shadows that modulate more quickly indicate a more sharply curving surface. Shadows that stop abruptly indicate an abrupt change of direction of the surface that forms an edge.

Simulating surface changes such as these creates the illusion of solidity. This is undoubtedly one of the most persuasive ways to create a sense of depth, and there are unlimited ways and materials for accomplishing this. These ideas are discussed in greater detail on the pages that immediately follow.

◀ *Nude Study 2,* 1991, colored pencil on paper, 24 x 18 inches (61 x 45.7 cm), collection of the artist

The areas of this drawing that convey the most convincing sense of volume are those that mimic the shading effects of spheres and cylinders—specifically the buttocks, upper arms, lower abdomen, rib cage area, and legs.

CHIAROSCURO

Light is the medium of sight. The body is a collection of shapes whose forms are revealed by this light. There is logic to how this process takes place. We learn how that logic plays out by observing and recording the locations and variations of light and shadow on the individual forms of the figure.

The traditional name for the use of light and dark in art is *chiaroscuro*. When done well, the subtle modeling of the subject gives the viewer a sense for the volume of the figure and the surrounding space. This approach was developed to great heights in the Renaissance and then carried to dramatic extremes in the Baroque period.

▼ *Blue Nude Mood*, 1992, pastel pencil and white chalk on paper, 16½ x 23½ inches (41.9 x 60 cm), collection of Rose Scott

Starting with a freely painted toned ground on your paper, you can achieve great subtlety of modeling quite easily by adding both shadows and highlights to your figure.

Executing a figure using traditional chiaroscuro takes time. The drawing that appears below was begun with some loose strokes of gold acrylic ink. Once dry, a wash of various blue and blue-green acrylic inks with some unblended strokes of opaque white was added. This provided the background upon which I could build the drawing. With this layer bone dry, I built up the figure with pastel pencils in a variety of blue shades, working from light to dark. Right from the beginning, I placed the figure on the page so that it incorporated some of the incidental tones of the background as darks and lights. In most areas of this chiaroscuro study, the blue-green underpainting functions as the mid-tone. I used a white pastel pencil to render the highlights, an ultramarine pencil for the shadows, and a red-violet pencil for the warm accents. The overall chiaroscuro effect creates a definite mood. The central diagonal swath of gold acrylic, although done in an early layer of the prepared ground, shows through in the final work as an intriguing and surprising counterpoint.

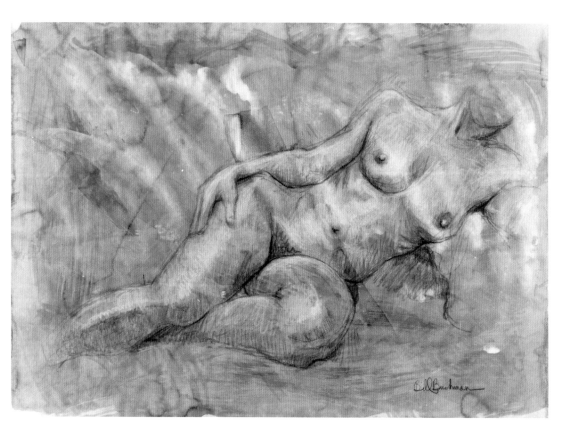

[CAPTURING LIGHTS AND SHADOWS EFFECTIVELY]

Expressive figure drawing techniques do not necessarily have to be quick, but they tend to be. In most situations, when an artist is drawing the figure from life, there are time limits of various kinds. In particular, the model's stamina and shifting daylight can call for capturing the gesture and the light relatively quickly.

As we have seen on the preceding pages, many drawing techniques can be used to reveal the dimensionality of form splendidly without resorting to tonal effects at all. Nevertheless, light and shade effects are dramatic tools—so in the interest of pursuing our expressive goal, we need to have ways to capture and indicate our lights and darks light relatively quickly. Here are some thoughts and ideas to help to you with the mysteries of tonality:

- The body can be seen and drawn as a collection of illuminated and shaded shapes.
- Shadows reveal the form of the object/figure according to the direction of the light.
- The transitions between light and dark follow along the body's surface and reveal the undulations of the form. They provide topographical indications of the subtleties of the surfaces.
- The transition from light to dark on the body's rounded surface is gradual when the surface gently bends away from the light.
- The transition from light to dark on the body's rounded surface is more sudden as the surface is more sharply curved and bends away more quickly from the light.
- Where there is an abrupt shift of planes on the surface (creating an edge), there will be an abrupt shift along the sharp line that divides the two surfaces.
- Shadows have shapes, called *value shapes*. If you want to see them more clearly, squint your eyes.
- The shadows or value shapes on the human body tend to be generally semicircular or rectangular. Why? It's because body forms are generally cylindrical or composed of spherical bulges and indentations. Notice how these forms flow together and connect.

- Because these cylindrical and spherical body forms are irregular, the semicircular and rectangular value shapes are irregular. They are uneven. They expand and contract as they follow the forms. They taper.
- Many figure drawing environments feature several light sources—overhead lights, windows, skylights, spotlights, and so forth. In your drawing, always decide on one predominant light source direction and emphasize the shadows that support that view. (Earlier we spoke of finding the significant lines; the concept of significant shadows is also important.)
- The inherent color of an object is known as the local color. When the local color is particularly dark, it needs to be accounted for in your rendering of values. When making a monochromatic drawing, the simple rule is: the darker the local color of one's subject, the darker the illuminated areas and shadows both need to be.
- With expressive drawing techniques, the idea is that the light and shade—like line, mass, proportion, direction, and so forth—are part of your expressive arsenal. Ultimately, you may use modeling effects as you see fit.
- Always simplify. Look for the most defining shadows. Try to use them for emphasis. Chiaroscuro, used well, heightens and intensifies the emotive power and psychological mood of your drawing and, of course, creates a sense of volume.
- Beware! When you add shading at a later stage to a successful line drawing, it can overwhelm and destroy the line qualities.

[PLAYING WITH VOLUME AND PERSPECTIVE]

On pages 124 and 125 we discussed various traditional methods (some of which date to the Renaissance) that can be utilized to indicate volume in drawing. These are, of course, not the only approaches. For example, the Cubists came up with many innovative ways to play with volume and the perspective of the figure. Their most common device was to reduce forms to basic geometric shapes. However, they also sometimes completely flattened forms, showed parts of the same body as seen from different angles (including from behind), deliberately twisted and bent forms, inverted volumes by making bulges into cavities, and generally subverted expectations.

Most of these developments were made by Picasso and Braque, from ideas first implied in the works of Cézanne.

These devices were based on a sophisticated knowledge of how form is revealed. Nevertheless, these entertaining and visually fascinating activities were frequently misjudged and misunderstood by the general public. This is still true a century later.

▼ *Nude Figures 24,* 2008, black chalk on paper, 18 x 21 inches (45.7 x 53.3 cm), collection of the artist

These two drawings of the same pose utilize a dramatic trick developed by Picasso. The dimensionality and structure of the figures are established by the clear overlapping of forms. However, the actual mass of the forms is distorted by the startling spacing and angles of the contours, which, in some instances, deliberately defy reality. Examine the individual lines in each version. Using these imaginatively makes the figures speak with a stage voice.

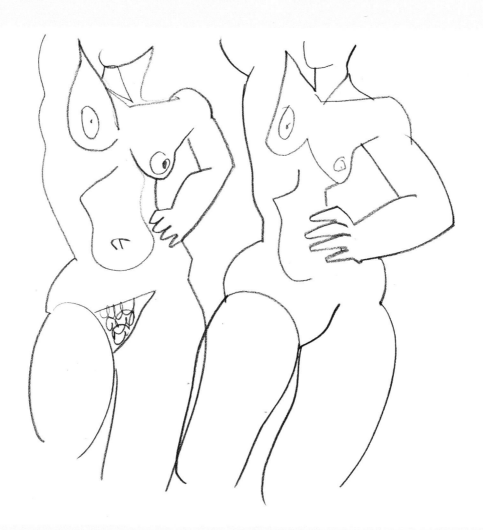

OVERLAPPING CONTOURS EXERCISE

For this exercise, observe and record only what is in front and what is behind. This drawing strategy will help you achieve dimensionality in your renderings. Do two matched figures to a page and allow four to five minutes for each drawing.

Recommended Materials
• black Cretacolor pastel chalk or Conté crayon 2B
• Canson Biggie Sketch pad

Enclosed Mass
The basic idea behind doing a line drawing based on overlapping is to see which body section is on top of or in front of which. As you draw each line, make sure to leave room for the next overlapping line, taking care to connect each line to the line that cuts it off. The process is like weaving.

Feel the mass that your line encloses as you carefully record each fluid contour stroke. This process will make your lines persuasive and your figure solid. The roundness of the forms will be articulated by the way the overlapping lines enclose the white space.

▼ Each of these two drawings contains a line that is a false start. These lines, left as they are, do not hinder the overall effectiveness of the drawings.

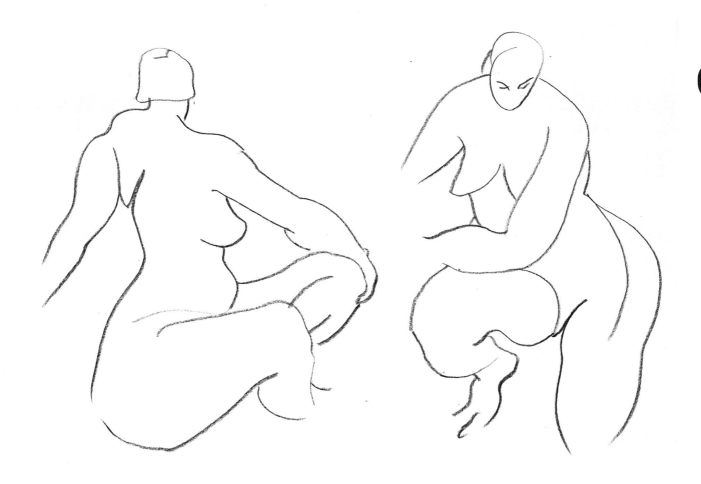

[CREATING CONVINCING SHADOWS]

The laws that govern light and shade may be learned by direct observation of the figure. The most basic law is this: Light and shadow follow the form. A good place to begin learning more precisely how these principles operate is to study simpler forms, such as spheres, cylinders, cones, and cubes. A systematic exploration of techniques for rendering shadows, highlights, and so forth, while outside our focus here, is also indispensable. However, by simply applying the selective-seeing technique to the shadow shapes, you can create convincing shadows with two simple methods.

One method uses the Sumi brush with thin transparent washes of acrylic ink. The essence of the technique is to become sensitive—first to the proportion of ink to water to get the right transparency, and second to the shape and edges of the brush to control the shadow's shape.

The other method is with Conté crayon, chalk, or anything else that comes in a stick. You break the stick in half, turn it on its side, and use it like a wide brush. To vary the breadth of your stroke, twist it relative to the direction in which you are moving it. To vary the darkness or lightness of your stroke, press harder or less hard on the stick.

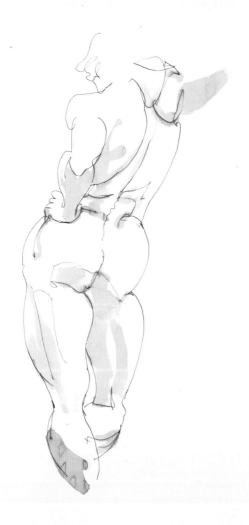

▲ *Male Nude 11,* 1987, pen and wash on paper, 24 x 18 inches (61 x 45.7 cm), collection of the artist

When shaping your strokes and rendering shadows with a Sumi brush, push the brush into the paper to widen the brush head and pull it back to narrow it.

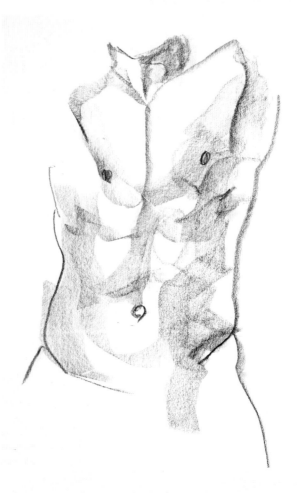

▲ *Shadow Study,* 2002, Conté crayon on paper, 24 x 18 inches (61 x 45.7 cm), collection of the artist

Varying the thickness and pressure of the strokes of the Conté crayon on its side creates convincing shadows out of abstract shadow shapes.

CYLINDRICAL FORMS EXERCISE

As discussed on pages 98 to 101, more sections of the human body resemble the cylinder than any other geometrical shape. Therefore, being able to render this form successfully goes a long way toward being able to create roundness and depth in figure drawing. This exercise, which requires the model to strike a frontal pose, will help you establish realistic volume in your figures. Allow three to five minutes to draw each pose.

Recommended Materials
- black Cretacolor pastel chalk or Conté crayon 2B
- Canson Biggie Sketch pad

Cylinders in Profile
Most views of the figure present cylinders as seen from the side, and it is this view of the cylinder and its shading we are going to take advantage of in this exercise. Therefore, the model needs to be viewed straight on, more or less full figure.

Observing the live model, turn the crayon on its flat side and make vigorous and rhythmic strokes to quickly create the shadow shapes that express the cylindrical nature of each of the main body segments. The angle at which you hold your crayon as you move it will determine how wide or narrow the stroke is. Varying the pressure will enable you to produce tonal variations as you go. As you carve out the shadows, the edge of your crayon will be describing the contours as well. Add a few contour lines with the point of your crayon where needed to further define the pose.

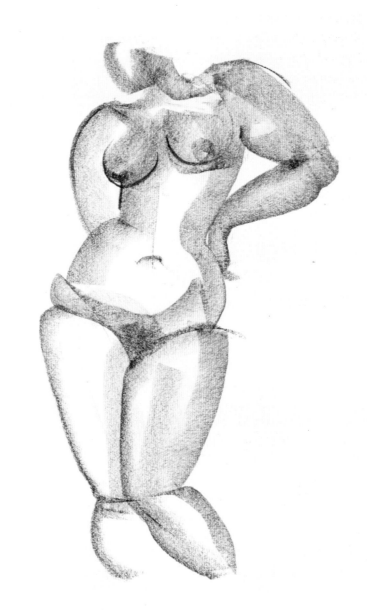

▲ The flat side of the crayon can create contours and shadows at the same time. Can you identify the shadows that imply ellipses in this drawing?

SHAPED SHADOWS EXERCISE

The values within shadows are not uniform. They get darker as the surface turns farther away from the light source. In addition, light from multiple sources will cause shadows to be darker where they overlap. The longer you look at shadows the more nuances you will detect. Nonetheless, the most important thing to recognize when drawing shadows is that they have visible overall shapes. This exercise will help you to see them. Allow ten to fifteen minutes to render the figure.

Recommended Materials
- black Cretacolor pastel chalk or Conté crayon 2B
- Canson Biggie Sketch pad

Shape Consciousness
Observe the model and try to visualize the shadows as flat shapes. Lightly draw in the general outlines of the shapes first, and then fill them in with a medium tone. And finally, add a few darker shadow shapes and nuances. As you work, note that the illuminated surfaces also have shapes.

Focusing on the general shadow outlines directs your attention to where and how the surface planes meet and diverge. Becoming conscious of the shapes of the lights and shadows will help you to understand what the surfaces of the forms are actually doing in a way that just toning in the surface as you go will not.

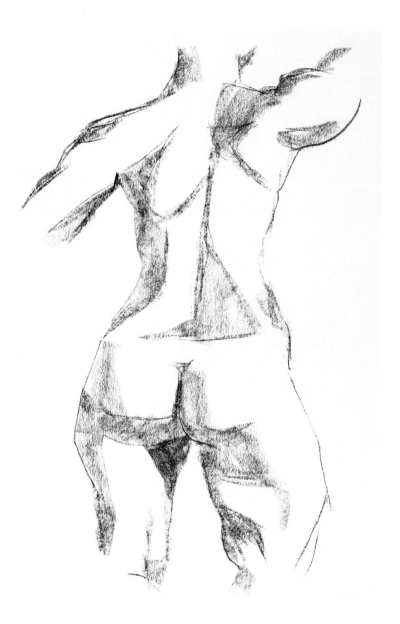

▲ Being able to see the flat shadows shapes makes the figure round. It helps to squint.

SHADOWS AND MASS EXERCISE

This exercise—which should utilize at least five distinct levels of value, from the white of the page to the darkest dark—explores subtle ways of building tone. The resulting drawing should be fairly three-dimensional in appearance. Each figure study requires fifteen to twenty minutes.

Recommended Materials
- Conté crayon 2B
- Canson Biggie Sketch pad

Subtle Tone
Use the Conté crayon flat on its side to block in the masses. Feeling and mimicking the cylindrical and spherical volumes as you draw, establish a sense of roundness and shading right from the start. Let your movements follow the surface contours. Make sure to leave a few of the most highlighted areas untouched.

Next, add contours with the point of the crayon, capturing every nuance and exaggerating the bumps and hollows. This will heighten the three-dimensional implications of your line. These contours, because they are freshly observed, may create subtle and pronounced alterations that override the edges of some of the masses. Finally, with the crayon again on its flat side, carefully deepen the shadows one layer at a time, creating additional depth and bringing out the structure.

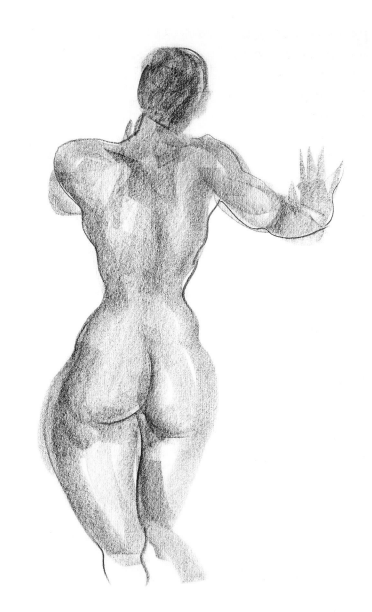

▲ This drawing (which features a dark-skinned model) explores subtle aspects of building tone when local color plays an important role. Notice that the illuminated areas are dark and the shadows even darker. The lightest areas suggest reflections that are characteristically more perceptible on darker than on lighter skin.

[WORKING WITH TONED PAPER]

Most drawing techniques use the color of the paper to represent the light areas of the drawing. The idea is to create tonal variation by adding degrees of shadow with darker media. Using the blank paper as the lightest light allows for a quick drawing process.

Working with toned paper offers other possibilities. For instance, in the image below you can see that doing a simple pen-and-wash drawing on a sheet of toned paper immediately creates a sense of atmosphere and mood. The brownish-gray paper shows through the blue washes, warming them up and making their appearance muted and subtle. In this image, the fountain pen lines were drawn first with water-soluble India ink. Then the shadows were

brushed in with acrylic wash. At this point, some of the pen lines bled into the wash, darkening some shadows and lines and adding gray tones to the blue. Note that the figure and background harmonize together as an overall image on the toned paper in a noticeably gentler way than they would if they were presented on a white background (such as the image on page 128).

▼ *Nude Figures 22,* 1999, pen and acrylic wash on gray paper, 13 x 19 inches (33 x 48.3 cm), collection of the artist

Unlike the image on the facing page, also done on toned paper, this image does not employ added highlights. To do so would break the subdued mood of the drawing.

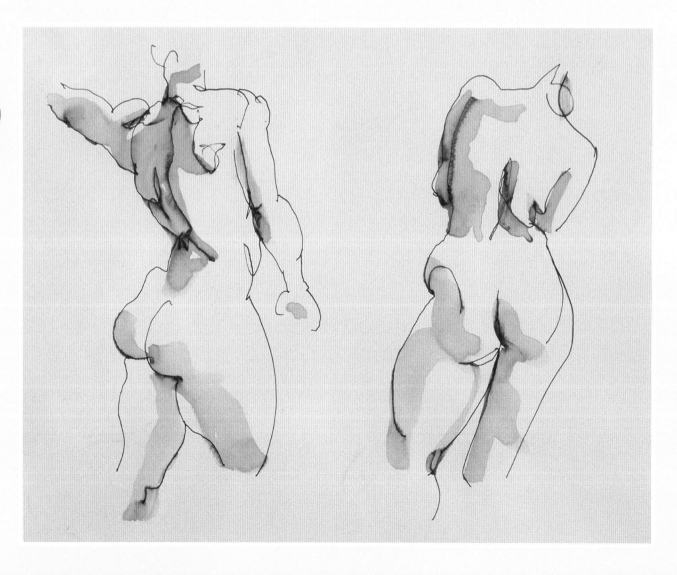

HIGHLIGHTS AND SHADOWS EXERCISE

Rendering volume realistically through careful observation is not the only way to use shadows and lights on the figure. This exercise—which features dark and light media on a medium-toned page—encourages you to add shadow and lights in a freely interpretative manner. You will be surprised at how much you can take from this and use in your carefully modeled drawing endeavors. Each figure study requires five to seven minutes.

Recommended Materials
- black Cretacolor Art Chunky
- white Cretacolor Art Chunky
- toned acid-free recycled paper, 30 x 40 inches (76.2 x 101.6 cm)

Highlights and Shadows

The model should strike three consecutive energetic poses. This type of pose is difficult to hold, so you must capture them quickly. While the model is in front of you, create continuous-line gesture drawings and make mental notes of the main highlights and shadows. Be careful to match the sizes of each of the three drawings and the page.

Once the model session is over, add highlights and shadows very roughly, following the logic of the forms. The idea is to be loose and achieve a somewhat arbitrary and abstract result. Feel free to use your fingers to spread some of the black from the contour lines into other areas to create a few additional defining shadows. Don't worry about lack of accuracy. This will give the drawing its excitement.

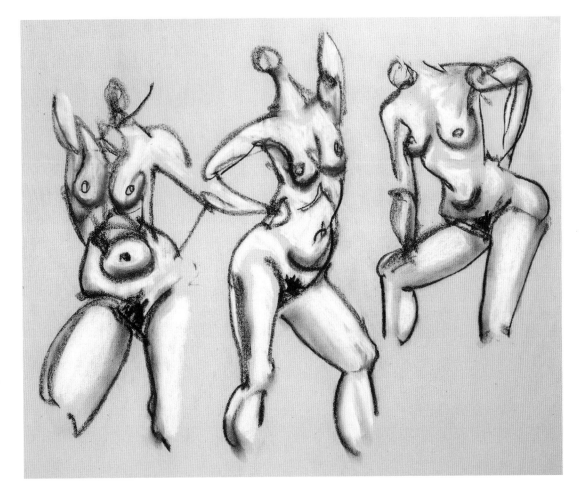

◄ Toned paper is a forgiving drawing environment, as the process of modeling is much easier when you can add both shadows and highlights to a mid-tone.

DEMO > Combined-Techniques Drawing with Conté Crayon

Sometimes I like to build the figure with a combination of fundamental elements. With this image I started with the Conté crayon on its side, drawing contours that described edges at the same time that they indicated mass and shadows. Right from the beginning of the process, I was also defining both structure and direction.

1

2

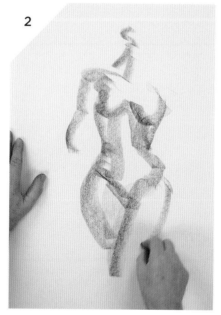

3

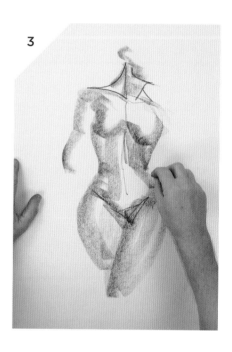

4

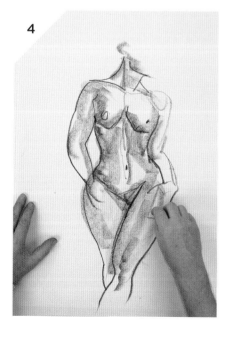

Step 1: Using thick contours, I hinted at the angle of the shoulders, hips, and spine. Likewise, these contours suggested the position of the head and the backward thrust of the shoulder and upper arm.

Step 2: I fleshed out the torso and quickly blocked in the overlapping forms and angles of the legs. This provided a good foundation upon which I could then build the rest of the drawing.

Step 3: Using the tip of my Conté crayon, I added select contour lines to further define the angles of the shoulders and hips.

Step 4: With the "trunk" firmly established, it was easy to add the "branches." The way the model's left forearm came from behind and wrapped around the hip was a special challenge that required extra care.

Result: Notice how the slant of the shoulders is echoed in the slant of the breasts and how the opposing slant of the hips is echoed in the angles of both the waist and the pubic triangle. This gentle contrapposto effect gives the figure a sense of swing.

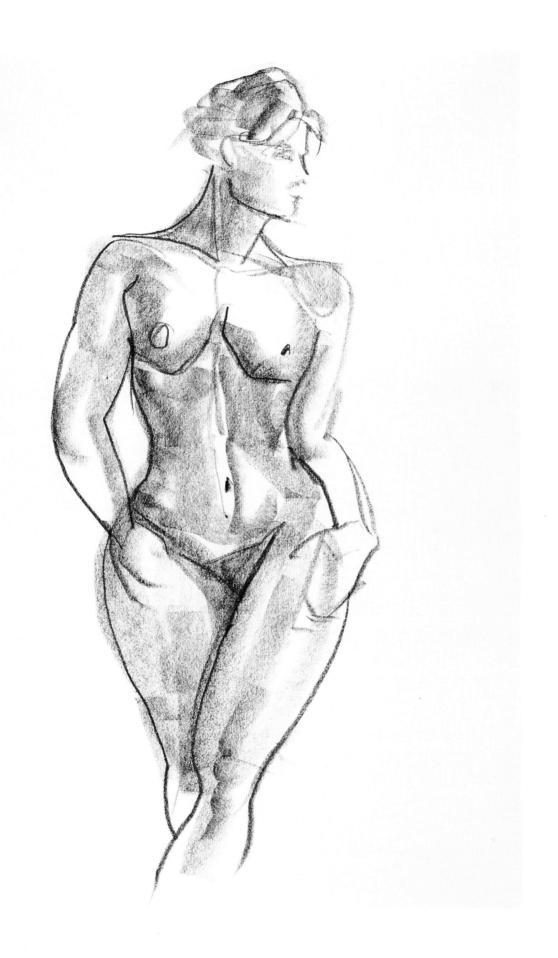

DEMO > Dimensional Drawing with Reed Pen and Sumi Ink

Drawing with a reed pen means that every line counts. This is a good thing because every line *does* count. As with every art technique, this drawing method is difficult to control at first, but with practice you can learn how to choose the significant lines and get them to work for you.

1

2

3

4

Step 1: With a few bold strokes, I established the size and position of the figure on the page with lines indicating the shoulder, neck, and upper torso. The quality of the rich black line is like no other and engaged me completely.

Step 2: I solidified the figure with additional significant lines and established the angles of the shoulders, spine, and hips to create dynamic tension. Note the varied thickness and darkness of the lines. Along with being very attractive, these helped to create a sense of depth.

Step 3: Working with the brush and diluted black ink, I focused on creating sharp contrasts. I controlled the transparency of the ink as I went both by changing the proportions of ink and water and by altering the pressure with which I touched the paper.

Step 4: I defined the main volumes with shadows. Notice the transparency and variety of tones created by the brushed ink. This is an essential part of Sumi technique.

Result: With this high-risk technique, you never know if it will come out successfully until the last stroke is done. As all who have tried it will agree, the hardest part of this process is knowing when to stop. My rule is to always stop before I think I'm done.

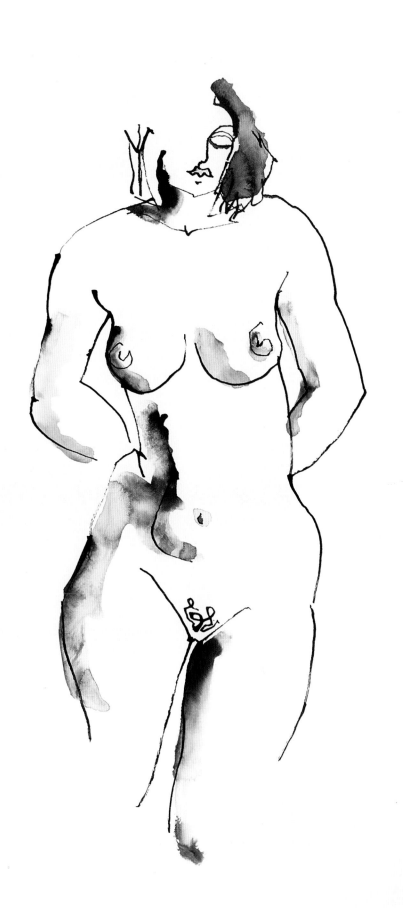

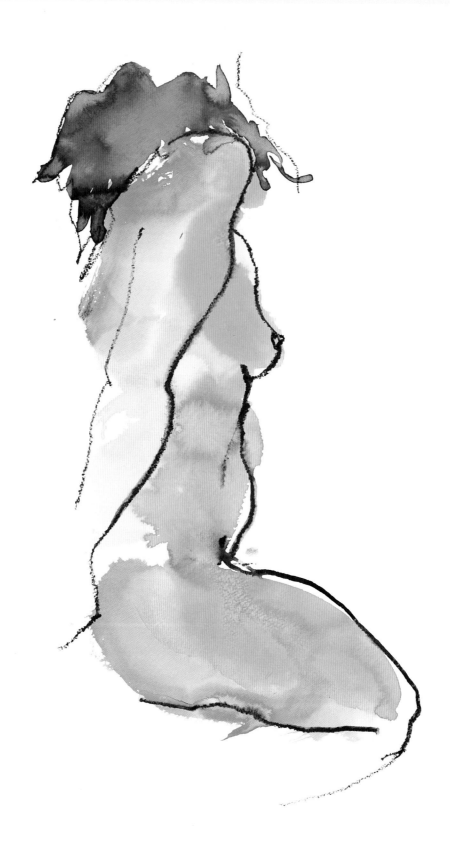

COLOR

Contrasts of color are essential to making things not only visible, but visually interesting. As in life, so in art, color is key. Understanding the principles of color and knowing how to use them are critical to your development as an artist.

At first look, the nude human body appears fundamentally monochromatic, and consequently it is frequently drawn as such. However, there is no reason that this needs to be so. Skin tones come in myriad variations. These range from deep and light shades of purple, brown, red, olive; orange, pink, and yellow; and an infinite variety of blends thereof. Moreover, when you look closely at the shadows and reflected light on the figure, you may see the full spectrum of colors—just as the Impressionists discovered them in the landscape about 150 years ago.

And yet, most often the figure is drawn in black, brown, red ocher, or yellow ocher on a white or toned support. Clearly, color as it has been used in drawing has always been somewhat arbitrarily dictated by various stylistic conventions and the popularity of certain materials. But these conventions are no longer sacred, and contemporary materials offer a seemingly infinite and accessible smorgasbord of color possibilities and effects.

The figure does have countless hues other than the basic skin tones mentioned above. The Impressionists, Post-Impressionists, Fauvists, Cubists, and Expressionists all pointed the way to a world of unlimited expressiveness through color that we have yet to fully explore. When you set out to draw the figure, the first and most important choices you should make in your drawing plan are what color or colors are going to make up your image and what color or colors your support will supply. By choosing to be daring and adventurous with your color, you guarantee an element of excitement to your drawings. And, of course, the first person that needs to be excited about your drawing is you. Working with interesting and unusual colors and color combinations is a great way to make that happen.

◀ *Attitude 124,* 2008, acrylic wash and water-soluble crayon on watercolor paper, 24 x 18 inches (61 x 45.7 cm), private collection

BASIC COLOR PRINCIPLES

Because of the enormous range of possibilities and the many laws of physics and optics involved, color has a tendency to overwhelm many artists. Color theory is a vast subject that alone requires a thick book—and you should get your hands on one and study it the first opportunity you have. But for our purpose, there are two essential things to understand about color. It creates contrast and it projects emotion. And, oh yes, there's one more thing—it's fun!

So use color to create contrast, mood, and interest in your drawings and also to have fun. When choosing colors to set an emotional tone or to interact with each other, make all your evaluations and decisions by considering the colors according to the three relative scales discussed below. Using these three principles and keeping the color range limited to two, three, or a maximum of four colors (including the white of the page) will help to keep your figure drawings focused.

Warm to Cool

The colors on the left half of the color wheel below are considered cool, and the ones on the right are considered warm. The colors along the edges of this division—yellow-green, yellow, violet, and red-violet—are less well defined in this regard and may sometimes appear cool or warm. There are also warmer (more red or orange) and cooler (more green or blue) versions of each basic color. For example, ultramarine blue is a warm (reddish) blue, and Prussian blue is a cool (greenish) blue. Cool colors tend to recede into the picture. Warm colors tend to come forward toward the viewer. Make use of these tendencies accordingly, when applying colors in your figure drawing.

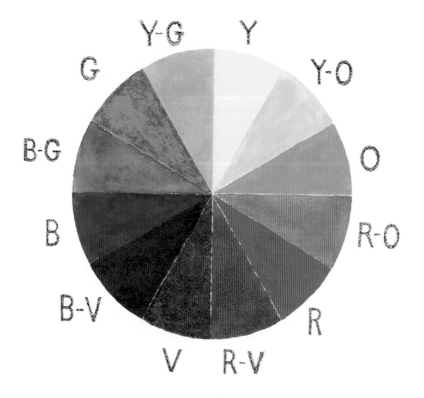

◀ This simple color wheel features the three primary colors (yellow, red, and blue—labeled Y, R, and B respectively), the three secondary colors (orange, violet, and green—labeled O, V, and G respectively), and the six tertiary colors (yellow-orange, red-orange, red-violet, blue-violet, blue-green, and yellow-green—labeled Y-O, R-O, R-V, B-V, B-G, and Y-G respectively). The colors of the spectrum behave like a family. Some are closely allied. Some are more distant. Some get along easily. Some have more strident relationships. All are related and with proper encouragement and prodding can usually be made to get along.

▶ *Aura,* 2007, acrylic wash and water-soluble crayon on watercolor paper, 18 x 24 inches (45.7 x 61 cm), collection of the artist

The appearance of each color in a composition is determined by its relationships with the surrounding colors. The longer you look, the more nuances you will see.

Light to Dark

You will notice on the color wheel, especially if you squint, that some colors are naturally darker than others. Yellow-green, yellow, yellow-orange, orange, and red-orange rarely read as dark (except in relation to each other). This may be because they have a tendency to glow and come forward off the page. Like warm and cool color, light and dark colors also advance and recede respectively and thus can be used to create depth—with the lighter colors coming forward and thereby indicating highlighted surfaces and the darker tones moving back and therefore indicating shadows.

Analogous to Complementary

All colors may be thought of in terms of their proximity on the color wheel. The closer they are to each other, the more closely related (analogous) they are. The farther away they are from one another, the more contrasting (complementary) they are. Closely related colors link up and appear to be part of the same area. By comparison, contrasting colors separate and differentiate one area or surface from another.

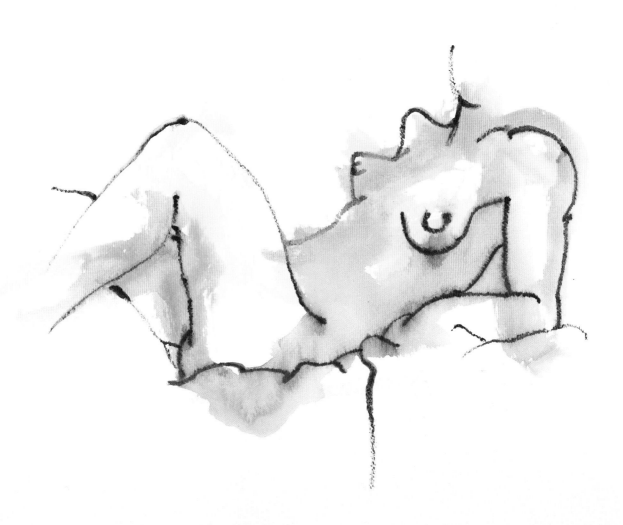

MONOCHROMATIC SCHEMES

The simplest way of using color in expressive drawing techniques—one that will add interest and expressive excitement to your drawings—is to do monochrome drawings in colors other than black. (See pages 35 and 39, for example.) Unless the page is darker than the drawing media, cool, dark, and dull colors will recede into the space of the page. Since the lines and tones on the page stand for receding events (such as edges turning away from the light, crevices, hollows, and so forth), cool dark and dull colors are usually the best choice. These are, for example, cool blues, dark greens, as well as gray-greens, blue-grays, dark cool violets, and a wide range of grays and olives.

Warm, light, and bright colors tend to advance and are too aggressive for most monochromatic drawing purposes. The warmer tones can work well in somewhat muted versions, however. Colors such as dark red and the more traditional sanguine and ocher are particularly good, especially when they are used on similarly hued, lightly toned paper. Experiment to see which colors project the moods and feelings you wish to convey.

Doing your monochrome drawing on a toned or colored paper (such as the image on page 124) adds a powerful dimension of mood to a drawing. Neutrals, pastels, flesh tones, and ochers work well as backgrounds. In fact, any pastel or muted tone will work. Bold colors can also work, too, for a more forceful effect.

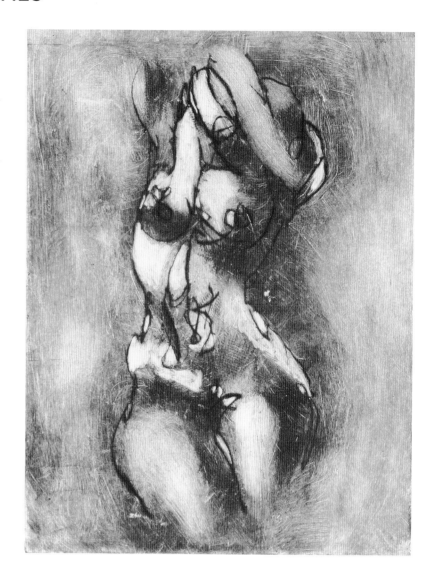

▲ *Figure in Red Earth,* 1994, drypoint on paper, 11 x 9 inches (27.9 x 22.9 cm), private collection

In this drypoint etching and the one on the page facing we can compare the emotive effect of warm and cool colors in two examples of the same image. (Both images were based on the pen and wash drawing on page 120.) The one above in the muted red earth tone (sometimes called sanguine) exudes a warmth without being garish. The same image in cool shades of Prussian blue on the right projects a much more subdued and restful mood.

ALTERNATIVE COLOR SCHEMES

Colors express moods. Using them well can not only draw the viewer into your image but can take her on an emotional journey. Tune in to your own emotional response to colors, study systems of color psychology, and experiment with as many color avenues as you can. Working with a narrow range of analogous (closely related) colors, you can create a very specific emotional statement. (See pages 20 and 21, left image, for example.) Working with two contrasting colors or color groups can give a sharp focus to your drawing and add a little more zing. (See pages 38 and 138.) Working with dark, cool colors can generate quiet and somber moods. (See page 78.) Working with bright, warm colors can yield a more cheerful or passionate atmosphere. (See pages 60 and 113.) Find and study more examples of each of these approaches—both in this book and in the works of your favorite artists. When the emotional message of your colors corresponds to the character of your subject—its lines, shapes, and gestures—it unifies and dramatizes the expressive significance of the drawing. Then it will successfully speak with a stage voice.

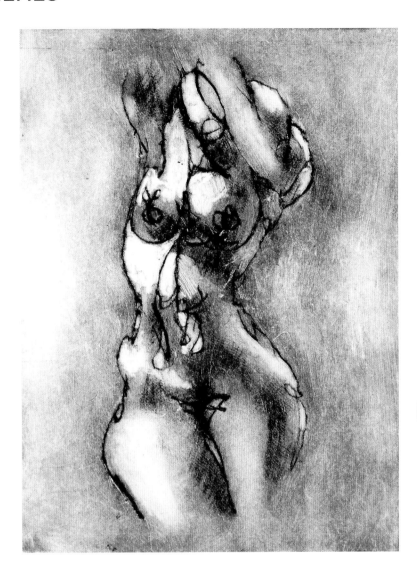

▲ *Figure in Blue,* 1994, drypoint on paper, 11 x 9 inches (27.9 x 22.9 cm), private collection

The drypoint etching technique is highly suited to color chiaroscuro effects, as etchings exude an inimitable richness and softness. The many variations of light and dark in both of these images show how much tone and expression can be found in a single color.

TWO-TONE GESTURE EXERCISE

This exercise—which comprises two parts—will train you to use two or more contrasting colors to create depth in your figure. This technique allows you to work in layers from warm to cool (or vice versa) and/or from light to dark (or vice versa) to quickly and easily create and define the volumes. Each gesture drawing should be completed in five to eight minutes and should feature a single medium.

Recommended Materials
- Cretacolor AquaMonoliths and/or Cretacolor Art Chunky colored chalks
- Fabriano Eco-White drawing paper

Warm and Cool, Light and Dark Hues

Start with your light, warm colors, loosely indicating masses and contours. Next, add the dark, cool contours. Experiment with using warm and cool tones as shadows. The secret to this approach is learning how to loosely indicate what you see. This will allow you to build up your drawing in layers and will give the drawing life and charm.

Earthy Hues

Starting with black, articulate the contours and some shadows. Then, with red, lightly add some details and shadows. With two-tone drawings you can work from light to dark, from dark to light, or go back and forth. Experiment with all possible ways to learn how to play the contrasting tones off of one another.

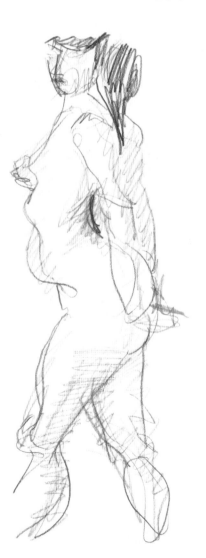

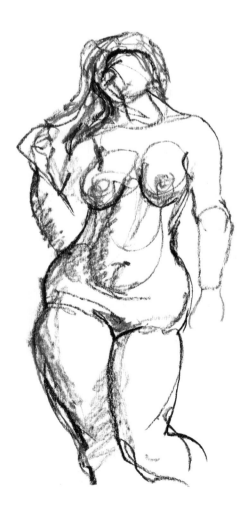

◄ This gesture drawing, executed in colored pencil, pits blue and blue-violet contours against shadows and flesh tones in ocher and red.

▶ Cretacolor Art Chunky colored chalks have a palette of earth tones that always fit together. This combination of black and sanguine works every time.

MULTIPLE CONTOURS EXERCISE

This exercise focuses on using edge and surface contour lines to generate forms. It also employs natural tendencies—for light and warm colors to advance and dark and cool colors to recede—to enhance the depth of those forms. Allow fifteen minutes to complete this exercise.

Recommended Materials
• Sennelier La Grande (or standard) oil pastels
• Fabriano Eco-White drawing paper

Rhythmic Lines
In this technique, draw edge contours to indicate form boundaries and draw surface contours in areas close to the edges of forms, where the shadows tend to be. These surface lines should suggest light and shade as well as the flow of the surface features.

Before you begin, select your colors—three or four cool hues of varying degrees of darkness and three or four warm hues of varying degrees of lightness. Start by drawing both types of contour lines using light, warm colors. As the edges and surfaces become more defined, introduce the dark, cool colors to render the deepest crevices and sharpest edges. Then use additional gradations of both the light, warm and dark, cool colors to convey the rise and fall of the surface toward and away from the light. Of course, the most prominent surfaces are fully in the light and thus should be left white.

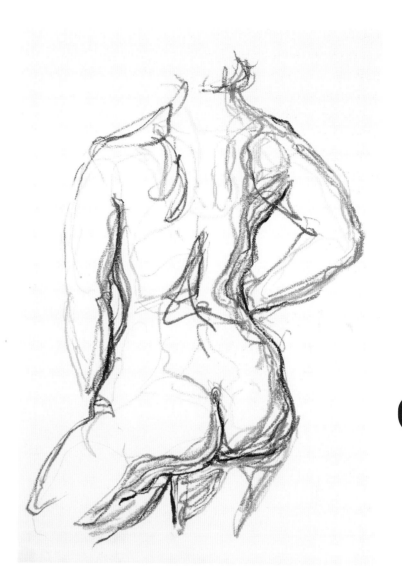

▲ This drawing uses edge contours and echoing surface contours in cool blues and greens, warm reds and yellows, and ochers to build up a vivid sense of the volumes of the figure.

DEMO > Color Drawing with Soft Pastels

Although called a hard pastel, Cretacolor Pastel Carré is actually fairly soft and easy to work with. These chalks can be used to build up rich, colorful drawings with smooth gradations and interesting blending effects. In addition, they can be used with a great variety of supports, and their appearance and behavior will vary greatly accordingly. The following demonstration shows a very simple approach to exploring this versatile medium.

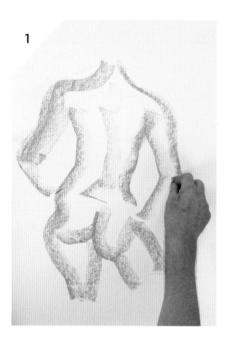

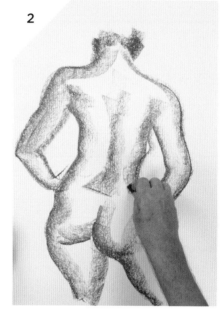

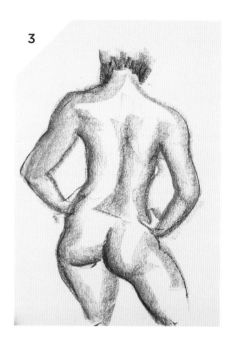

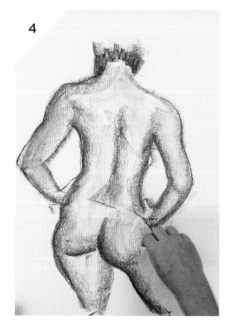

Step 1: I began by establishing the big forms and angles of the figure with a light orange underdrawing. Turning the chalk on its side, I used wide strokes that created contours and cylindrical mass at the same time.

Step 2: Using a thinner and darker stroke of violet, I further defined and deepened the contours and some of the shadows and established the head position. The orange took on a sense of solidity.

Step 3: I brought in some cool green shadows and then the darkest tone yet, a cobalt blue, to refine my contours and shadows. The cooler darker tones contributed depth and roundness to the figure.

Step 4: Up to this point, I was working light to dark, but here I went the other way—introducing a bright yellow, which added mass, solidity, and a sense of local color rather than just the white of the paper.

Result: After adding some deeper shadows with the blue and a few harmonizing accents with the violet and green, I was done. Notice the cylindrical feel of the shading.

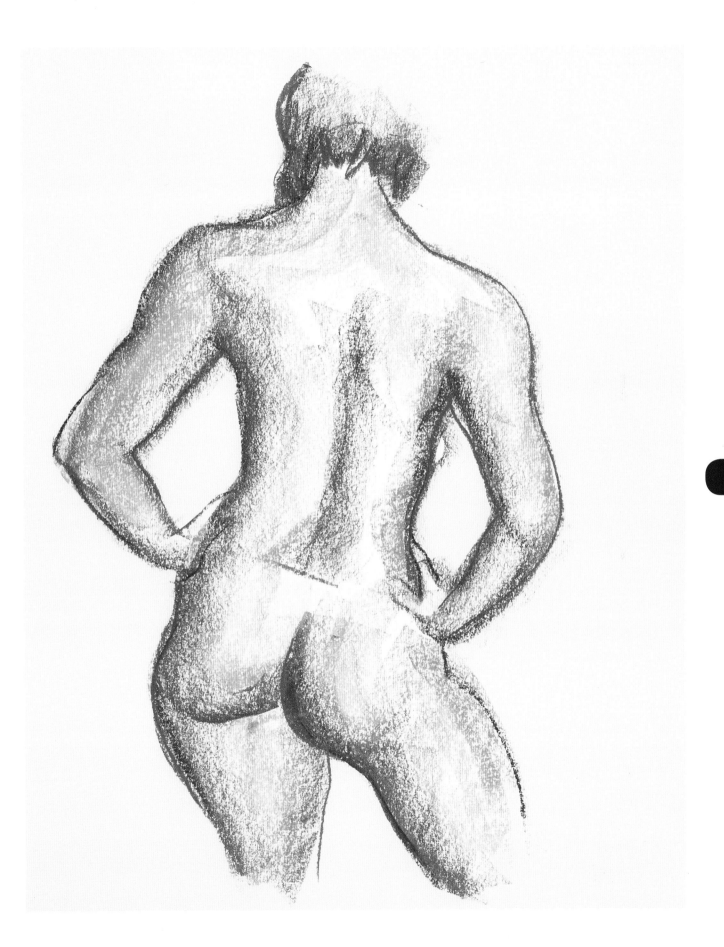

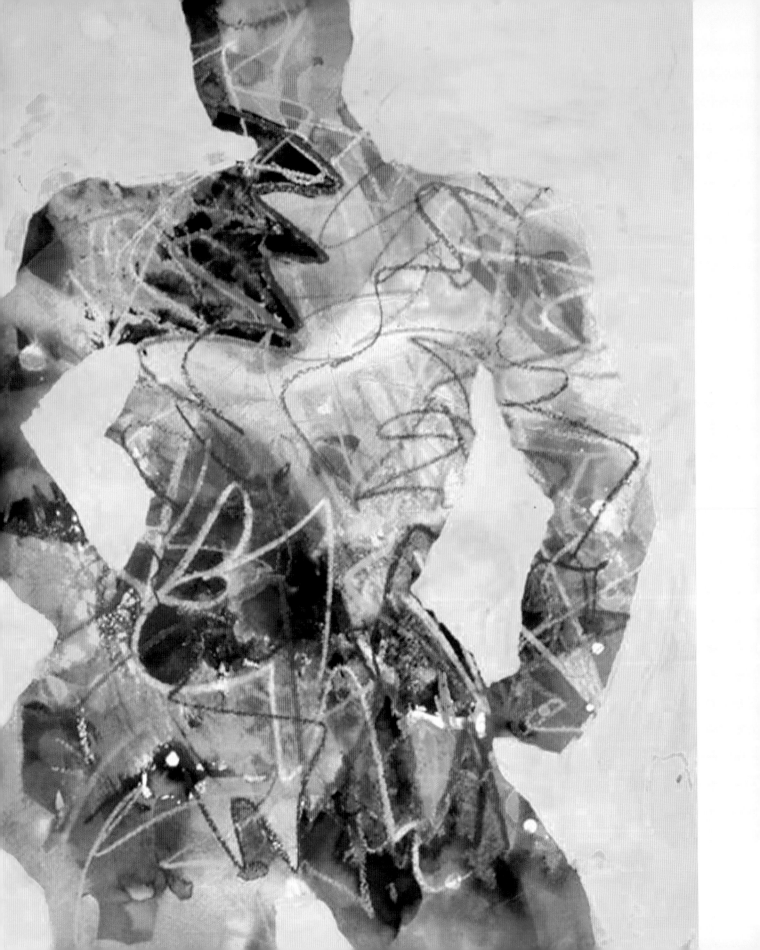

PART IV:
Figure Drawing
Be-Attitudes

Process and attitude are closely interrelated. Certain attitudes—ways of perceiving, thinking, feeling, and so forth—go a long way toward helping you develop the focus that you need. You can influence your own drawing progress greatly by refining your attitudes. In fact, this is one of the quickest routes to improving your drawing.

Even small changes in how you go about your drawing process can yield big improvements in your drawing results. Most importantly, to focus properly on the task of drawing the figure, you need to shift modes from "everyday" mode to "drawing" mode. You need to decompress.

Figure drawing is a contemplative art. The mental and emotional states you have when you are driving in traffic, going shopping, working at a computer, and so forth are not the ones you want when drawing. Why? Because in your everyday mode you are busy processing all kinds of input through multiple senses. But when you are drawing the figure, your analytical mind, although still there, must become somewhat passive. You must narrow your input to just two senses: visual awareness (seeing) and bodily awareness (feeling and moving). Drawing is a matter of coordinating these two specific activities into a single channel.

In the two chapters that follow, you will find a number of ideas and attitudes worth trying to ingrain on your drawing activities. Doing so will yield results.

◀ *New Nude II,* 2008, watercolor, acrylic, and oil pastel on watercolor paper, 24 x 18 inches (61 x 45.7 cm), private collection

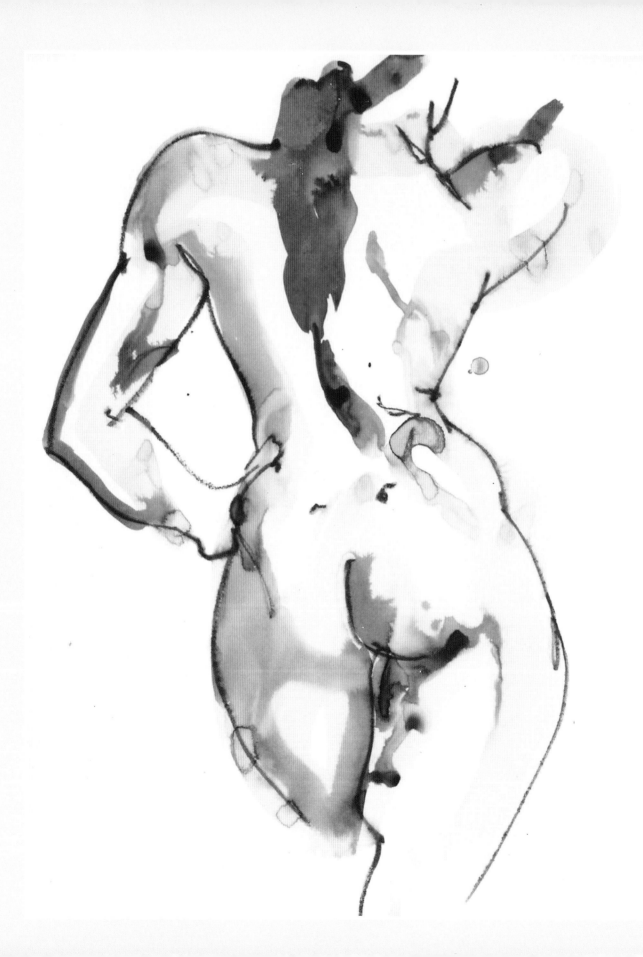

MUSIC AND POETRY

To express the music of the figure is to play on the melodies, rhythms, and harmonies of its lines, shapes, and colors. To express the poetry of the figure is to identify its meaning and mystery and crystallize them into a visual moment.

The human figure expresses the spirit and life of woman and man. This is what makes it endlessly fascinating. Every emotion that can be felt and every idea that can be thought can be expressed through the language of the figure. Dancers and actors do this in real time and space. Figure artists do this in the timeless realm of pictorial space. This expression of meaning is what lifts drawing to the realm of poetry. To deepen your concept of poetry—and to even write some of your own—can help your drawing process. Many artists do this.

My definition of poetry as it pertains to drawing is simply the idea of capturing the mood or meaning of the moment. It might be your subject's or your own meaning. It might be some archetypal or imaginary quality or some very concrete quality of the contours, shapes, volumes, colors, and so forth. When you find a way to express these qualities, the poetry happens. Observations and expressions of lines, mass, movement, texture, and any other visual elements and effects may be fashioned and accentuated so that they sing and speak. Often the most effective poetry conveys a great deal of meaning with just a few words—or, in the case of drawing, with just a few pictorial elements. This may be a matter of personal preference, but good communication in any art tends to be clear and simple. As Shakespeare said, "Brevity is the soul of wit."

The gesture drawing is the basis for learning how to capture the poetry of the figure. When you look at the figure, you are not just looking at the surface of a bunch of forms piled together. It is a harmonious interaction of forms. You are looking for the few singular lines, shapes, angles, or interactions that encapsulate, epitomize, or express the feeling of a pose. This is the meaning of the pose, and this is what you are after. The gesture communicates the motion and emotion. This is the poetry of the figure. Work on developing this skill, and it will pay dividends.

As metaphors for the drawing process, music and poetry differ somewhat. In the musical concept of drawing, the emphasis is on the abstract melodic, rhythmic, and harmonic qualities of the lines, shapes, and colors and their relationships. It embraces design, structure, execution, and abstract beauty. The poetic concept involves expressing feelings and meanings through these elements.

◀ *Attitude 41,* 1993, acrylic ink and water-soluble crayon on paper, 24 x 18 inches (61 x 45.7 cm), collection of the artist

SPEED

The act of drawing is a paradox. You need to have both freedom and control at the same time. Yet there is a tendency to alternate between too much of one or the other. Learning how to vary your speed helps to develop drawing freedom, control, and confidence because it enables you to adjust your concentration and focus. Drawing quickly and drawing slowly perform two different functions.

There is much to be said for being able to put your observations down on paper quickly. Drawing quickly is one of the most important skills to develop. You draw faster for a more general and freer result. Drawing quickly gives energy, rhythm, and life to your marks. It helps you to keep moving and it helps you to block in the main shapes and movements while avoiding becoming too bogged down with the details. It helps you to develop confidence and trust in both your eye and your hand, and quite naturally it makes your marks look professional and accomplished. It forces you to concentrate and commit yourself. It encourages fluidity. These are all good things. Of course, there is the danger of sloppy observation and careless mark making, but drawing quickly challenges you to learn to observe and record accurately and quickly.

Drawing slowly also has great virtues and is quite different. Working slowly gives you more time to observe and understand what you are looking at. It should enable you to make highly controlled marks. When you to have to handle difficult passages and details or are doing techniques that require great precision, then it's time to slow down. But there is a danger here, too. You must avoid allowing carefulness to degenerate into fiddling. This is why the concept of tempo is so important.

TEMPO

Fiddling, in terms of the drawing process, is getting hung up in unnecessary details, adjustments, and corrections and is actually the opposite of drawing. It expresses mistrust rather than commitment. Maintaining your tempo can help you avoid this pitfall (and many others).

Regular Tempo

To avoid the trap of fiddling, establish a regular tempo and keep it. Keep moving and avoid becoming obsessed. In fact, do so whether the speed is slow or fast. Maintaining a tempo gives a sense of unity and flow to your drawing. The mantra is, "Observe, react, and move on." The emphasis is on "move on."

Varied Tempo

Once you have become adept at drawing with a regular tempo, the next step is to vary it. You will notice that situations arise in a drawing where you, in fact, need to do so. Use a fast tempo for free passages and broad strokes and a slower tempo for the trickier areas—and be prepared to vary your tempo when necessary.

When you change tempo, there is a tradeoff between your freedom and your control, but it's worth the sacrifice. Give up control to get control. Learn how to negotiate the razor's edge of freedom and control through mastery of speed. Explore this spectrum and learn to exploit the possibilities of speed and tempo in your drawings. Their power to improve your drawing skill will amaze you.

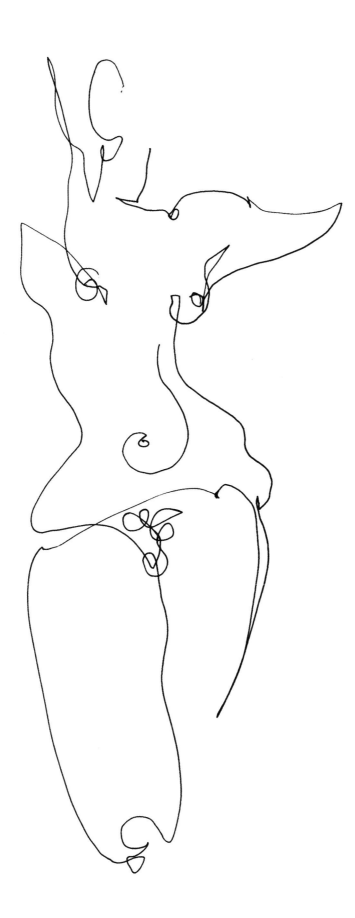

◀ *Line Dance,* 1994, Pelican Fount India ink on paper, 18 x 12 inches (30.5 x 45.7 cm), collection of the artist

This drawing, made almost entirely of a single continuous line, was done as fast as I can move. The speed of my observation, the understanding of what I was seeing, and the movement of my hand were all completely in sync. This degree of musicality and freedom seems to come after many hours, even days, of concentrated drawing activity.

RHYTHM

Rhythm refers to the occurrence of events in measured intervals. These occurrences can be in regular or irregular patterns or even random ones. The events can vary in strength, and this variation of strength creates accents within the rhythm. In music these events are sounds of various strengths that occur in time. In art these events are lines, shapes, colors, and textures that occur in a space. The human body itself can be viewed as a rhythmic pattern of visual events. The shapes, lines, undulations, and directions of the bodily forms interact with each other and with the space around them. In each pose the forms of the figure express a unique flow of energy. They push and pull against one another and create echoes. As these forms flow they punctuate and accentuate the space they occupy in a kind of visual music. Your goal as an artist is to translate the three-dimensional visual rhythms of the figure into two-dimensional rhythms on your page.

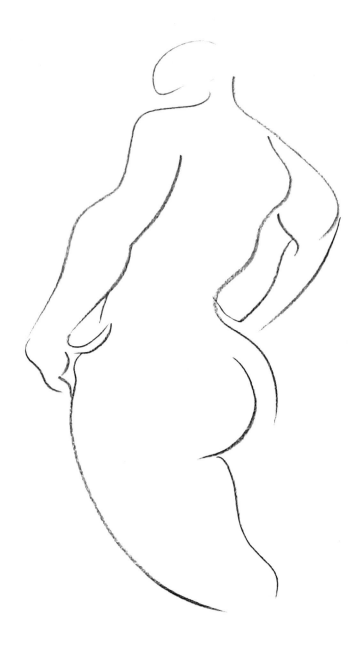

▲ *Rhythmic Figure,* 2005, Conté crayon on paper, 18 x 12 inches (45.7 x 30.5 cm), collection of the artist

Quickly and smoothly run your finger over each separate stroke in this image, one line after the other. This will give you a good idea of what putting rhythm into your drawing stroke feels like. Do some figure drawings with this type of quick movements.

[CAPTURING THE FLOW]

Always look for the main rhythms and movements, the repetitions, the echoes, the peaks and valleys of the surfaces and contours that create the visual rhythm of the figure. The rhythms and pulsations of the figure can be evoked on your page by the use of divisions of space, the flow of line, darks and lights, contrasting shapes, repeated marks and strokes made at different rates, and the whole spectrum of artistic devices. The rhythmic impression of speed or languor of a contour of the body may be suggested by your own rate of movement. Gesture, mass, line, structure, shape, volume, and color (all of the categories covered in Part III) can all be enlisted to create rhythm in your drawing to give it a musical level of abstraction. The ultimate goal of the drawing process is to achieve a work that succeeds as a representation and also as a visual design—as the visual equivalent of a musical composition.

▼ *Grand Sauté,* 2009, acrylic ink and water-soluble crayon on paper, 11 x 13 (27.9 x 33 cm), collection of the artist

Here colors and lines appear to have flowed onto the paper with the same ease that the dancer flies through the air. The echoing upward thrust of the arms, torso, and head and forward-pressing diagonal of the legs neatly divide the negative space into exciting shapes. At one level this is a dancer; on another it is a musical abstraction in space.

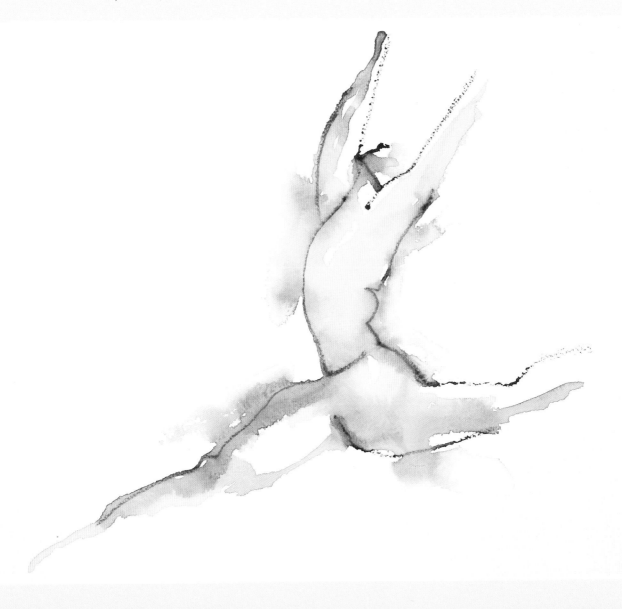

SPEED AND TEMPO EXERCISE

The forms of the figure flow, but do you? That is the question. This exercise—comprising two successive poses—provides the opportunity to capture the flowing nature of the muscular forms of the body with continuous lines. Allow one to two minutes for each pose.

Recommended Materials
- Zebra GR8 or other medium-point rollerball or gel pen
- Canson Biggie Sketch pad

Continuous Flowing Line
Many poses struck by a model have expressiveness built right into their contours. To translate that onto the page, you must actually feel the exuberance of the pose in your own body and let the rhythmic movements of your arm and hand attentively express the excitement of what your eye sees. The eye is the master, and the hand is the slave.

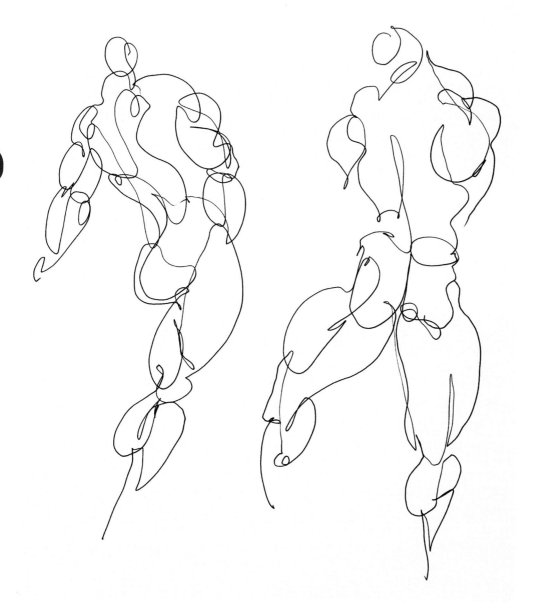

For this exercise, a model with excellent muscle definition or lots of other interacting rhythmic forms is required. Make the quick fluid movements in a continuous motion, describing the travels your eyes make in, out, and all around the muscular forms. Use loops to record your changes of direction, and do not lift the pen from the page more than a very few times.

◄ The looseness of the lines of this image exemplifies what I mean by "giving up control to get control."

RHYTHMIC REPEATING CONTOURS EXERCISE

This exercise will help you get the feel of putting rhythm into your lines. You will end up with a kind of consensus drawing and a good awareness of what the contours are doing. Getting your mind tuned in to the rhythmic shapes and contours of the figure in this way will ultimately allow you to create a sense of the pose and a sense of the three-dimensional forms using very few strokes. Allow four to five minutes to capture the pose.

Recommended Materials
- Conté crayon 2B
- Canson Biggie Sketch pad

Continuous Contours
Using the full page, follow the contours of the figure repeatedly with your crayon in long, flowing, continuous strokes in one general direction. The movement is fast, free, and even exhilarating. Vary the depth and length of the undulations you are observing as you record each contour several times. The contours don't have to connect with each other, but they will intersect. The important features of the pose will appear by themselves. This is a great method for learning how to use fluid drawing movements to translate the body's various forms into shapes on the page.

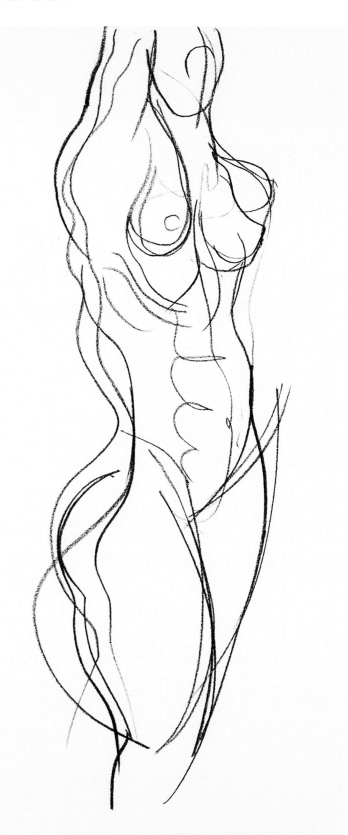

▶ Look closely to see the variations produced by repeatedly observing and recording the contours. The result is a consensus of the different readings and responses to the pose.

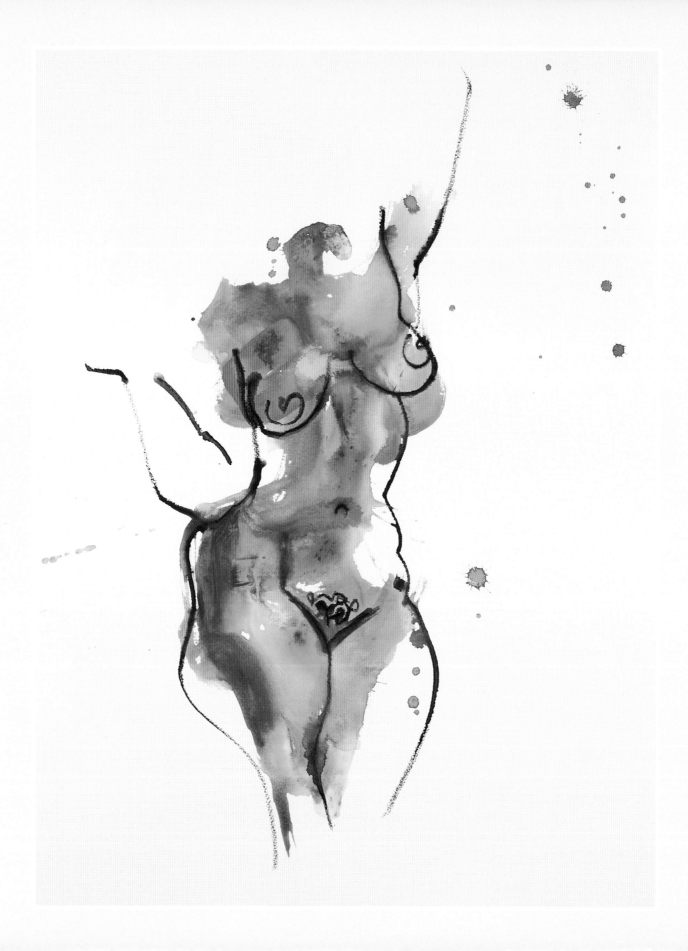

THE EXPRESSIVE MIND-SET

In art, as in life, attitude is everything. There is a unique attitude within you that will enable you to make the best art you can make. Find it, call it forth, make friends with it—and enjoy yourself in the process.

Confidence is the ultimate secret of being good at anything—and it is one of the biggest factors in your drawing efforts. Naturally, you will grow in confidence as you gain the tools and skills to meet every drawing challenge. But confidence can be, and actually needs to be, cultivated for its own sake. Furthermore, it can be learned. You can turn it on.

Have courage. If you begin by telling yourself that you cannot draw, you are beaten before you start. The bottom line is that your ability to draw is a function of believing you can. So you can save yourself a lot of trouble if you will just start believing and understanding that you can. Say to yourself every time before you start to draw, "I can do this." Even a little bit will go a long way.

In this chapter, which is devoted to expression, you will find some liberating concepts. The message is simple: Break free of inhibited and pedestrian approaches. Be bold. Spread your wings and explore the unlimited creativity of the expressive way. Of course, the methods and exercises from the preceding chapters are designed to help move you in this direction. But beyond these, how do you go about doing this? Well, if you want the drawing process to be more than a hit-or-miss affair, you will need to spend time thinking about what expression is and what really goes into it, which is what this chapter is all about.

◀ *Attitude 138,* 2009, acrylic gouache and water-soluble crayon on watercolor paper, 30 x 22 inches (76.2 x 55.9), collection of the artist

THE LANGUAGE OF DRAWING

Drawing is a language—a form of communication. To succeed as an artist, you must learn the language. Start with the alphabet, the basic elements. Then learn the vocabulary and grammar as well. Do this by thoroughly familiarizing yourself with the basic elements (as discussed in Part III). Once you have gained familiarity with these concepts, you can, step by step, begin to speak the language of drawing with ease, confidence, and even flair. Eventually you will be ready to invent your own dialect.

Self-Expression

When you draw, something that is uniquely you shows up on the page—a certain quality or qualities. The experience can sometimes be like hearing your voice recorded for the first time. It is hard to accept or even recognize that it's you. One of the secrets to being creative is to learn to greatly value these unique qualities and turn them into assets. When your inner artist speaks, be sure to listen and follow. Be it ever so humble, your inner artist has something to tell you—and the rest of us.

Stage Voice

If you think about it, no stage actor would go on stage and speak in a normal voice. If she wants to be heard by the audience and convey her message, she uses a larger-than-life way of speaking called the "stage voice." Your page is your stage. To gain your viewer's attention, learn to speak/draw upon it with your "stage voice."

MOODS AND EMOTIONS

Your drawing shows what you are interested in and the degree of your interest. Be moved by forms and lines of the figure. Let them resonate in your feelings. Take in their moods. Learn to sense and capture the emotional implications and meanings contained in them. When you take pleasure in the figure's lines and forms and emotions, this pleasure will come out of your fingertips as you draw.

You can capture your own moods or the moods of your model as you express joy, intimacy, tenderness, humor, fun, sorrow, loneliness, suffering, or even ecstasy. In art, the idea is not to hold back but to let it all out. This is the world of expression. Let it lead you to powerful drawings.

The expressive drawing techniques give emotional as well as technical focus to the drawing process. The idea is to find and use the techniques, materials, and methods that match the look, mood, and pose of the model as well as your mood and intent. If you can do this, you are as close to fail-safe is it gets. If you can do this, you will succeed.

▶ *Simplified Structure, Shape, and Line,* 2006, water-soluble crayon on paper, 24 x 18 inches (61 x 45.7 cm), collection of the artist

Drawing is a language made up of line, shape, color, and texture. Lines, either straight or curved, are used to reveal fundamental shapes that, when combined, make a structural statement. Color and texture add additional mood and feeling.

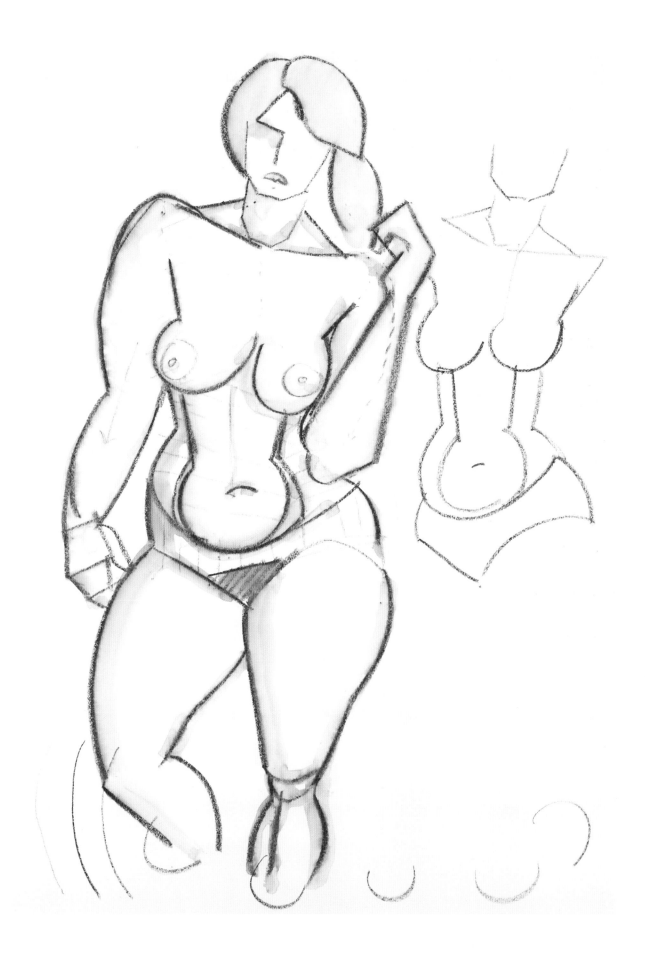

[LEARNING TO EMPHASIZE]

All things are not equal in the realm of drawing. You have to make choices. If all the aspects of the figure you are drawing are treated with equal interest and attention, there is scant possibility to make an artistic statement. Instead, look for and choose aspects or components of the pose that are inherently more interesting and dramatic and find ways to emphasize them. At the same time, de-emphasize or ignore the parts that are less interesting. You will find that this, quite naturally, makes a powerful artistic statement.

Here are some ways to dramatize areas of the figure:

- Apply darker and thicker contours in the more significant areas and lighter and thinner contours in the less significant areas.
- Have more detailed handling of the significant areas and sketchy handling of the less significant areas.
- Use more detailed handling of light and shade effects in significant areas.
- Use greater contrast of light and shade effects in the significant areas.

- Make the significant areas predominate by enhancing their position and size on the page.
- Make the significant areas predominate by inclusion and omission—leaving out the less significant areas entirely or making a vignette.
- Use design elements such as direction, rhythm, and movement to direct the focus of attention.
- Exaggerate the tendencies of the significant areas and interesting features. In other words, swell bulges, deepen crevices and indentations, enhance inclinations and angles, elongate already long areas, decrease already thin areas, extend already wide areas, further darken already dark areas, and so forth.

▼ *Attitude 123,* 2008, acrylic ink and water-soluble crayon on watercolor paper, 18 x 24 inches (45.7 x 61 cm), collection of the artist

When making freely interpretive drawings, the idea is to suggest rather than depict. A patch of gray becomes a head of hair, a purple brushstroke becomes a shadow, a scratchy line becomes cloth on a couch, and another scratchy line becomes an arm arching up into the unknown.

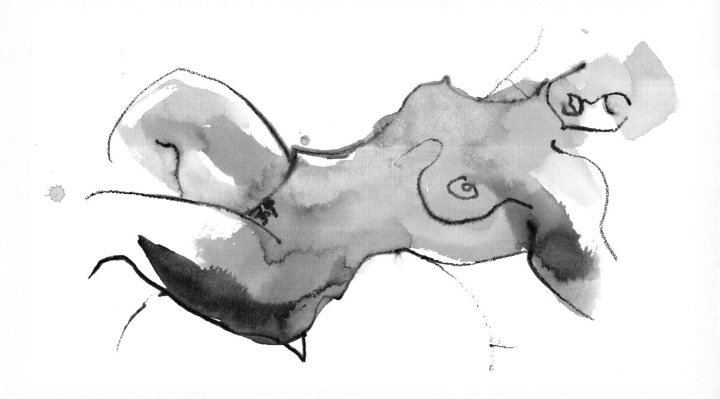

RISK-TAKING EXERCISE

Drawing involves taking risks. In fact, to draw is to risk. Learning to draw is like learning to how to ride a uni-cycle or perhaps to windsurf—you've got to be willing to fall off innumerable times to learn how to ride with the flow and keep your balance. The key is to be willing to live with an imperfect result while patiently making progress. This exercise will help you build trust in this process. Allow eight to ten minutes to render a figure.

Recommended Materials
- acrylic ink (one warm, one cool)
- water-soluble crayon
- Sumi brush with a 3-inch head
- watercolor paper, 24 x 18 inches (61 x 45.7 cm)

Flat Masses, Simple Contours

Apply the ink, in diluted form, with the Sumi brush in an effort to suggest the mass and some of the internal forms of the torso in a flat, somewhat abstract way. You may use the cool color to indicate shadow and the warm one to indicate lighted areas, or you may use the colors arbitrarily in an experimental way. Put the color on very wet so that some areas bleed into one another. The way the wet inks blend cannot be controlled much.

While the ink is still wet, add just enough contours and details to convey the pose. The key is being able to use the shapes and contours to suggest accurately the invisible internal structural angles of the spine and legs. The looseness of this approach ensures that there is no way to know how the drawing will turn out until after it is complete. In reality, that's the way it is with creative ventures.

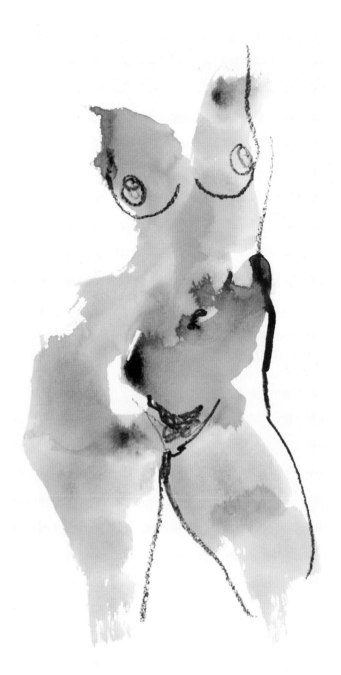

▲ Not knowing how an artwork will turn out can be an advantage. Going beyond the limits of your control can lead you to unexpected and pleasing results.

ANATOMY AND ART

To learn to draw the figure freely, you may want to reconsider how you think about the concepts of proportion, anatomy, and realism. Misconceptions in these areas often constitute major stumbling blocks when learning how to draw freely, expressively, and even accurately. Throughout art history, the figure has been stretched and tweaked for expressive purposes. If you closely examine the figures in great artworks, you will find that they are inventions of the artist. In other words, the artist has adapted, consciously or unconsciously, the figure to his expressive needs rather than strictly adhered to mundane reality. Invariably, the figure's form is dictated by an idea, an expressive goal.

Throughout history, great artists have altered aspects of their subjects—proportions, volumes, shapes, lighting, or various kinds of verisimilitude—to suit their purposes. Even the classical sculptures of Greece and Rome, often thought of as models of realism, are, in fact, distorted. (Their forms and proportions are smoothed out and idealized.) In the freer climate of more recent times, modern and contemporary artists have mined the possibilities of malformation and even mutilation, pushing the boundaries in the quest of ever-greater extremes.

This all shows that proportion is an expressive tool. How it should be used is up to an artist's discretion. There are no "correct" proportions relative to the figure you are drawing. There are only "correct" proportions in terms of what you are trying to express, what will make the drawing work. Proportions are relationships. Relationships are what artists play with; they should not be what artists are controlled by.

But then, you ask, how do you get the parts of the body to fit together and read correctly? It's done by making adjustments. It's a balancing act that is learned by doing, doing, and doing. Remember, once the model is gone, all you have left are relationships on a page, a work of art.

Understanding this opens the door to a world of creativity. And conversely, not grasping this tends to stifle the development of drawing skill. The reason for this is simple enough: When concern with getting the proportions right occupies too high a rung on your list of priorities, there is a tendency to block out the things that are far more likely to determine a successful drawing outcome. By this I mean, of course, contrasting shapes and tones, interesting line quality, good directional angles and volumes, solid structure and weight, dynamic composition, mood, rhythm, flow, liveliness, looseness, freedom, intensity, and so on—all the things that go into a good expressive drawing.

There is a similar confusion about the importance of learning anatomy in order to portray the figure. It is widely believed that a thorough understanding of anatomy is necessary to be able to draw the human figure well. This is simply not the case. And believing that it is has often had an intimidating effect on artists who, by temperament, are not attracted to this study. The fact is that many of the greatest figure artists throughout art have had only modest studies in anatomy or none at all. Rather, a thorough understanding of drawing techniques, strategies, and practices is what is necessary to be able to draw the figure well and consistently. If you practice good drawing strategies—if you observe well and become adept at translating what you have observed onto your paper—your drawings will look like you have studied anatomy. This you will have done, from life. An anatomically correct drawing is not guaranteed, by any means, to be a good or even an interesting drawing. But a drawing that has a powerful sense of mass or structure or a good sense of direction as a result of good observation will always be interesting and convey good anatomical sense without the need for deep anatomical knowledge.

Of course, knowledge of anatomy can be helpful. The study of anatomy offers an opportunity to become familiar with the structure beneath the surface that causes bodily forms to appear the way they do. It is helpful in solving difficulties and providing landmarks. But too much scientific knowledge may hinder your ability to see and express mass, line, and structure.

Anatomical knowledge provides a lexicon of forms and structures. As such, it has the relationship to drawing that a dictionary or a thesaurus has to writing. Anatomy is no substitute for drawing techniques. You still have to learn how to draw the forms and structures. I believe that the benefits of studying anatomy should be generally be put off until one has developed powerful observation and recording skills, and then anatomical knowledge should be added as a refinement. Drawing is visual. It's about learning to see.

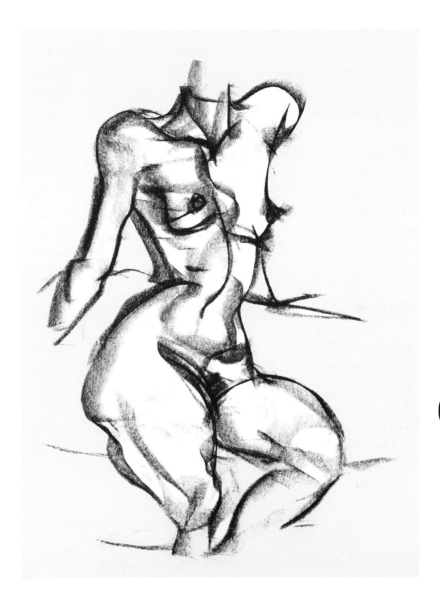

▲ *Seated Nude,* 2007, Cretacolor Art Chunky on paper, 23½ x 16½ inches (60 x 42 cm), collection of the artist

Is the anatomy of this image totally accurate? No, but it is more accurate than not. The exaggerations and accents here and there are precisely what give the pose compositional strength and make the contours of the figure seem alive with rhythm and movement.

REALISM AND ABSTRACTION

An unfortunate dichotomy, a conflict even, seems to exist in the minds of many artists and the general public regarding the concepts of realism and abstraction in art in general and figurative art in particular. This conflict interferes with many a beginning artist's learning process. However, this conflict would be entirely unnecessary if the concepts were rightly understood.

The fact is that all art is abstract. This is because art is always one step removed from life. Even the most refined, hyperrealistic drawing or painting, even a photograph, is at some level just a collection of colored or shaded blobs on a flat surface that our mind can assemble and recognize as an image. The pixels on a computer monitor are perhaps the ultimate example of this. Abstraction is all a matter of degree. The more noticeable the marks and blotches that make up an image are, as marks and blotches, the more the image will tend toward abstraction. When the more general and structural elements of an artistic subject are brought out, this is also the case. On the other hand, the more the artistic means of creating an image as well as its general and structural elements are hidden or disguised, the more likely it is that the image will be thought of as realistic. In any case, we must learn how to see abstractly if we want to learn to draw concretely. And this is so regardless of where the artist chooses to position his art on the abstraction/realism spectrum, regardless of whether he likes to disguise or to reveal the traces of his thought process and handiwork in the drawing.

In expressive drawing techniques, the drawing is understood to be a symbolic representation of the subject where the marks on the page and where the forms and lines have meaning in and of themselves. The abstract qualities are used to enhance the interest of the drawing. The materials and handling and thought process are plainly visible, and the goal is to suggest and describe rather than to replicate. The drawing does not pretend to look like anything but what it is—a drawing.

Because of its inherently abstract nature, the drawing process naturally lends itself to this approach. The temptation when starting to learn to draw is often to fight this natural tendency and instead struggle for overambitious levels of exactitude and detail. Making art, whether representational or abstract, is about creating illusions. Go past your dread of dealing with the figure in free and abstract terms. Learn how to get your marks and lines to convey the simple shapes and directional events. Develop your own shorthand for doing this. Respond to and take advantage of the unique nature of your materials. Do these simple things and your drawings will become more convincing, more real, and a whole lot more fun to do.

▶ *Attitude 89,* 1996, acrylic ink and water-soluble crayon on paper, 24 x 18 inches (61 x 45.7 cm), collection of the artist

Here the abstract blending of the wet inks on the paper takes place inside of shadows that are representational in nature. The visual excitement of the ink's behavior is as much the subject of this drawing as the figure is.

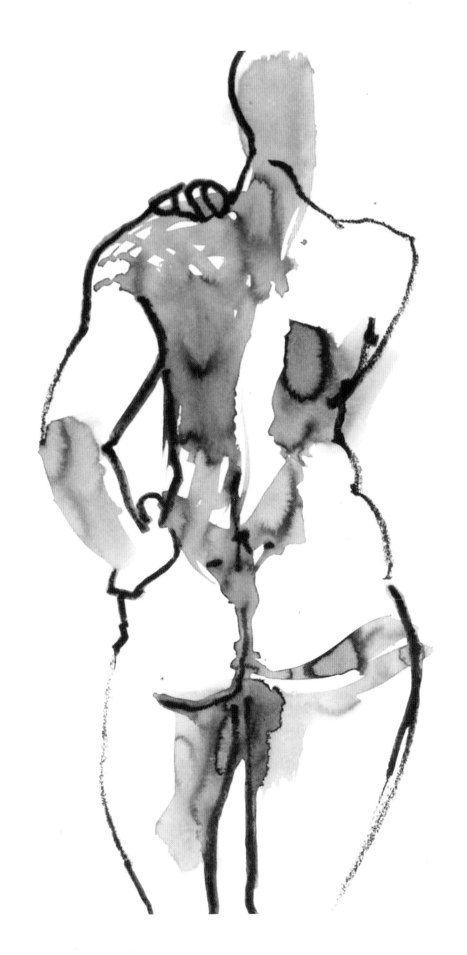

CLASSICISM AND ROMANTICISM

In today's world we have reached the point, thank goodness, where it is widely accepted that there is no one absolute right way of drawing or of how things ought to look. But this is a new phenomenon. Throughout history, movements and periods of art have tended toward homogeneity of expression as a reflection of their specific culture. These art movements or periods have been generally thought of as falling into one of two supposedly opposite categories: the "classical/ideal/formal" or the "romantic/expressive/primitive."

This classification method is helpful in bringing some order to our understanding, evaluation, and appreciation of artistic tendencies and trends. But the reality is that it's never that simple. Every period and every artist, in fact, is a blend. The greatest formal works invariably contain powerful expressive elements, and the most expressive works tend to contain powerful formal elements. There is a big point here: Although these two approaches are often thought of as contrary to one another, it is really always a matter of emphasis within a spectrum. These two categories are much like yin and yang: You can't have one without another, and the great danger is not to have either.

Most artists tend to feel more comfortable with one approach over the other and need to find where they fit in along the spectrum. If you feel comfortable with both, you may have to choose at some point to lean one way or the other. Although I have emphasized the expressive side, the exercises and concepts put forth in this book are designed to help every artist of either tendency improve her fundamentals and draw better. The same principles apply and are at work in both realms.

Just as it is obvious that there is no one right way to approach drawing, it is also clear that the same approach will not work for every person. Today there are nearly as many approaches as there are artists. The main thing is that the approach should match the result one is trying achieve. Realistic figurative art creates a sophisticated illusion, making something appear to exist where it does not. It pleases, impresses, and dazzles us with its magic. The marks on the page are swallowed up in that illusion. Expressive figurative art is more abstract. The figure becomes a take-off point from which the artist may go in myriad directions of individual vision and expression. The drawing is to be understood as a symbolic representation of the subject. The marks on the page are allowed to retain their identity as marks on a page that have their own voice. It is multilevel and entertains on several levels. And, of course, the viewer's mind is invited to complete and even add to the picture.

It's not a matter of one approach being superior to the other. Each approach shows off different skills and offers different expressive possibilities and opportunities for virtuosity and enjoyment. But I think it's fair to ask even more of an artwork than virtuosity and technical prowess. I think the crux of the matter is, Does it communicate? Does it tell a story? By what means and methods does it tell its story? Is there deep feeling? Does it inspire? And even, What does it inspire? And these questions raise practical questions: How do we develop the skills to do these things in our figure drawings? How do we evaluate our success?

▶ *Attitude 97*, 2007, acrylic ink and water-soluble crayon on watercolor paper, 24 x 18 inches (61 x 45.7 cm)

Is it possible for the classical impulse and the expressionist impulse to exist in harmony together? This drawing sets out to demonstrate that it is.

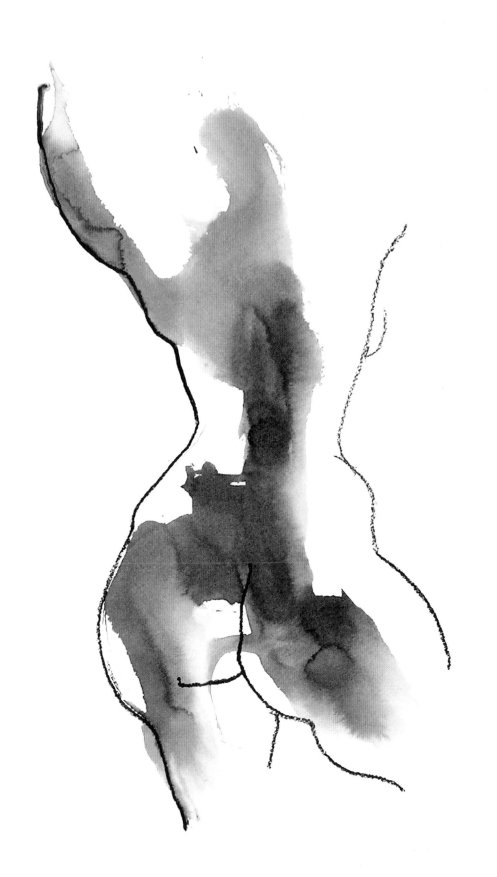

THE CHI

For me there is an approach that offers assistance with these issues in figure drawing. It comes from the Chinese tradition of art precepts. It is the principle called *pictorial reality*. In this concept, the concern is not outward representation per se but rather a sense of aliveness. It's about capturing the spirit of your subject, the *Chi*, as it is called. It is the idea that the picture itself should be as alive as possible—and alive in the way that your subject is alive and that you are alive, with the same feeling and character. This, to me, is the ideal of expressive drawing. It's what makes an artwork truly work. It's the idea that your drawing must be alive in order to bring your subject to life. It's an expansion of and a whole different take on the word *lifelike*. It's easy to see that achieving this result in a figure drawing is a great deal more than just handling of proportions and capturing shadow and light on the surface. Deeper qualities are needed to create this sense of life in a figure drawing, and these qualities have to do with good technique and artistic decisions as much as with more transcendental skills.

Any of the following elements will help make your drawing more expressive and alive:

- Getting the weight of the figure and positions of the limbs to appear believable
- Making the lines themselves appear alive, both in terms of their texture and their movement
- Creating a dramatic sense of depth
- Creating interest through emphasis and exaggeration
- Creating interesting directional tensions with the angles and directions (the oblong axes) of the major shapes
- Creating interesting tensions through variations of the angles, directions, sizes, and placements of the major shapes

A drawing, by no means, needs to have all these qualities. Even having one or two will go a long way toward making your drawing succeed. The key expressive drawing skills will enable you to develop the ability to achieve these qualities. Work on the elements (not all at once, mind you, but one or two at a time), and train your eye to see and your hand to master each phase.

Step by step, even your anatomical knowledge and your sense of proportion will develop, and, most important, your drawings will become more true to life because they will live and they will speak.

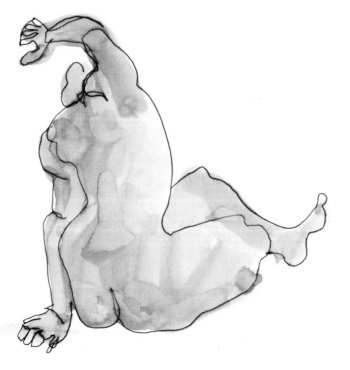

◀ *Moon Reach*, 1999, pen and acrylic wash on paper, 18 x 12 inches (30.5 x 45.7 cm), collection of the artist

The ample figure sits on the ground but reaches for the sky. The confident masses, jovial pen lines, and translucent muscle patterns in the brushstrokes all unite to broadcast a whimsical sense of lightness and heaviness at the same time.

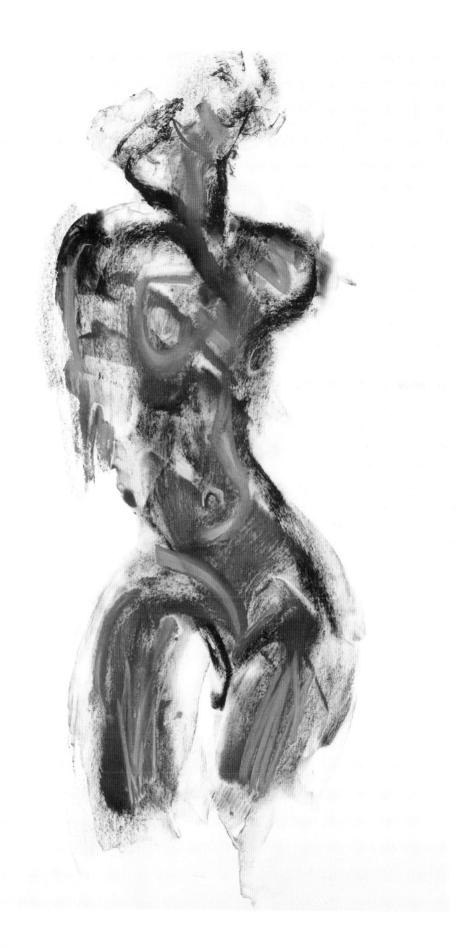

▶ *Evocation*, 2009, Cretacolor
Art Chunky on paper, 24 x 14 (61
x 35.6 cm), collection of the artist

For the drawing to be alive in
the way the model is alive, the
artist must sense that life and
by whatever means put it down
on paper. This is what is meant
by Chi.

[REVIEWING THE DRAWING GOALS]

Ultimately, drawing is dependent on understanding what you are trying to accomplish, what techniques and approaches can help you to get there, and what attitudes work when you are actually drawing. And it is about understanding how to adjust. What works one day does not necessarily work the next. That said, here is a checklist of simple and essential drawing goals:

- Establish an overall figure-to-page ratio. This is the proportion you need to establish.
- Position the figure on the page so that it creates interesting negative shapes.
- Choose a guiding principle. This will help you decide what to concentrate on, how to see it selectively, it how to render it, and what to ignore.
- Make a point of applying your marks in an interesting way with your chosen materials.
- Capture the gesture.
- Capture the directions using the clock or compass system.
- Capture the mass.
- Capture the significant lines. Do this with an interesting line quality.
- Capture the big shapes first and then incorporate the smaller shapes.
- Understand and reveal the structure.
- Capture depth, roundness, and volume.
- Create mood with the way you use light, shade, and color.
- Draw with a tempo and a rhythmic flow.

Remember, in expressive figure drawing, the process of learning to draw the figure and the process of releasing your creativity and expressivity are one. The approaches are varied and the skills needed are numerous. You may start almost anywhere as long as you get around to all the basic areas of learning. There is no one absolute right way of drawing or of how things ought to look. You must find out for yourself how your figure drawings should look.

The realism approach sets out to reinforce what we already know (or think we know), which is useful and wonderful, without a doubt. The expressive approach pushes the boundaries of what we know and tells us things we didn't know. It challenges and questions our understanding of our world. Its purpose is to enable us to see and understand things we did not understand before—to surprise us and, well, yes, make us think.

The big paradox in art is that you must first learn the rules and then learn how to break them. Some of most spectacular results come from going beyond or outside of your conceptions of what should work and how your finished result should appear. If you wish to be truly creative, you must be prepared to change or expand your hypotheses of what works best or will look best and be open to what appears as you go along.

Making art is an abstract process. It's a language. The more you are able to see a body shape as an abstract shape rather than as a muscle or a bone with a name, the better you will be able to render it. Drawing is abstracting. You need to be able to see the shadow in a side-lit navel as a half-moon. To draw concretely, you need to see abstractly, to think abstractly. And the more you can understand the meaning and emotional significance of the shapes and lines you see and draw—that is, the more you can understand what they are saying to *you*—the more your art will speak.

▶ *Attitude 125,* 2007, acrylic ink and water-soluble crayon on watercolor paper, 24 x 18 inches (61 x 45.7 cm), collection of the artist

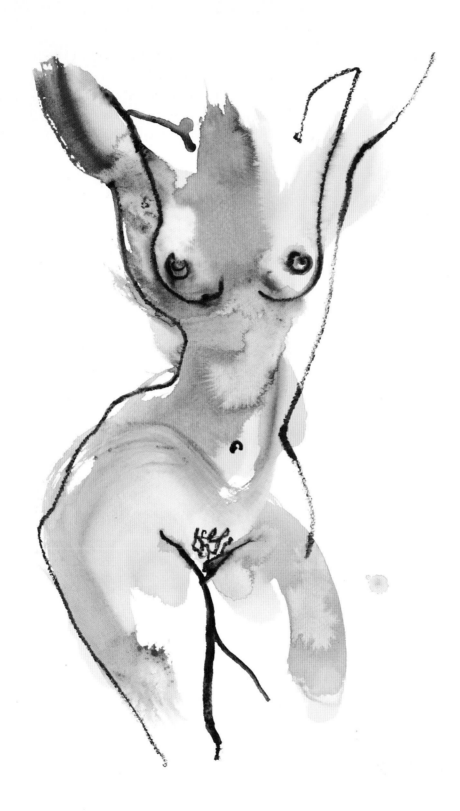

GLOSSARY

abstraction ▶ The consideration of things as ideas or concepts.

anatomy ▶ A glossary of bodily structures.

art ▶ The skillful expression of meaning.

Chi ▶ The sense of aliveness in a drawing.

chiaroscuro ▶ Using graduated dark and light tones to create the illusion of three-dimensional forms.

closure ▶ The powerful tendency of the mind to conceive of a complete or fuller understanding of something from an incomplete or limited depiction of it.

color ▶ The prime means of creating contrast. Color enables us to distinguish objects in our world.

confidence ▶ Believing that you can.

contour line ▶ A line that records the changes of direction along an edge or surface with the intention of implying three-dimensional and structural qualities. Changes along the visible outer edges of the figure are indicated by outer contour lines; changes along the edges of forms within the figure are indicated by inner contour lines. The changing undulations of the surfaces with no visible edge may be indicated by imaginary surface contour lines.

contrapposto ▶ A Renaissance term referring to a contrasting twist between the upper and lower torso (and thus the upper and lower body). These opposing forms give the figure a sense of tension, swing, and power.

contrast ▶ The essential means of perception; therefore, the essential tool of the artist.

control ▶ In drawing, the movement of the body at the command of the mind's eye. Paradoxically, this often requires giving up a sense of control and feeling free.

depth ▶ The appearance of dimensionality (where there is none). A great deal of the interest in a drawing lies in the degree and the manner in which depth is achieved.

direction ▶ A two-dimensional means of indicating the orientation of a three-dimensional object in space in relation to the viewer by its position relative to the horizontal and vertical edges of the page.

drawing ▶ Revealing a thought, feeling, intuition, idea, attitude, and so forth on paper.

expression ▶ The manifestation of a thought, feeling, intuition, idea, attitude, and so forth.

fear ▶ The enemy.

fluidity ▶ Continuous, uninterrupted movement.

freedom ▶ No limits.

fundamentals ▶ Basic elements; useable knowledge.

goal ▶ A predetermined intention. To draw without a goal is akin to fishing without a hook.

guts ▶ A desirable attribute for an artist to have.

hinged I ▶ A simple and essential key to understanding what the spine, shoulders, and hips (and thus the torso and limbs) are doing in a given pose.

idea ▶ A picture.

inner artist ▶ The part of us that knows how to make art. The invisible director of the play.

inspiration ▶ The vehicle that allows the inner artist to come out.

interaction ▶ A visual phenomenon in which stationary elements in a picture appear to create a sense of energy and even movement by their relationships.

knowledge ▶ Something that must be tested to determine its value. A little is dangerous, a lot is desirable. Knowledge should not be allowed to interfere with inspiration.

line ▶ A drawing convention that primarily indicates either an edge or a direction but that can be used in myriad other ways. For example, lines can be used to build up mass and texture or to create symbols such as words and numbers. Lines can be varied in quality to suggest an infinite range of feelings and moods.

mass ▶ The sense of something solid that is occupying space. The opposite of negative space.

materials ▶ Your actors. Your friends.

meaning ▶ A more difficult word to define than even *poetry* or *significance*. The pure subjectivity that art invites. In art, everyone gets to have his or her own meaning.

negative space ▶ The space that surrounds a figure (regardless of whether that space is occupied by other objects or not).

page ▶ Your stage. An imaginary space whose horizontal and vertical edges are generally thought to correspond to the horizontal and vertical axes of our world.

perspective ▶ Any means or device that reveals three-dimensional spatial relationships on a two-dimensional surface.

picture ▶ An idea.

poetry ▶ An ideal moment or situation where ideas, thoughts, perceptions, impressions, elements, forces, influences, and so forth combine to convey a sense of significance.

principle ▶ A starting point.

process ▶ A series of logical or illogical steps leading to a result (a product).

product ▶ The direct and precise result of a process.

progress ▶ Being able to do something one couldn't do before.

proportion ▶ Comparative relationship; an essential tool of artistic expression.

realism ▶ Paradoxically, the art of creating convincing illusions.

risk ▶ The handmaiden of progress.

selective seeing ▶ A way of perceiving where one looks for the specific and the significant.

shape ▶ An enclosed area. A powerful element in the language of significance.

significance ▶ Something that increases our understanding.

simplification ▶ Reducing something to its essentials; including what is significant, excluding what is not. (*See* significance)

statement ▶ A clear expression.

strategy ▶ A plan or sequence for a process.

structure ▶ An arrangement of parts; the way things are put together.

swing ▶ A term borrowed from jazz that applies to drawing as well. The rhythmic and lyrical placement of drawing elements to create a sense of movement, flow, and power.

Tao ▶ The essence.

technique ▶ A means to achieve an effect.

tension ▶ A heightened sense of energy in a drawing that is conveyed by strongly contrasting interactions of drawing elements, such as shape, direction, mass, and line.

vitality ▶ Chi.

Zen ▶ Direct experience. What drawing is.

INDEX

176